A Painter's Guide to Design and Composition

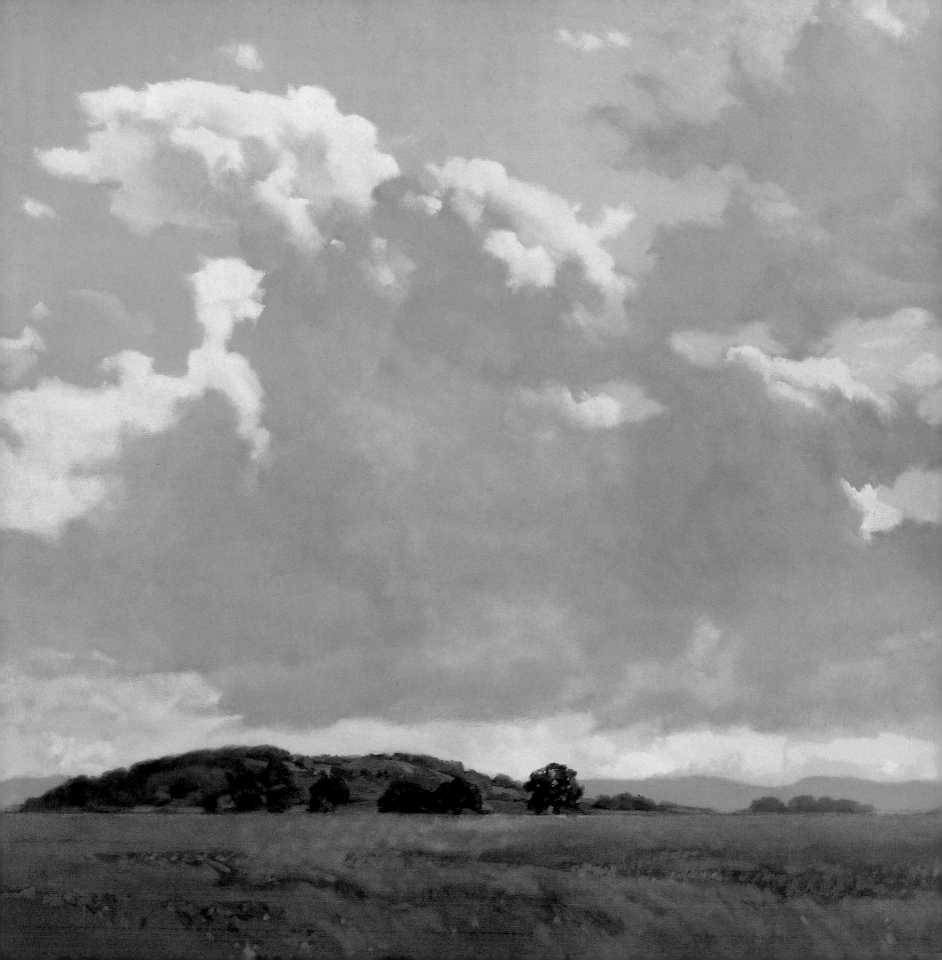

a PAINTER'S GUIDE to DESIGN AND COMPOSITION

26 masters reveal their secrets

MARGOT SCHULZKE

NORTH LIGHT BOOKS
CINCINNATI, OHIO
www.artistsnetwork.com

Art on pages 2–3:

Spring Clouds, Sonoma
Duane Wakeham | Oil
42" × 46" (107cm × 117cm)

1700
James Toogood | Watercolor
22" × 19" (56cm × 48cm)

Rachel in Blue
Jan Kunz | Watercolor
14" × 16" (36cm × 41cm)

Summer Sun
Linda Erfle | Watercolor
18" × 30" (46cm × 76cm)

Yosemite: Cascade
Margot Schulzke | Pastel
19" × 24" (48cm × 61cm)

A Painter's Guide to Design and Composition. Copyright © 2006 by Margot Schulzke. Printed in Singapore. All rights reserved. No part of this book may be reproduced in any form or by any electronic or mechanical means including information storage and retrieval systems without permission in writing from the publisher, except by a reviewer who may quote brief passages in a review. Published by North Light Books, an imprint of F+W Publications, Inc., 4700 East Galbraith Road, Cincinnati, Ohio, 45236. (800) 289-0963. First edition.

Other fine North Light Books are available from your local bookstore, art supply store or direct from the publisher.

10 09 08 07 06 5 4 3 2 1

DISTRIBUTED IN CANADA BY FRASER DIRECT
100 Armstrong Avenue
Georgetown, ON, Canada L7G 5S4
Tel: (905) 877-4411

DISTRIBUTED IN THE U.K. AND EUROPE BY DAVID & CHARLES
Brunel House, Newton Abbot, Devon, TQ12 4PU, England
Tel: (+44) 1626 323200, Fax: (+44) 1626 323319
Email: mail@davidandcharles.co.uk

DISTRIBUTED IN AUSTRALIA BY CAPRICORN LINK
P.O. Box 704, S. Windsor NSW, 2756 Australia
Tel: (02) 4577-3555

Library of Congress Cataloging in Publication Data
Schulzke, Margot
 A painter's guide to design and composition : 26 masters reveal their secrets / Margot Schulzke.-- 1st ed.
 p. cm.
 Includes index.
 ISBN 1-58180-643-4 (hardcover : alk. paper)
 1. Painting--Technique. 2. Composition (Art) I. Title.
 ND1475.S38 2006
 750'.1'8--dc22
 2005010345

Editors: Stefanie Laufersweiler and Amy Jeynes
Cover designer: Wendy Dunning
Designer: Guy Kelly
Production artist: Kathy Bergstrom
Production coordinator: Mark Griffin

fW
F+W PUBLICATIONS, INC.

Pages 140–141 constitute an extension of this copyright page.

Ex Cathedra
Margot Schulzke | Pastel
39" × 27" (99cm × 69cm)

METRIC CONVERSION CHART

To convert	to	multiply by
Inches	Centimeters	2.54
Centimeters	Inches	0.4
Feet	Centimeters	30.5
Centimeters	Feet	0.03
Ounces	Grams	28.3
Grams	Ounces	0.035

About the Author

Margot Schulzke knew art would be a major focus of her life from early childhood. After earning a degree in art education, she taught art and English in Chicago's public schools and later oil painting to adults for a number of years. About twenty years ago, she decided the time had come to get serious about her own work. At the same time, she rediscovered pastel, and shortly thereafter founded the Pastel Society of the West Coast (PSWC), which would soon become the largest pastel organization outside New York City. Although pastel has become her primary medium, she still loves oil and works actively in both media.

She has written for most of the major arts magazines, and is a contributing editor for *The Pastel Journal*. Her work has been shown in competitive and museum exhibitions coast to coast and in Canada. She is an artist or signature member of several major societies, including American Artists Professional League, California Art Club, Pastel Society of America, Degas Pastel Society and PSWC, which ranks her as a Distinguished Pastellist. As this book goes to print, she is scheduled to be recognized by PSWC as the fourth recipient of its highest honor, the Pastel Laureate Award.

Margot has juried competitions of all sizes and media, among them the Pastel 100 and Pastels USA. Conducting workshops on location at various sites in the United States and internationally, she makes composition a major focus in her instruction. She lives with her husband, Ernie, in the upper foothills of the Sierra Nevada. Visit her website at www.margotschulzke.com.

Dedication

With great appreciation to my husband, Ernie, and to my late parents, Charles and Helen Seymour.

Acknowledgments

First, I must thank God for blessing me with the talents I've been given. I don't consider them truly mine; they're a trust, for which I'm deeply grateful. I'm also profoundly thankful for the rare environment in which I grew up, with long-suffering parents who were unusually sensitive to a child's needs and longings; they built my confidence and kept me armed with art supplies, books, lessons and even, at my request, a mini-forest they planted in our yard when I was ten.

And to my wonderful husband, Ernie, who has endured my artistic clutter for all these years, my Viking wanderlust and a good many other things. He has actively encouraged and supported me in my painting and writing career.

I'd like to recognize the substantial contributions of my college design professor Warren Wilson, and Dr. Conan Mathews, who taught me art history. Both of these men, now deceased, contributed heavily if indirectly to the content of this book.

And my appreciation goes to North Light acquisitions editor Jamie Markle, who saw promise in this book, and who with good humor and patience steered me through the proposal process. To Stefanie Laufersweiler and Amy Jeynes, my editors, who have been helpful, wise and pleasant throughout. Thanks also go to the design and production staff, including Wendy Dunning, Guy Kelly, Kathy Bergstrom and Mark Griffin, who helped bring this book to life.

To the contributing artists, for sharing their lovely work. Special thanks to those artists who labored long and hard to provide our demonstrations.

To the unflappable Pat O'Kane and Holly Owen at Cali-Color Photo Labs in Sacramento, for getting slides and transparencies to me, often on short order. And to my regular students, who allowed me time off to produce this book, and whose insights and feedback over the years have contributed more than they will ever know.

Table of Contents

Introduction
8

PART I
DESIGN BASICS

1 Elements & Principles:
The Building Blocks of Design

Every successful painting begins and ends with a solid design. A good composition elevates a work of art from amateurish and ordinary to stunning and extraordinary. Learn how to apply the elements of design to bring the eye-pleasing principles—and your intentions—to beautiful artistic life.

12

2 How Artists Think as They Create

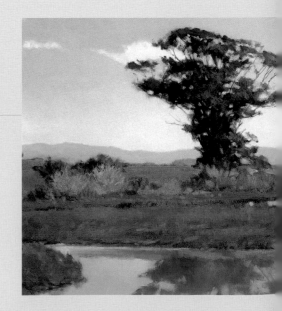

Discovering how others navigate the painting process may help chart your own route. A lifetime of lessons can be found inside the brains of successful artists. Find out how they artistically develop what inspires them, determining the best compositions, making effective color choices, selecting appropriate backgrounds and more.

62

PART II
MASTER CLASS

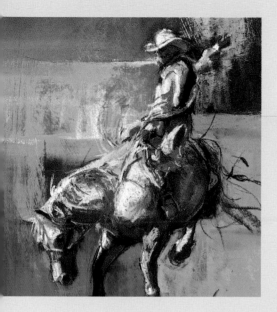

3 What Takes a Painting Beyond "Good"

What gives a painting that special something, the masterful touch that makes it unforgettable? Harnessing the immense power of mood, discovering your own style and taking risks are a few of the keys to unlocking the artist you dream to be.

92

4 In the Artist's Words

Knowing the concepts or subjects that motivate you, and playing to your strengths, can help you regularly turn out powerful, memorable works of art. Seven accomplished artists share, in their own words, their motivations, intentions and approaches for their paintings.

130

Conclusion

138

Contributors

140

Index

142

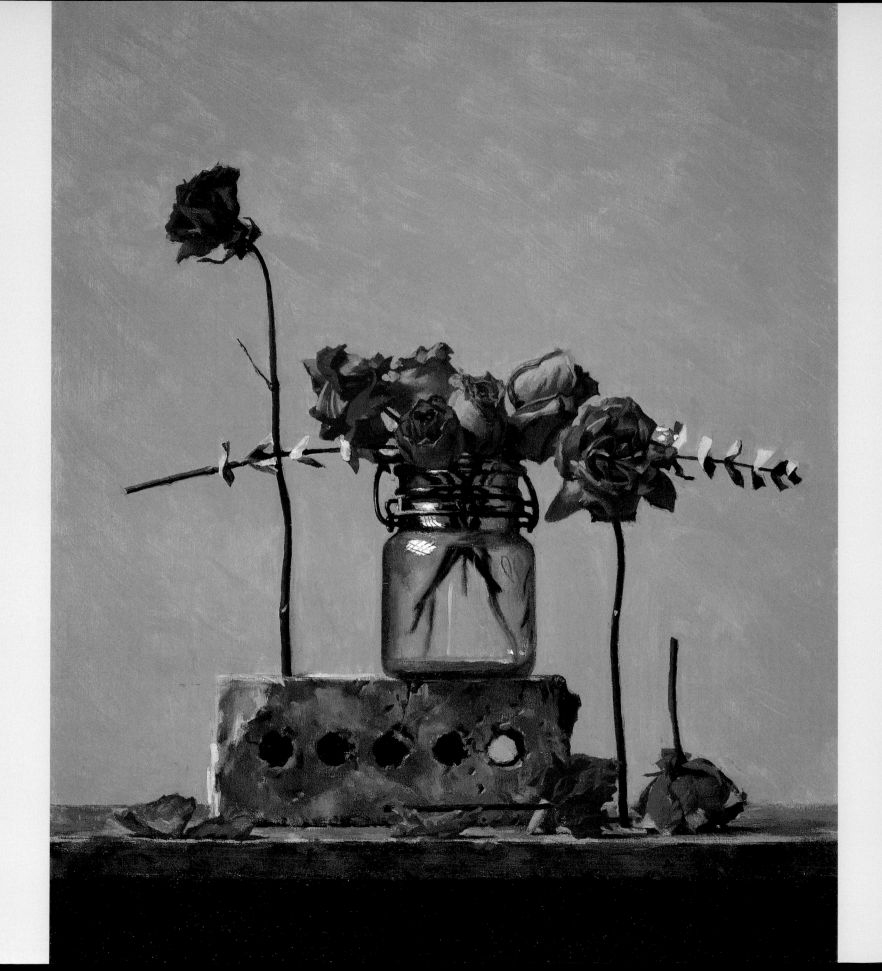

Introduction

In fine art, design is the same thing as composition. Despite rumors to the contrary, there's no essential difference. They both boil down to what you put where. We make a decision, then a mark somewhere on the picture plane.

Composition and design are ultimately what painting is about. Knowing why you do what you do, how to do it a second time and how wide-ranging the possibilities actually are puts wings beneath your feet. Gaining control of it is liberating in virtually every sense of the word.

Yet many artists feel intimidated by design, that it's more than they want to deal with. They push it onto the back burner and hope that somehow it will take care of itself. However, the fact is that design can be demystified—and it must be, since consistently successful results come no other way.

As a visual person, abstract concepts don't do me much good. I like analogies, and mountain climbing seems to mirror the act of creating art. Does anyone just forgo planning and "hit the road" to reach the peak? Obviously, not if you intend to see the view from the top, and not if you plan to get there again. Happy accidents seldom happen when climbing to great heights. That requires understanding, planning and practice. As with legendary mountain-climbing expeditions, so it is with great paintings.

Many of my painting adventures have kept me in a degree of suspense that must bear close resemblance to the adrenaline surge climbers experience when scaling a rock face. There are times, as artist Lesley Harrison puts it so well, that what I feel is "sheer terror." But what a delicious terror! Living on the edge is why people climb mountains. And I confess it is one of the reasons I paint.

Even with a plan, success is never guaranteed. It just improves the chances. We want to know where we're going and how to get there. And how to do it again and again. To do that requires a well-developed sense of design. How do you acquire one of those? You study, observe and ask questions. In the process, you learn to see critically. And you paint—a lot, while consciously applying the concepts you've discovered. With persistent, informed application, the concepts will become yours.

We're all aware that there's much about art that is intuitive. But few realize how much of art is logical and reasonable. It can be understood. And, once understood and absorbed, eventually it becomes second nature. Anyone who sets out with serious intent can master design.

In the first part of the book, we'll review the elements and principles of design. Practical advice, insights and tips, accompanied by related demonstrations by master artists in various media, will reinforce your understanding of good design and expand your knowledge and skill. Concepts developed in the second part of the book carry you beyond basics to a deeper comprehension of design and a higher level of confidence in putting it to use. Your understanding of design will open the door to more experimentation and a greater willingness to take risks.

Does this book cover it all? No. There will always be more to learn—hopefully so—till the end of your painting days. May it be for you as with Renoir, who said as he put down his brush on the last day he painted, "I believe I have learned something today." The joy of discovery we experience in the painting process is one of its major rewards. May you never stop making such discoveries.

Jar, Brick and Roses
Daniel Greene | Oil
20" × 16" (51cm × 41cm)

Contrast and Rhythm

The large off-center blossom is the undisputed focal point, as it is the only one of its size and is emphasized by the deep value contrast with its adjoining shadows. Petals and leaves provide a rhythmic flow of line and pattern, moving the eye from left to right. Smaller blooms on the right edge of the painting act as the "stopper" to keep the viewer's eye in the frame.

Tulip Tree
Penny Soto | Watercolor
23" x 16½" (58cm x 42cm)

PART I

DESIGN BASICS

KNOWLEDGE IS POWER; THE WRIGHT BROTHERS FLEW BECAUSE THEY UNDER-
stood the laws of aerodynamics. Likewise, understanding the "rules" of composition sets you free. It doesn't obligate you to use all of them all of the time. Knowing them well, you'll know when you can safely ignore them. You'll use the rules not merely to prevent or solve problems, but also to have fun thumbing your nose at them. Degas could challenge the rules of composition because he knew them well—you could say they spent a lot of time together.

Good painting is two-fold. First, a mastery of the medium, learning the way of the paint. And second, a desire to tell the viewer something about what it is we are painting. Otherwise every painting should be titled "That Was the Way It Was."

—Richard McKinley

11

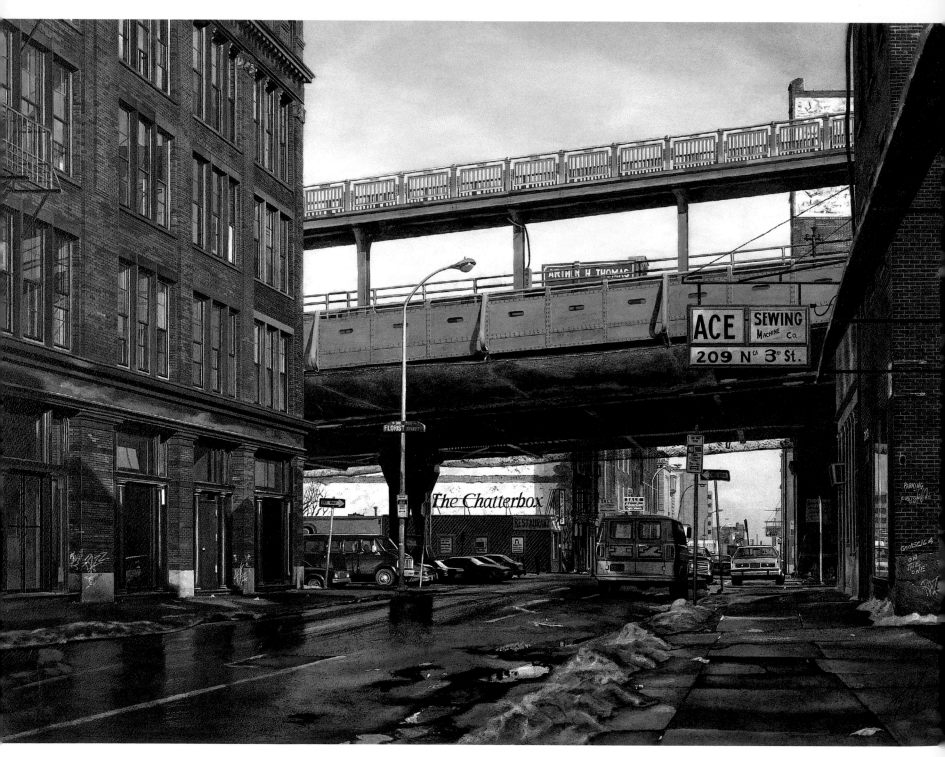

A Question of Balance

Warm and cool, dark and light are contrasted here, with unequal proportions. So why is it balanced? First, because light draws the eye and gives that smaller but brighter area greater visual weight. Second, the elevated railway serves as a brace between the lighted building and the heavy weight of the larger shadowed area.

The Chatterbox
James Toogood | Watercolor
22" × 30" (56cm × 76cm)

ELEMENTS & PRINCIPLES:
The Building Blocks of Design

1

A DESIGN IS SIMPLY A RECIPE FOR A SUCCESSFUL PAINTING. WITHOUT A DESIGN, we get something ordinary, like scrambled eggs. With one, we might have Eggs Benedict.

The elements of design—space, shape, line, value, color, texture and pattern, plus intervals and proportion—are the raw materials of composition. They are to design what stone, mortar, lumber and steel are to building construction.

The principles of design might be described as the artist's intentions. They are the objectives or results we have in mind while combining the elements. Among these principles we find contrast and emphasis, rhythm and movement, harmony and discord, and balance. To achieve these objectives, there are rules of design artists have developed over centuries. These rules are surprisingly consistent from era to era and artist to artist, suggesting they are valid and should be taken seriously.

Yet artists don't, and shouldn't, hold to all the rules all the time. You'll use them to prevent problems and to solve them, but selectively breaking some or ignoring others now and then is part of being innovative and original. However, to challenge the rules effectively, it's essential to know them well so you can break them with authority.

Using Abstraction to Analyze Painting Design

Before we get into the nitty-gritty of design, you need to understand abstraction. Abstraction describes the process of removing recognizable aspects of a subject until we get to its bare bones or basic underlying structure.

In a book that's mostly about representational art, why should we care about abstraction? Because under every great representational work, there is a successful abstract pattern of line, value and shape—one that can stand on its own, with or without recognizable subject matter. Gaining control over abstract patterns is the business of this book.

In much the same way that you focus past the raindrops on the windshield to view the road, you mentally and visually move past subject matter in a work of art to see the design structure that supports it.

If you can drive a car on a rainy day, you can learn to focus on the design structures beyond the subject matter.

Therefore, understanding how design considerations play out in a particular painting requires seeing at two levels: concretely and abstractly. The physical eye sees concrete things: In a landscape, perhaps that's a mountain or a building. But in design terms, you see these things as abstract shapes. The mountain becomes a pyramid or series of pyramids; the building becomes a rectangle or a cube. You boil the specifics down to their essence—to the skeletal structure that supports the flesh of reality.

Force your eye and your mind to focus past the rain on the windshield. As you analyze paintings, look beyond subject matter and details to see lines, shapes and values, not things. Instead of getting mired in details, seek to discover the underlying abstract structure that drives a painting and makes it a success.

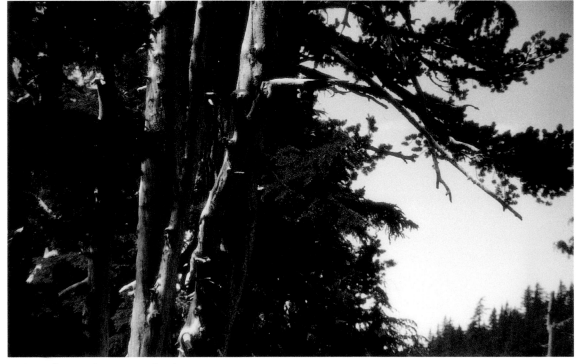

Using Abstraction From the Start
Abstraction not only aids you in analyzing finished paintings but helps you evaluate and plan your subject before you lay paint to paper. Abstracting a reference photo in stages, by eliminating or simplifying detail, can help you plan an eye-pleasing underlying structure on which to build a successful painting.

Simplified
Here the photo is simplified to clarify value patterns.

Simplified Further
Only the linear pattern is retained here. You can take it in any direction you choose at this point, adding values, color, textures and so on.

SPACE

The concept of space begins with the format of an artwork—the orientation and proportions of the painting surface itself. Once you choose a format—whether it be vertical, horizontal or square, even round—you must decide how you will divide the space to represent what you want to say about your subject. Part of that decision involves considering the point of view of your audience as they look at the subject.

Choosing a Format

The orientation and proportions of a painting's format should be whatever is required to support your composition and the forms you plan to present.

If you settle on a horizontal format, the issue is not just how wide, but how tall in proportion to the width. Likewise with a vertical. What mood or experience are you trying to convey to the viewer? Different formats inspire different feelings. A horizontal landscape is usually calming, expansive and restful; a vertical may be more dramatic or inspiring. Though some artists regard square formats as static, I consider them simply neutral, their emotional impact determined by how the surface space is designed and what is painted on them.

Determining the Viewpoint

The viewpoint—the level and angle of the viewer's eyes in relation to your subject—is the next consideration. How high or low the horizon line is placed determines whether the viewer is looking down, straight ahead or up at the subject.

Your viewpoint indeed makes a difference. A portrait with the face placed high on the picture plane projects force and dignity; one placed lower is approachable and less intimidating. In landscape, a low horizon line suggests that the viewer is looking down from above, surveying a

scene that is expansive and open. Looking up at the horizon line suggests a more intimate, perhaps introspective scene.

When placing the horizon line, remember that unequal divisions of space are generally considered the most interesting. Avoid centering the horizon line and the painting's focal point.

Establishing Space

The horizon line may divide the space, but creating the illusion of three dimensions requires more effort. Overlapping objects is one way to achieve depth. Converging lines toward a vanishing point, either on or off the picture plane, is another. Yet another is to create aerial perspective, a concept used frequently in landscape painting to show the effects of atmosphere in the distance. Colors appear cooler and contrasting values less distinguishable the farther away they are. So, placing a light haze—most often blue or blue-gray—behind a shape will move it forward from the objects it overlaps.

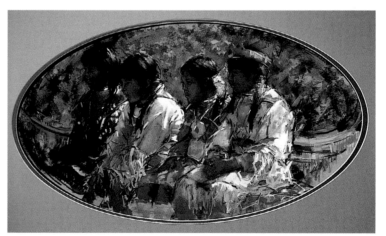

**A Unique Format
With a Purpose**
This oval format commands attention because it is unusual. So here it serves as a design element, its shape giving more sense of movement to an otherwise quiet composition.

Fun at Crow Fair
Dee Toscano | Pastel
14" × 18" (36cm × 46cm)

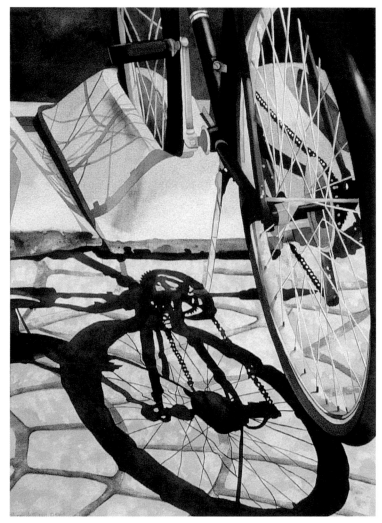

An Intimate View
Soto has an unseen, high horizon; it's completely off the picture plane, a viewpoint used in many still-life paintings. The viewer looks down at the ground to see the shadows cast by the bicycle.

Bicycle Shadows
Penny Soto | Watercolor
22" × 30" (56cm × 76cm)

THE QUADRANT TEST

While every painting needs quiet space for the eye to rest, too much "dead" space in any direction is, well, deadly. Examine your painting in quadrants; be sure every quadrant is interesting.

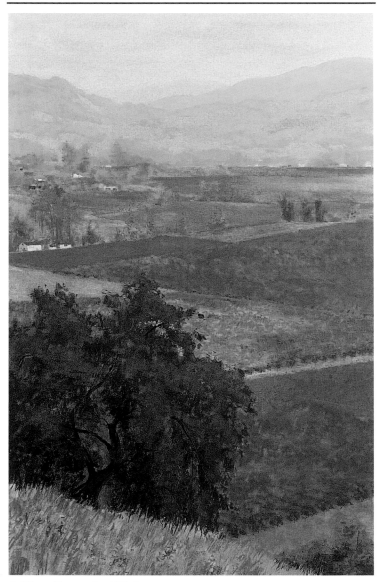

A View From On High
Mitchell's viewpoint high on a hill lends drama and distance, with the zigzag lines of the fields leading the eye back into the painting.

Above
Clark Mitchell | Pastel
44" × 30" (118cm × 76cm)

SHAPE

Shapes are not limited only to those objects you can touch. They can be thought of as any space contained or defined by an edge. Objects that would be tangible in reality are positive shapes; the shapes of the space surrounding those objects are called negative shapes. Such shapes would include the triangle of air formed by an arm placed akimbo on the hip, the space between a pitcher and its handle, or the blue sky embracing a mountain peak.

For a shape to have an identity, it must have contrast in value or hue, or an outline, to distinguish it from its background. Otherwise, we can't see it. When the shape becomes part of a large area of light or shadow, then it is part of a mass.

Shapes may be geometric—circles or spheres, rectangles or cubes, triangles or cones—or organic, such as teardrops, egg shapes and so on. There also are amorphous or irregular shapes—clouds, for instance. Shapeless shapes!

Seeing objects as shapes rather than as things is critical to painting them well. For instance, take away its coat and tie, and a book is simply a rectangle. An ice-cream cone is a sphere on a cone. A more complex object, such as a car, may be a combination of shapes. No amount of dressing up with detail will fix an object whose basic underlying shape or shapes are captured inaccurately.

Interesting paintings contain shapes that have variety. In terms of size, think small, medium and large. Large size does not necessarily make a shape dominant; dominance is determined by qualities that distinguish the shape from its setting—it may be brighter, darker, lighter, more textured or otherwise different in shape from those around it.

Everything you paint has a shape. Even brushstrokes have shapes, and shapes have direction. Consider whether the shapes you are creating with your strokes flow with and support the form you are depicting.

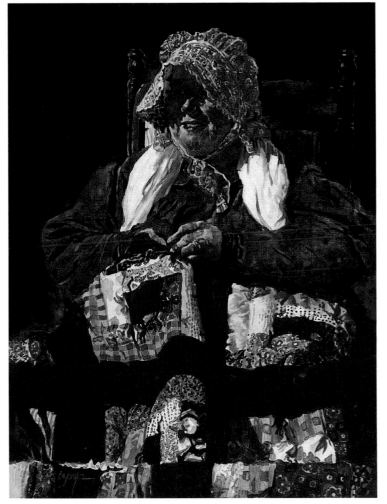

A Mixture of Shapes
Bill James uses an appealing mix of geometric and amorphous shapes, although the geometrics—the quilt squares—are gracefully distorted by the folds. The bonnet is amorphous. The chair, a geometric shape, merges with the dark background, becoming part of the background mass, another amorphous shape.

The Red Quilt
Bill James | Transparent gouache
19" × 14" (48cm × 36cm)

LINE

"More mass, less line" is a painter's rule of thumb. It is certainly true that an artist should think first in terms of broad brushstrokes, masses, shapes or forms. But we have only to look at the exquisite use of line by masters such as Degas, Renoir, Cézanne and Cassatt to see that it has a legitimate role in painting.

Lines are not merely long, continuous strokes of the pencil, stick or brush; sometimes lines are simply suggested. A line of sight, suggested by eyes looking in a certain direction, is implied line. The same is true of an arm that is pointing, or an arrow. The eye will follow that implied line until it encounters something that changes its direction. Applied line is the defined line, directly drawn or painted, along a contour or edge of a shape or mass. When we speak of line in generic terms, this is usually the line we mean. Applied lines have dimension (length and width) and may be restated to emphasize an edge. Whether they are applied or implied, lines support the entire design structure.

The direction of line evokes feelings from the viewer in a way similar to format. Horizontal lines tend to expand or broaden space; they also tend to create a feeling of tranquility. Vertical lines may signify stability, rigidity or spirituality, as seen in the soaring lines in a cathedral spire. Diagonal lines create a sense of movement or tension.

The Art of Lost and Found Edges

Lost edges are portions of a contour that briefly disappear, or merge with the background or with the object they overlap. As our eye moves on along the contour, the edge reappears and is found again. It's crisp and defined, even if for just a fraction of an inch, effectively re-establishing the direction of the line.

When the definition of an edge goes from lost to found, then lost again, important things happen. The eye moves readily back and forth between foreground and background, between positive and negative shapes. The areas become visually connected. This action mimics the normal action of the human eye. We can't focus everywhere at once.

Also, edges that alternate in and out of focus have the effect of rhythmically urging the eye on, at varying speeds.

Avoid the "cut-out" look by keeping edges undefined as long as you can during the painting process. A hard edge can function as a wall, trapping the eye within a shape. Because the eye is blocked from moving across the hard or found edge, the object it defines is divorced from its background. Giving definition to form is better left to the refining or finishing stages, not to the beginning.

Remember that all emphasis is no emphasis. Uniformly hard edges tell us that everything is equally important, leaving us uncertain about where to look. Save the most defined edges for the area you intend the eye to focus first: the focal point.

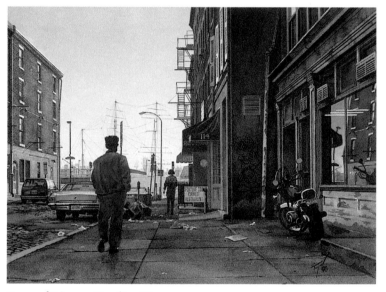

Lots of Linear Quality Here
Toogood uses line to define both contours and perspective, giving us a powerful telescoping effect. The fine detail, such as the lampposts, would be impossible without it, and in this painting, they make a significant contribution to the effect.

Chestnut Street
James Toogood | Watercolor
14" × 19" (36cm × 48cm)

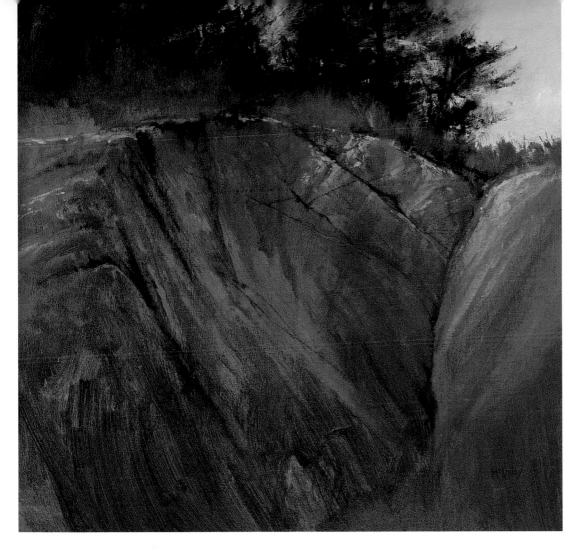

Leading the Eye

Line appears in many forms here: lost line, found line, applied line, even multiple directions of line. The near-vertical line in the lower-right quadrant serves to stop the eye and leads it back through the painting. The horizontal line of trees across the top braces the composition against the margins, supporting the free flow of line beneath.

The Point
Richard McKinley | Oil
24" × 24" (61cm × 61cm)

A Great Ride

Handell's favorite line is diagonal. He uses it powerfully and simply here, giving the viewer a ride. The movement is supported by the bracing lines of surf and shore, upper right. Challenging the rules, he brings the line at upper left almost to the corner on the lower right—but not quite.

Monterey
Albert Handell | Oil
24" × 24" (61cm × 61cm)

DON'T TRAP YOUR LINES

Lines should never be constricted by margins. Don't stop a line or turn it just short of the painting's edge; let it run unfettered out of the picture area.

Creating Purposeful Edges
Margot Schulzke · Oil

Königsee means "the king's lake." Situated in the Bavarian Alps at the foot of the magnificent Watzmann, the lake is surrounded by nearly vertical mountain walls rising directly out of the water. This painting began with a visit to this out-of-the-way site. Crossing the lake's deep waters silently in an electric boat, coming around a bend in the lake to see this view of St. Bartholomew's Church suddenly revealed took my breath away.

Handling edges successfully has a lot to do with not committing to any hard edges early in the process. I don't even worry about accurate margins at the start, just building masses and keeping it loose as long as possible, saving details until required.

MATERIALS

Oils
Amsterdam Deep Rose • Cadmium Yellow Light • Cadmium Red Light • Cerulean Blue • Cobalt Blue • Permanent Green Light • Phthalo Yellow-Green • Raw Umber • Sap Green • Titanium White

Brushes
Nos. 6 and 8 bristle flat • nos. 2 and 4 filbert • nos. 1 and 6 script liner • nos. 2 and 4 bristle fan blender

Surface
Gesso-primed canvas

Other materials
Brown pastel pencil • odorless mineral spirits • turpentine substitute

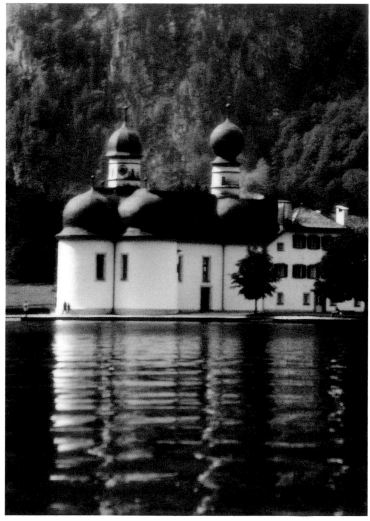

Reference Photo
Several photos were taken from the moving boat. There is no vantage point on land where this view can be seen.

Preliminary Sketches
I study the photos, selecting, shifting and distorting elements, making notes about my intentions on the margins. I often use pen and ink to fully develop the values so I know what the value patterns will be before I touch the painting surface.

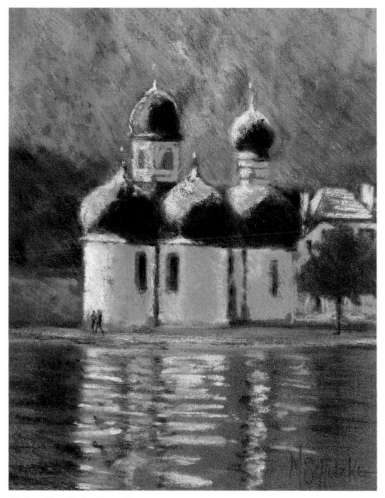

Color Study in Pastel

This is the third time I've painted this exquisite Russian-styled church. This time, I take a broader view of the church so I can use a square format, which seems sympathetic to the side-view contours. To harmonize the red domes with the setting, I underpaint the entire canvas with a glaze of Amsterdam Deep Rose thinned with mineral spirits. I also decide that the adjacent rooftop to the right margin will become red, to expand the dominant shape and maintain a sense of continuity.

1 Make the Underpainting and Drawing

The idea is to keep the rose underpainting mostly sheer, allowing light to reflect from the white of the canvas. Once it dries, sketch the drawing with a brown pastel pencil, then restate the lines with thinned Raw Umber.

UNDERPAINT FOR HARMONY

You can unify color within a painting by applying a uniform color over the entire surface before beginning to work, and allowing the undertone to remain visible in areas as you finish the painting.

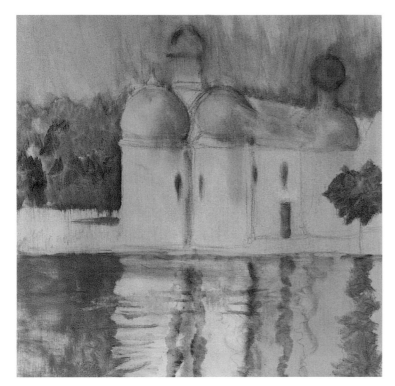

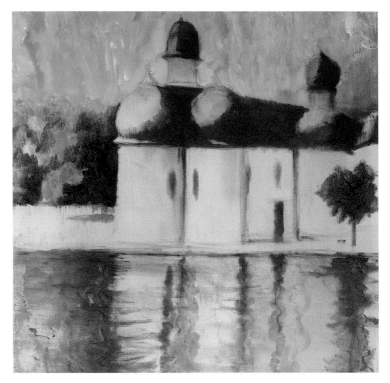

2 Begin Laying In the Darks

To establish value patterns, build the darkest areas first to establish value patterns. Apply thin glazes of transparent color: Sap Green on the darkest foliage and reflections of foliage on the water, Cerulean Blue on the background mountain. The rose underpainting desaturates the blue so it's not too strong. Wipe back with a paper towel wherever it seems too heavy.

In step one, the line dividing the grass from the trees on the left seems too high, making the widths of the tree band and the grass strip too similar. Lower the line for irregular and therefore more interesting intervals.

3 Build Areas of the Painting

Lay in heavier applications of paint, avoiding crisp edges and excessive detail. Reserve the rose underpainting on the sunlit parts of the domes, and allow bits of pink to show through in the water, on the shadow side of the building and in the face of the mountain. Keep the mood in mind—a tranquil, flooded-with-light Alpine morning. On the background, the lower face of the enormous Watzmann, apply a tint of Cobalt Blue mixed with a bit of Cerulean Blue.

Begin building color masses, establishing a clear pattern of reflections on the water from the sunlit side of the church. Also build the water reflections from the shadow side, but scrape them down and wipe them back so they won't detract from the sunlit reflections. Develop the grassy area, with a bit more blue in the distance and more yellow in the foreground, and develop the background trees without getting too detailed. As you deepen the shadows on the domes, giving them dimension and heightening the contrast with the background, make sure nothing is competing too much with the focal point: the first dome and its reflection.

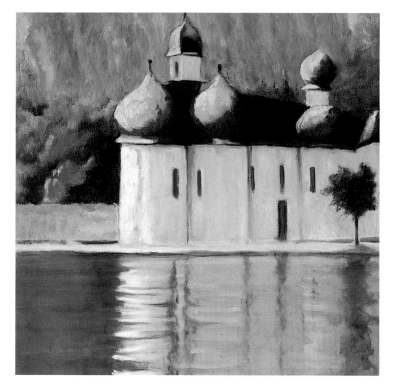

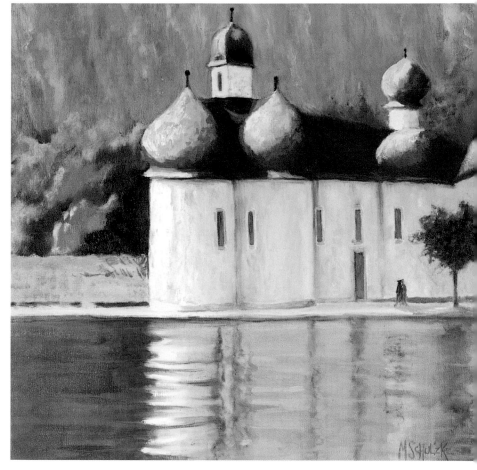

4 Begin Refining

Continue to build the masses, refining shapes and creating textures. I've reproportioned the small dome at the top right so that it will be subordinate to the dominant mass to the left. Deepen the blues and greens behind the center of the roofline to lessen the value contrast. By merging the values of that portion of the roof and its background, we lose the edge between them, and thereby diminish its importance.

Developing the foliage reflection in the water on the far left would only serve to break up the area and compete with the brilliant reflection of the church, so I don't. The light on the water is carefully controlled so that intervals between bright and dark are varied and interesting. The tree on the far right of the shore, with its dark reflection, serves as a stopper, a critical element that keeps the viewer's eye within the painting.

5 Add Finishing Touches

Frame the windows, door and base of the church with Cadmium Yellow Light toned with Raw Umber and a bit of Phthalo Yellow-Green. Deepen the shadows on and between the domes, then add ripples to the water with a mix of Amsterdam Deep Rose and Titanium White toned with Cerulean Blue. Take care to paint soft-edged ripples across the columnlike reflections so the eye is led through them, not stopped by them. To hold the masses together, keep the values of the ripples and the water similar.

Lost edges allow the foliage at the far left and right to bleed into the mountain above for a subtle merging of the two masses, which helps the viewer focus on the main attraction. The brightest bright, the lightest light and the deepest contrast—and, therefore, the most distinct or "found" edges—are on the central domes, giving them importance over everything else. Add the figures to give a sense of scale.

Morning on Königsee #3
Margot Schulzke | Oil
18" × 18" (46cm × 46cm)

VALUE

"Value" refers to gradations of light and dark: black, white and the degrees of gray between. More subtle qualities may hold your attention once you are close to the work, but it is bold value contrasts that probably capture your eye first. Along with their drawing power, value patterns largely control the movement of the eye within the work. Controlling values is therefore the first design priority.

Seeing and Comparing Values

Before you can control values, you have to be able to see them. All color has value, but beginners often let color confuse the issue of value. Squinting is a helpful trick—it reduces or eliminates color and detail, allowing you to read lights, darks and the tones in between, and to visually merge shapes.

Artists speak of the gray scale, an arbitrary measure on which black is ten, white is zero and the gradations in between are one to nine. Each step on the scale represents a 10 percent change in value. The object is to compare the values in the subject, as well as values within the work, to each other and to the gray scale. You can buy a commercially made scale or easily make your own (be sure to punch a small hole in each value gradation).

Place the scale over the small area you are trying to compare to find the correct value. The gray on the card will merge or contrast with the area in question; move the card to compare it to other areas. Adjust the values in your painting as needed. Once your eye is trained to see values acutely, you can do it with the unaided eye, but en route to that exalted condition, this little tool helps.

Taking Control of Value

Controlling your values means you assume command. You aren't merely reporting what you see, you are orchestrating it. Here are some tips to help you pull off a painting with successful values:

Manipulate lighting conditions whenever possible. You can control values by (1) choosing the time of day and weather conditions in which you paint outdoors; (2) establishing studio conditions, including

Gray Scale
This artist's tool helps you to determine and compare the values of the colors of your subject and those in your painting.

the type of light you choose to work under; and/or (3) manipulating the light and shadow in your value study. You call the shots.

Plan ahead. If there is one mistake that I see beginning students making consistently, it's the failure to plan a painting. They'd rather not take the time. But planning saves time. Thumbnails and/or value studies allow the artist to see values, proportions and overall shapes and to adjust them as needed, without the fear of destroying a painting in progress. They are maps to get you where you want to go.

Choose high key or low key. "Key" refers to how light or dark the overall values are in a painting. High-key paintings are predominantly light, low-key primarily dark. Bear in mind you are picking light or dark values to dominate; you aren't eliminating a group of values altogether.

Limit your values. Try to focus on no more than three (i.e., light, middle and dark values), with each appearing in varied proportions. Add the darker accents and lightest lights, or highlights, for a total of five.

Simplify areas of light and shadow. The shadow side of a tree and the cast shadow of a nearby building may act as one shadow mass. Connected areas of light and shadow establish a strong value plan.

Select a middle value or midtone as a point of reference. To be sure your light and shadow areas hold together, pick an area of middle value against which to compare all other values for consistency. Where angles turn from light to shadow are good places to look.

Save the highest value contrast for your focal point. Placing the darkest dark next to the lightest light is a magnet for the eye.

Lessen value contrast in the distance. Light and dark values appear to merge before our eyes because of the atmospheric effects in between.

Keep areas of light and dark straight. The lightest area in shadow should always appear darker than the darkest area in light. Reflected light can be particularly tricky. Typically surrounded by shadow, reflected light tends to appear lighter than it is. Rather than comparing it to the surrounding shadow, compare it to areas in full light and you will see that it is darker.

Remember, you are the conductor. If shadows need to be extended to make them connect and flow better, extend the shadows. If something doesn't fit, it's your role to tinker with it and make it work—regardless of what you actually see.

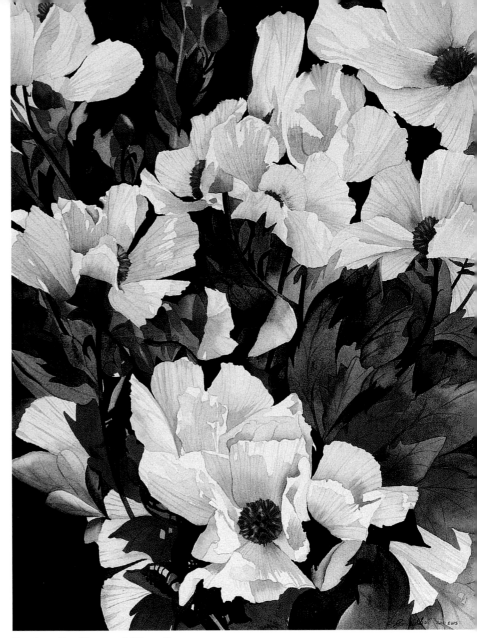

Design Quality, and Then Some
This painting has design quality in spades: high contrast, repeated shapes, a rhythmic "S-curve" value pattern, interesting intervals of size and spacing and subtle variations in value and texture within both light and shadow areas. A focal-point blossom looks us square in the eye at lower center.

White Poppy Patterns
Penny Soto | Watercolor
40" × 30" (102cm × 76cm)

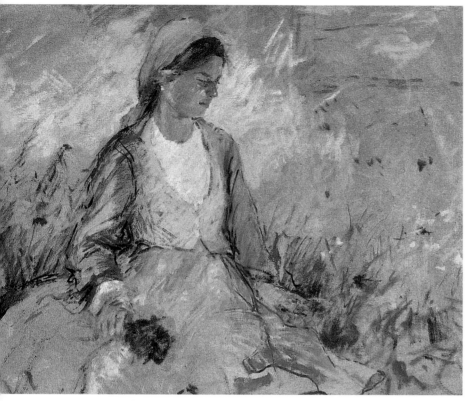

A High-Key Treatment

This fresh and airy piece uses a high key. A darker value key would lose the airy quality. Lights and midtones are unified. The few dark values are also largely connected.

Poppy Fields
Anita Wolff | Oil
24" × 30" (61cm × 76cm)

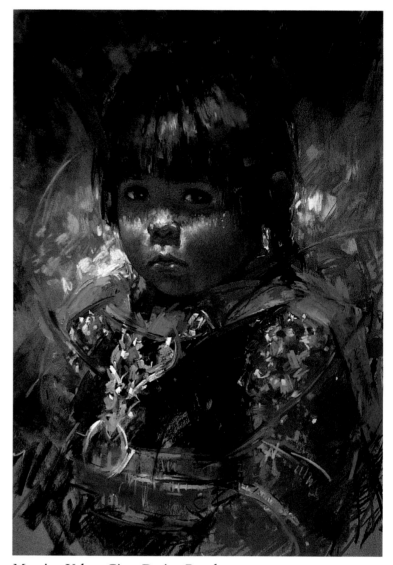

Merging Values Gives Design Punch

The artist has unified the dark values of the shadow behind the child's head with her hair and eyes. Likewise, the values of the light behind her shoulders, with the light across her cheeks and nose, and the shadows under the child's cheek merge with the reds of the collar. The artist has used broken color effectively—without breaking values, which usually is a mistake.

Shadow Eyes
Dee Toscano | Pastel
18" × 14" (46cm × 36cm)

Controlling Values
Albert Handell · Mixed Media

This painting was inspired by a waterfall in Bucks County, Pennsylvania, where I was living thirty-five years ago. I spent a lot of time there painting, drawing, dreaming, hiking and, of course, photographing. To maximize the drama of these beautiful falls, I'll need to exercise careful control of light and dark value masses.

MATERIALS

Watercolors
Aureolin Modern • Cadmium Orange Deep • Cadmium Red Light • Cobalt Turquoise • English Venetian Red • Hooker's Green • Manganese Violet • May Green • Payne's Gray Bluish • Prussian Green • Sap Green • Ultramarine Blue • Van Dyke Brown

Pastels
Burnt Sienna • Gray Blue 1 • Gray Violet • Moss Green 2 • Ultramarine Blue (all Schmincke) • Bottle Green • White (both Nupastel)

Brushes
Nos. 8, 10 and 12 Royal & Langnickel 408LT Regis longhair filbert

• nos. 4 and 6 Weber white bristle filbert (Note: Avoid using soft-hair watercolor brushes on sanded papers. The brands mentioned here are durable options.)

Surface
Kitty Wallis Belgian Mist Archival Sanded Pastel Paper, dry-mounted on four-ply museum rag board

Other Materials
2B drawing pencil

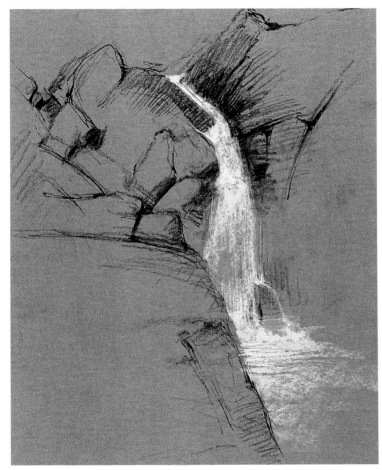

Study

This gray sanded paper provides a rich midtone to start with. I drew with an ordinary soft lead drawing pencil to establish the rocks, keeping in mind the larger value patterns I intended to create. The values alongside the falls are darkest, allowing the white pastel to create a nice contrast with the falling water. I placed the white of the falls off-center; placing it in the middle could minimize the drama of the falls, and the composition would become boring. I pay attention to movement—notably, where the white of the falls is thinnest compared to the width of the falls in general. Surrounding details are eliminated to unify and simplify those areas and to allow the falls to dominate.

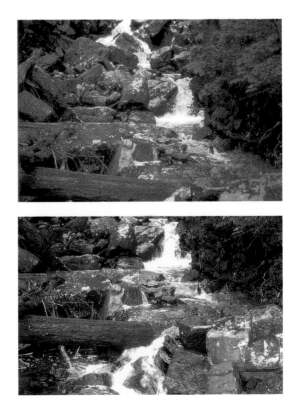

Reference Photos

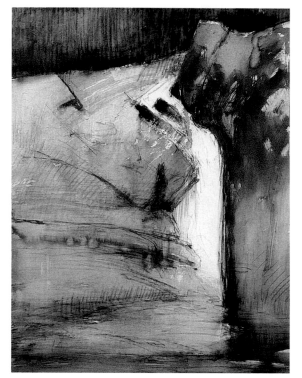

1 Make the Initial Drawing

The first lines you make are compositionally the most important. That's why we put the vertical line of the falls off-center and quite a bit to the viewer's right. Then draw a horizontal line close to the top of the paper. This line divides the vertical of the page approximately one upper part (the background) to five lower parts (the foreground). Placing the horizontal line at a slight diagonal adds to the sense of movement in the composition. Except for a few light accents, the background is consistently dark, filled with upright trees. Suggest the broken-up rocks to the left of the falls with a few dark lines.

2 Apply the Watercolor Underpainting

When I apply my watercolor washes, I paint with a sense of abandon, as this is merely an underpainting. Establish the darks first. Using a combination of Payne's Gray Bluish, Van Dyke Brown and Sap Green, paint the upper part of the painting, which will be the background, and establish some of the darks in the rocks, keeping tone and value consistent with the background. Add strong reddish browns, combined with the other dark colors, for some of the rocks on the right. With lighter colors, suggest the local colors of the rocks. This creates good color contrast in the rocks from right to left, but the values remain the same overall so that we have variety in unity. It also accentuates the initial vertical line that is so important to the composition. Vary the rock colors and values from warmer and lighter to cooler and darker as you work downward. To add variety—and thus interest—to the painting, try to show the sense of murkiness as the rocks descend to the water's edge. Using the above color mixtures to establish the water at the bottom, we then apply the lightest of color washes to "dirty" the white of the falls a bit.

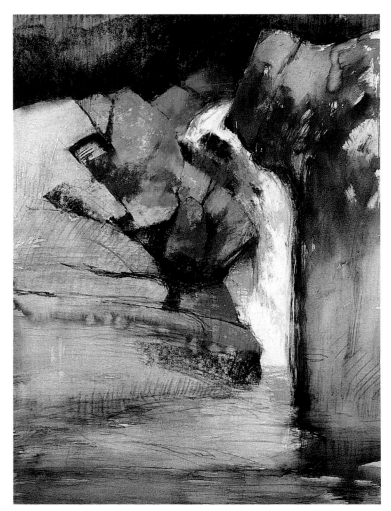

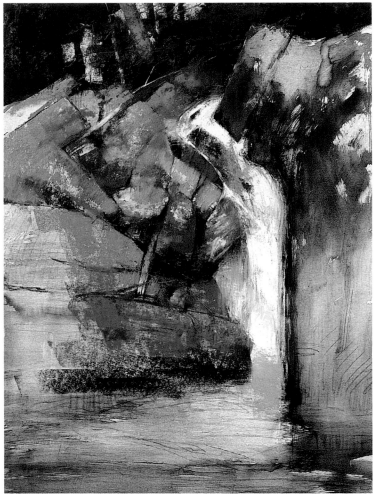

3 Develop Angular Rocks With Pastel
Now concentrate on the specifics, starting with the rocks and boulders to the left of the falls. We want the viewer to sense that the rocks are only stationary for the moment—gravity will ultimately prevail, and they will fall, fall apart or just slide down into the water. This creates visual tension. In a sense the rocks are in motion already, even though they are sitting still. Giving the rocks strong diagonal angles will develop this tension. Using darker pastels, establish these strong diagonals, then reinforce the local colors of the rocks with lighter pastels. Letting passages of the underlying water-color show through as you start developing the falls gives the water more form as it tumbles.

4 Begin Adding Details
Continue developing the painting with pastels. As you start adding details for realism, be careful not to break up masses, which would weaken the initial composition. Further develop the foreground rocks on the left side of the falls. Paint the background trees and foliage, developing the area just enough to add interest without competing with the foreground. Keeping these two areas separate from each other—yet related—is important to the overall composition.

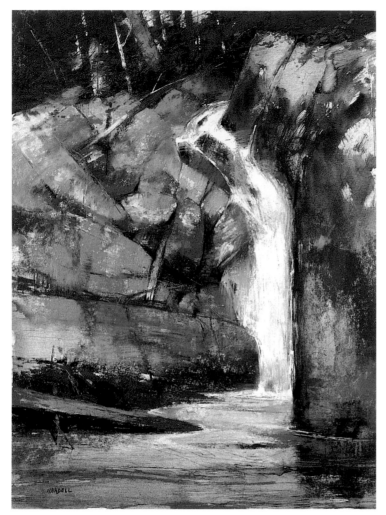

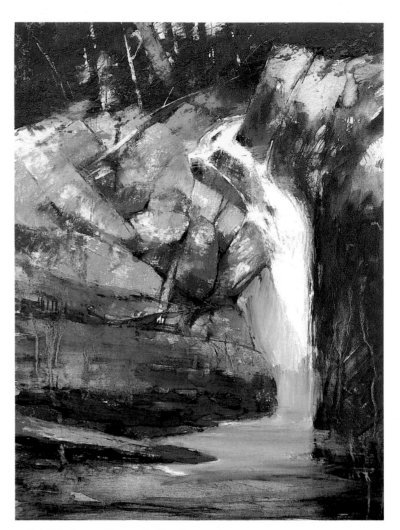

5 Choose Where and Where Not to Add Detail

To strengthen the composition, make sure the reflection in the water is a continuation of the straight line of the reddish cliff on the right. As you add more details to the background to create texture, interest and depth, make sure that edges are soft and that values remain consistent. Sometimes backgrounds are complex in contrast to stark, simple foreground shapes; other times it is just the reverse. Contrast between the two is the critical element, but it's essential to subdue and subordinate details used in the background. A powerful, clean and unified shape is required here. Reinforce and finish the reddish-brown cliff without adding unnecessary details, which would weaken it, and continue working on the rocks at left. Warmth, even if it is technically neutral, usually brings shapes forward, as it does in this case.

6 Make a Few Adjustments

I felt the straight line on the right was strong, giving drama to the composition, but too rigid, or too obvious. How do we break up this line, yet still keep it? Start with a cast shadow on the falls, painted with a wash of Payne's Gray. (It may be unconventional to use watercolor over pastel, but somehow it works.) This forty-five-degree angle of a darker color helps break the straight line without losing it—it's a matter of edge control.

For this watercolor wash, I used the no. 10 longhair filbert. Using the same brush, you can darken the foreground water with mixtures of Hooker's Green and Payne's Gray. And add some Payne's Gray to the red rocks on the right to darken them and to cool them off a bit. This helps to harmonize the entire pastel.

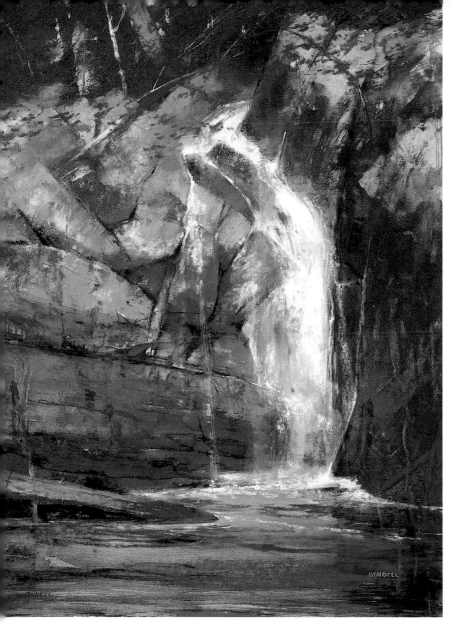

Once I establish the value of a particular area, I like to vary its local colors without changing the values. These different colors seem to float in and out of each other as their edges are very soft when they touch each other. This is an excellent way to add variety to an area without breaking it up.

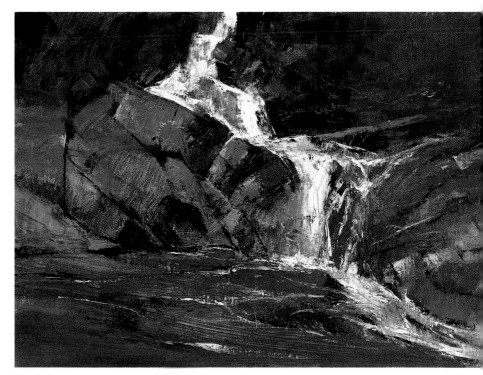

Variation on a Theme
Painting a number of different compositions of the same subject is something I do often. In these variations of essentially the same subject, I might zoom in or step back, change the lighting conditions or add or subtract some part of the scene.

Mountain Falls #3
Albert Handell | Oil
18" × 24" (46cm × 61cm)

7 Fine-Tune and Finish

Add a trickle of water falling to the left of the dominant waterfalls. It is very lightly established but effective in echoing the initial straight line, and it pulls the viewer's eye a bit to the left. Add more splashes to the dominant waterfalls. All this helps to break up that rigid straight line. Remember that details, especially selective details, add interest and pleasure to the viewer's eye without diluting the power of mass and line.

Mountain Falls #1
Albert Handell | Mixed media
24" × 18" (61cm × 46cm)

COLOR

Color has the power to stir emotions. We often associate certain feelings or characteristics with different colors. Red may provoke anger or passion; green often represents a sense of freshness and rebirth; blue can lend a feeling of tranquility or perhaps sadness. No wonder it has the power to make your paintings sing!

If color theory is new to you, don't expect to absorb it overnight. To experiment with new information, even before you understand it, is often a necessary next step. Understanding comes in the process.

Terms to Know

To talk about color as it relates to composition, we first need to understand some basic terms and concepts that include local color, the color wheel and the qualities of color: hue, value, intensity and temperature.

Local color is the dominant or basic color of a given object. For instance, the local color of a watermelon slice is red.

A color wheel is an artist's tool for organizing color. Because the

wheel lays out color relationships, it makes choosing the right colors for your painting much more manageable. The traditional model is comprised of the three primaries—red, blue and yellow—which cannot be mixed from any other colors; three secondaries—orange, green and violet—each a combination of two primaries; and six tertiaries—mixtures of a primary with a neighboring secondary (red-orange, red-violet, blue-violet, blue-green, yellow-green and yellow-orange).

Hue is the "color" of the color, its place on the color wheel, such as blue, blue-green, and so on. If it doesn't fall into line around the color spectrum, it isn't a hue. It may be a tint (a lighter version of the hue), a shade (a darker version made by adding black) or a tone (a dulled version made by adding its opposite on the color wheel). There are also neutrals, which are when enough of the opposite color is added to make it simply a cool neutral (gray) or a warm neutral (brown), no longer identifiably related to the original hue.

Value, as we've already learned, is how light or dark a color is. All colors have value.

Intensity, also called tone or chroma, refers to the brilliance or purity of a color. A "full-chroma" color is full-strength. A "toned" color's chroma has been diminished by the addition of white, black or its opposite. Some of the richest colors are toned or neutralized to some degree, while still being identifiable as the original color.

true green | gray-green | olive green

Temperature refers to the relative warmth or coolness of a color. We generally categorize reds, yellows and oranges as warm colors, and blues, greens and violets as cool ones, but it is possible to have cool reds (tending toward blue) and warm greens (tending toward yellow). It's all a matter of comparison.

warm red | true red | cool red

What Affects Color

Looking at color, what you see is relative to its background, to the time of day, and to your own eyes. It's obvious we don't all see the world the same way; color is no different. For years, a paint store in my neighborhood had a sign hanging behind the counter that read, "Husbands buying paint must have note from wives." It brought knowing smiles from the other side of the counter.

The appearance of each essential quality of color—hue, value intensity and temperature changes relative to its surroundings. Three particular things that greatly affect color are:

The quality of light. When light fades, color goes with it, yet this is not just a question of the quantity of light; it's also the quality. Both time of day and climactic conditions make a big difference. Morning, midday and afternoon light all have different effects on color, making them cooler or warmer, crisp or vague. Even studio light may vary from one day to the next.

Distance. Colors nearest to us appear brighter and warmer than those in the distance; colors seem duller and cooler as the atmosphere in between increases. If you want objects to recede in distance, they have to lighten as well.

Surrounding colors. Every aspect of color is relative. Learn to see each color—not just on your painting surface, but also in your subject and on your palette—with a fresh eye every time.

Under the Midday Sun

With the sun at an angle high overhead and to our right, we are able to see the beautifully modeled face of this mountain and its range of values: light orange on the face exposed to the sun, and rich, deep orange in the shadows. The contrast is the drama. As orange and green are near opposites, the simplified color scheme intensifies the effect.

Etched in Stone

Carol Harding | Oil
40" × 46" (102cm × 117cm)

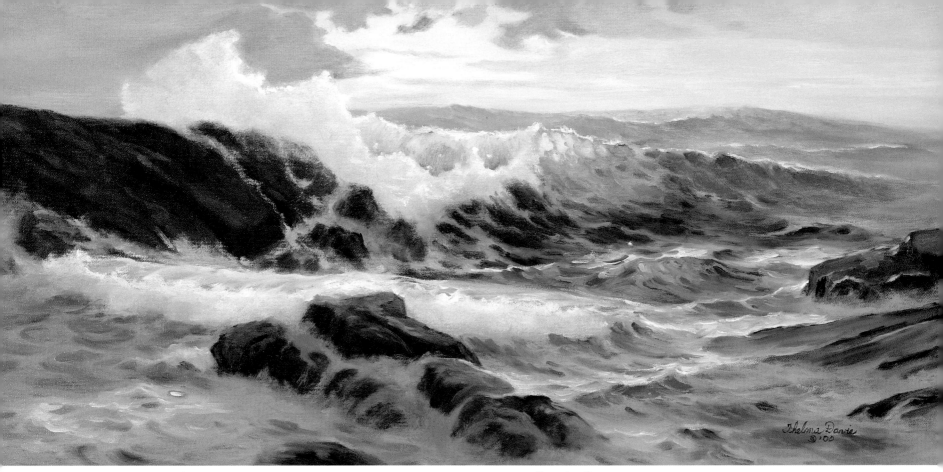

Warming Up the Sea

Balancing warm with cool in seascapes is a special challenge. Here the red-dish rocks and late afternoon sky, its color picked up not only in the rocks but also in the foam of the major wave, provide the needed balance.

Pounding Surf
Thelma Davis | Oil
15" × 30" (38cm × 76cm)

Color Tips

As you paint, the application of color may seem like the ultimate balancing act, in which you must constantly make choices between bright and dull, warm and cool, light and dark. Here are some tips to help you handle the challenge:

Understand what happens when colors mix. Not all colors can be brilliant. You can lessen the intensity of a color by adding its opposite. A small amount will do the job. But be cautious when using commercially prepared grays and browns to dull color. As neutrals are already mixtures of various hues, they tend to muddy color. Browns, if used in this manner, are ready-made mud.

Don't underestimate the power of neutrals. Some of the richest colors are "toned" or neutral. They can add drama and mystery to your work. It helps to remember that the liveliest grays are not made with black and white, but are simply opposites combined in more or less balanced mixtures. Working with all pure color can be like working with one hand tied behind your back.

When a color doesn't look right, look around. When a color appears to be "off," garish or out of place, look at adjacent values or colors. If the offending color appears dull, something nearby may be too bright; if it looks too bright, maybe the adjacent color is dull. If the color appears not to belong at all, the solution may not be to change or dull the color, but to add more of it elsewhere. Consider all the options.

Provide "relief" with complementary color. Complementary colors placed side by side react to one another, setting up vibrations in the eye. Simply stated, the eye tires of focusing on a particular color and seeks relief in the form of that color's opposite.

Bring variety to large areas of solid color. You can enhance these areas, without any loss of brilliance, by varying the temperature of the local color.

Use color to make areas come forward or recede. Cool and fade colors as they move into the distance. Warm and intensify colors that are closer to the viewer.

Remember that warm color is more attractive to the eye than cool. So, temperature balance generally requires that every painting has some warm tones. You can manage that in cool landscape subjects, for example, by using a warm underpainting or entry color that invites the eye into the painting.

Save the most intense color for your focal point. If you want an area to really pop out, don't repeat its color anywhere else at full intensity.

Using Color Schemes

Just as a musician selects a key in which to compose, so a visual artist needs to control variety of color. Color palettes should be limited to avoid a visual circus of overstimulating, overwhelming color. Employing planned color schemes is one way to get there. Here's a list of options based on the traditional color wheel:

- monochromatic—one color plus its tints and shades
- triadic—three colors equidistant on the color wheel
- complementary—two colors opposite or nearly opposite each other on the color wheel
- split complementary—one color plus the two on either side of its complement
- double-split complementary—the colors adjacent on each side of a pair of complements
- analogous—three or four adjacent colors on the color wheel
- analogous plus complement—three or four adjacent colors, plus the complement of one of them

Tints, shades and tones derived from any of the colors in a particular color scheme are considered "legal." Since black and white are not true colors, they can be added to any color scheme.

You'll find that a lot of latitude exists in color decisions. You'll rarely regret taking a chance on color, so don't be intimidated. The ultimate test is if it works, it's right. The experiments not tried are the ones certain to fail.

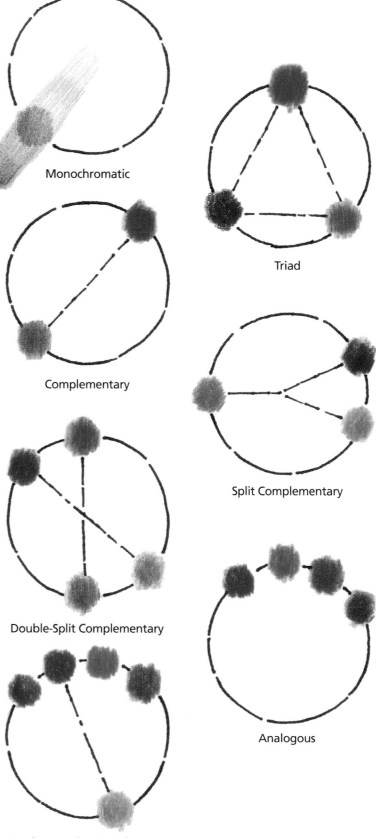

Monochromatic

Triad

Complementary

Split Complementary

Double-Split Complementary

Analogous

Analogous Plus Complement

Analogous Plus Complement

This artist uses blue in large quantities, plus the balloons in red-orange, orange and yellow, along with the noncolors of black, white and neutral gray. The various forms of complementary color schemes tend to be festive, which clearly enhances the holiday mood suggested here.

Fishing Fleet
Thelma Davis | Pastel
27" × 20" (69cm × 51cm)

Monochromatic Is Often Moody

The pensive but comfortable quality of this painting is established by its warm, monochromatic color scheme.

Twilight, Men's Club
Sally Strand | Pastel
22" × 15" (56cm × 38cm)

Analogous

This painting comes very close to a monochromatic color scheme, but it contains golds as well as oranges, and a small drift of bronzy green is tucked into the hillside on the far right, and so still qualifies as analogous. The closely related colors support rather than compete with the focal point—the farmhouse.

Coughlin House—Fall
Bill James | Oil
20" × 30" (51cm × 76cm)

Analogous Plus Complement

The subtle shifts of color temperature possible in this scheme make it potentially as moody as a monochromatic scheme. Drifts of soft red-violet toned by yellows in the foreground lead us to the predominantly violet middle ground and from there to the blue-violet background.

Rincon Shadows
Maggie Price | Pastel
11" × 17" (28cm × 43cm)

Triadic

Triads employ three colors equidistant around the color wheel, such as red, blue and yellow. Here we have a triad of orange, green and violet. The purple-brown background subtly echoes the purple of the lily's throat.

Purple Fringed Lily
Linda Erfle | Watercolor
22" × 30" (56cm × 76cm)

Black, White and Full of Color

The artist's punchy use of black and white, along with small additions of analogous red, orange and yellow—plus yellow's complement, violet— make this painting vibrant.

Flowers of the Sun
Carol Harding | Pastel
21" × 14" (53cm × 36cm)

Manipulating Color
Duane Wakeham · Pastel

I've done both a pastel painting and an oil painting inspired by this view of a clump of eucalyptus trees above the Big Sur coast. For this demonstration I wanted to place the trees into a setting with water. Planes of water offer the opportunity to reflect colors and shapes that provide compositional unity. I'm as much interested in color composition as I am in the division of space and the placement of shapes.

Reference Photo
I've always liked the silhouette of the main tree shapes in this photo.

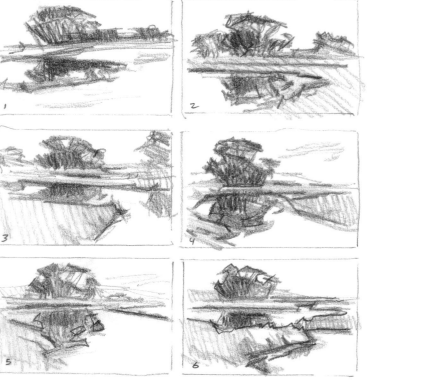

Compositional Studies
I wanted to place the trees within a water setting. In the first sketch, I simply excavate a hole and fill it with water. The sketch retains the slope of the hill as seen in the photo. In the second sketch I flatten the ground plane, taking the viewer right to the edge of the pond, and transform the distant mountain from the photo into another tree shape. Sketches 3, 4 and 5 relocate the tree to the edge of an undulating waterway. The difference between them is in the configuration and location of the banks. The final sketch has interlocking grassy banks that enclose foreground and middle-ground areas of water. A narrow band of water appears at the horizon line. The greater complexity of shapes and spaces in this sketch seems by far the most interesting to me.

M A T E R I A L S

Pastels
Soft and hard, in a variety of warm and cool colors

Oils
Alizarin Crimson • Burnt Sienna

Surface
300-lb. (640gsm) paper, stretched and prepared with two coats of a

mixture of acrylic gesso (⅔ cup), water (⅓ cup) and three to four tablespoons of powdered pumice or marble dust

Other materials
Turpentine substitute • soft brush • denatured alcohol

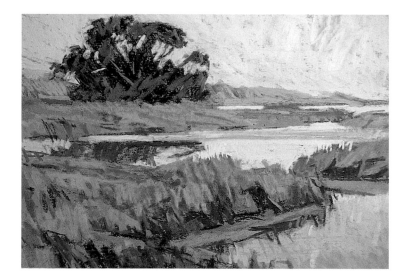

Color Study

My paintings, especially those that depict water views, almost always include a strong horizontal line to convey a sense of tranquility. However, I try not to allow the line to continue unbroken across the composition. As this study suggests, the viewer is standing on a low bank just at the edge of the water.

The colors of the foreground and middle ground are directly influenced by the photo. The pale blue of the sky is almost unnoticeable, and clouds seem unnecessary since enough will be happening with all the other shapes. A broad squiggle of slight pink suggests the possibility of introducing that color into the sky at some point.

1 Tone and Draw

Tone the prepared paper with a wash of oil color, a mix of Burnt Sienna and Alizarin Crimson diluted in a turpentine substitute. Using a hard pastel, make a drawing that only defines the main shapes.

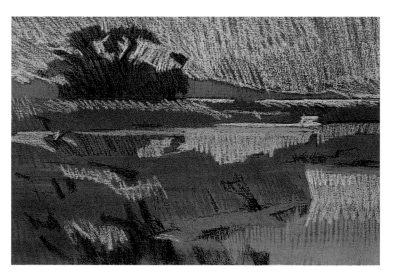

2 Complete the Block-In

Using hard pastels, roughly block in the large shapes, applying just a single color for each individual shape. Notice that the colors chosen here differ somewhat from those that appear in the color study. The blue of the distant coastal mountains is much stronger than in the study, as is the pink and red-violet in the lower two water areas. Add only a few touches of color for the ground and grassy areas.

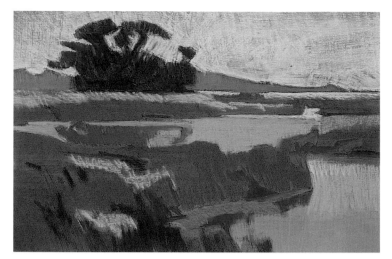

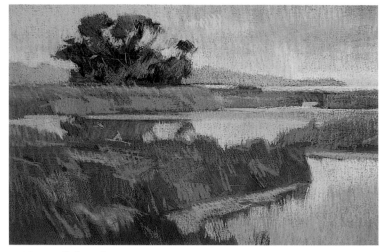

3 **Dissolve the Pastel Underpainting**

Using a soft brush and denatured alcohol (which evaporates quickly), dissolve the pastel, allowing it to sink into the surface. Work one color area at a time to avoid creating muddy color. Although some evidence of the sketchy strokes remains, much of the color is flat and opaque. Sometimes the dissolved color doesn't completely cover the toned ground (as in the upper left corner). This interaction will influence how the color develops in the process of painting.

Some artists who use this technique prefer to start with a precise drawing, fill in each shape fully and then dissolve each area very carefully. I prefer to block in the color loosely and apply the solvent somewhat freely for a broadly brushed underpainting.

4 **Build Color**

Consider the sizes and contours of the shapes more carefully as you start to develop the color with loosely applied strokes. At this early stage, continue to work with hard pastels to minimize the buildup of pigment. Get the color moving throughout the painting. Work all over the image, attempting to keep everything at the same degree of development. Switch to softer pastels when you want a wider range of color and greater subtlety.

As the painting progresses, more detail is given to the shapes, and color is developed more fully. This step shows the painting in between stages. The tree shape and everything below it is still in an early stage, but the sky is further along.

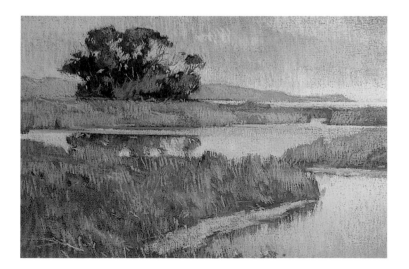

5 **Evaluate**

The upper portion of the painting is nearly complete, but the lower section has yet to be resolved. I'm not satisfied with the interior design of the foreground land mass, nor do I like the dark border creeping across the bottom edge of the painting.

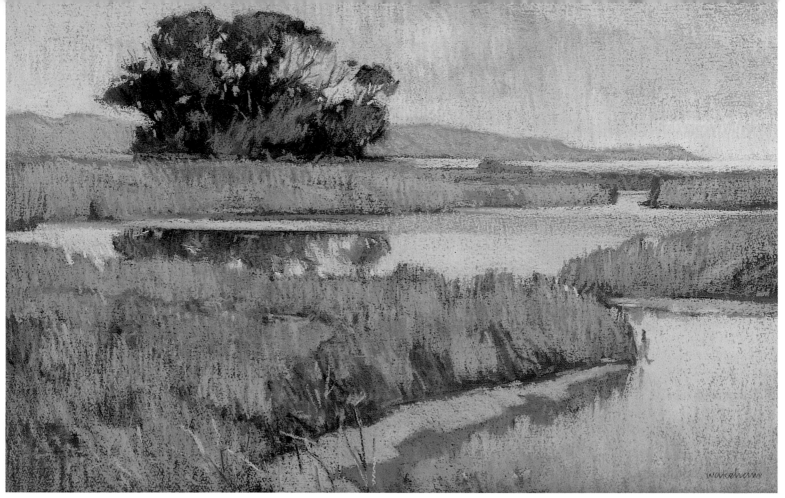

6 Make Key Adjustments

In finishing, the goal is to establish a pleasing balance between warm and cool color—so balanced, in fact, that the painting doesn't obviously lean toward one or the other. Make the light in the sky a little warmer and the band across the top slightly cooler. Suggest volume and definition in the distant coastal range with strokes of red-violet and blue of almost equal intensity. Apply the same colors to the two large water areas, as well as in the grasses. Apply some of the strongest accents of red-violet in the far middle ground—above the break in the opposite bank and on the undefined shape that breaks across the most distant water. Even though the two foreground banks intersect, the displacement of the two masses, the color and value change, plus the color accents along the top of the foreground grasses, all combine to provide a sense of access and depth. The opening in the opposite bank above suggests eventual access to the ocean.

Carefully consider silhouettes to provide the repetition of certain shapes and lines. The upper edge of the foreground land mass repeats the line of the distant mountains. The dips in the upper line of the foreground grasses echo the opening in the tree and reinforce the shape that breaks across the horizon. Redraw the patterns of light and dark and color that give definition to the foreground grassy bank. Eliminate the distracting dark border at the bottom of the painting, allowing the scenery to extend into the viewer's space. A few bare branches combine with the undulating diagonals that weave through the grass to gently counteract the strong directional movement to the right, resulting from the converging lines of the mountains and the water line of the foreground point of land.

Quiet Summer Evening
Duane Wakeham | Pastel
19" × 29" (48cm × 74cm)

TEXTURE AND PATTERN

While they are not structural elements, texture and pattern are as organic to fine art as skin is to the human body. They provide richness and yet another opportunity for eye-pleasing contrast—in their case, between the simple and the complex. Looking at the sensuous surface of paintings by great masters makes many of us almost itch to "get into" them.

Textural qualities come from three directions: the support, the stroke and applied textures. The support, or structural texture, makes a critical difference. Experienced artists know how various surfaces—cold press versus hot press, linen versus cotton, and so on—will impact the final work, and they pay close attention to it.

Although an artist's stroke evolves somewhat over time, in the drier media of oil, egg tempera and pastel, the characteristic stroke is considered to be an artist's signature. Like script, "handwriting" with the brush or stick creates effects that distinguish the work from that of any other artist. In these media, the stroke has potentially the most distinctive and perhaps the most aesthetically rich effect of any element of design.

Each medium has its own distinctive methods of applying texture. Like actors in a reader's theater, textures play a lot of roles: enriching the surface, adding interest, moving the eye along and—if their use is limited to a given area—distinguishing that area by providing contrast and/or bringing it forward. Repeated figures (such as rows of trees), random color effects (such as in a garden) or other intricate linear patterns create larger-scale textural or patterned effects.

Don't go overboard; if you provide no place for the eye to rest, the viewer may seek relief in someone else's painting. Create a break in the action.

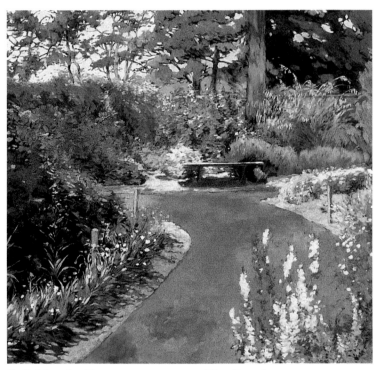

Relief for the Eye
The artist effectively provides relief from texture with a smooth swath of lawn leading the eye into the painting.

The Bench
Anita Wolff | Oil
30" × 36" (76cm × 91cm)

CREATING TEXTURE IN ANY MEDIUM

Textural effects in oil may be achieved by glazing, scumbling, drybrush, impasto brushstrokes and knife-painting.

In addition to brushwork, water-media artists spray with water, dab, rub and apply and lift tracing paper, wax paper, plastic wrap, salt and other items to produce textural effects.

Pastellists use a wide range of supports, which have considerable impact on this dry medium. They also use hatching, layering, dabbing, crosshatching and side strokes.

INTERVALS AND PROPORTION

My most memorable lesson on intervals occurred years ago, while I was attending the opening reception of an art exhibit in which my work was shown. Early in the evening, a small group gathered around the juror, listening attentively as he critiqued the works in the show. He came to a landscape of mine, and, pointing to a line of trees in the middle ground, told them that it was "boring." Well! My jaw dropped. But he was right: the line *was* boring. The intervals in size and spacing needed more variety. I've never since been casual about intervals.

Intervals and proportions must be varied. If I could order up a thunderclap to emphasize the point, you'd have one.

Intervals and proportions of what? Everything. We are not speaking here of the proportion of things, such as the human figure, but of design elements. You need varied intervals in the sizes of shapes, divisions of space, proportions of light, middle and dark values, warm and cool color, spacing of similar elements, the handling of edges and more.

You never want a horizon line that evenly divides sky and earth; think thirds or fifths, not halves. Something has to dominate. In terms of size, think small, medium and large, but the intervals between those shapes also should be irregular—so, it might be, for example, very small, medium-large and large. Like the other elements, the values within a composition should be unevenly distributed. Otherwise, you are setting up an unpleasant tug-of-war between equally divided lights and darks, and the viewer will quickly move on to another more aesthetically pleasing painting.

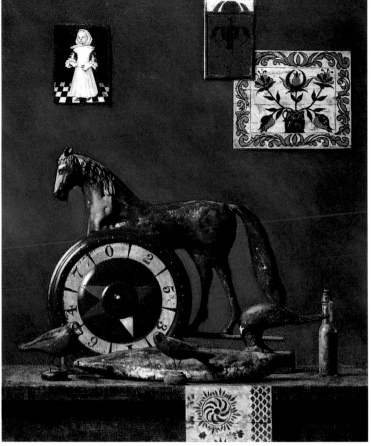

No Boring Intervals Here
The three rectangular shapes vary in intervals of placement, proportion and size—subtly supported by the long rectanglular shape of the table. Interest is heightened by the irregular shapes of the horse, bird and duck. Most important, however, is the wooden wheel— the only circular shape in the composition.

Folk Art
Daniel Greene | Oil
30" × 25" (76cm × 64cm)

Managing Intervals and Proportion
Linda Erfle · Watercolor

Generally I prefer to use the rule of thirds or Golden Mean when I begin to lay out a painting. This helps me locate the focal point in a way that makes it a more interesting composition. The reflected light and color in this scene are particularly interesting to me, as are the distorted images of the boat shapes in the water. The strong value contrast is another attraction. This painting is weighted unequally between light and dark areas to avoid a boring balance. It will have a light value dominance.

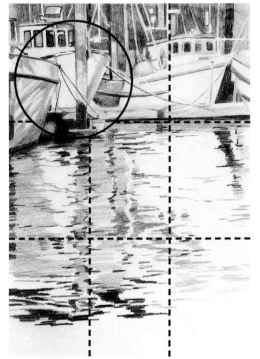

Value Sketch

MATERIALS

Watercolors
Burnt Sienna • Cerulean Blue • Indanthren Blue • Permanent Red • Permanent Rose • Quinacridone Gold • Raw Sienna • Transparent Yellow • Ultramarine Blue • Van Dyke Brown

Brushes
1-inch (25mm) and 2-inch (50mm) flat • nos. 8 and 12 round • ½-inch (13mm) stiff-bristled bright

Surface
300-lb. (640gsm) cold-pressed paper

Other
Pencil

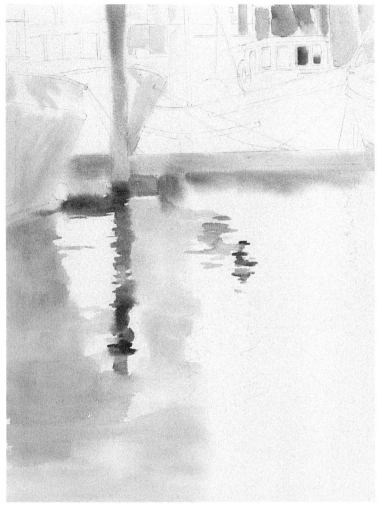

1 Draw and Paint Light Washes

Lightly make your drawing in pencil on the watercolor paper. Before applying paint, wet the back and front of the sheet, then begin painting light washes of warm and cool color with a 2-inch (50mm) flat; using a soft brush on wet or damp paper will help you avoid harsh edges. It is important at this stage to save the white of the paper for the lightest shapes by painting around them.

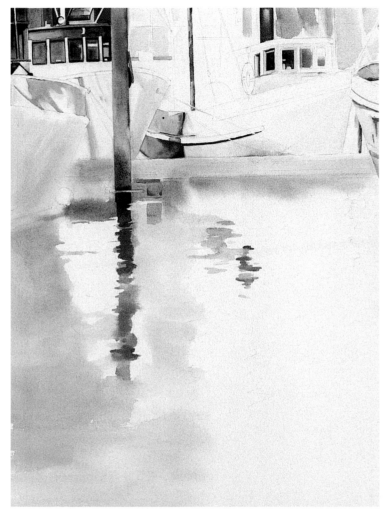

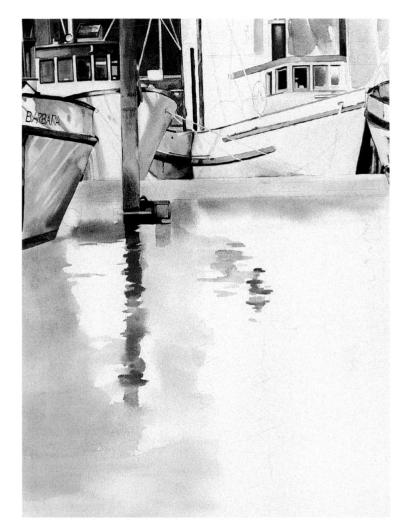

2 Begin the Boat Details and Background

Start adding details that define shapes associated with the fishing boats by rewetting the paper first in those areas before applying pigment. When painting the evenly spaced and similarly sized cabin windows, focus on making these intervals interesting by adjusting the values and colors within the window spaces.

Start filling in the background (painting around the boat masts and other objects), changing the shapes, values and colors as you move through each interval. If distant edges between objects seem too sharp, run a damp, stiff-bristled brush along the edges to soften them.

3 Develop the Shapes

Going back to the original wash passages where you created some indications of subject shapes, add more pigment and definition to strengthen them. Capturing the cool shadows on the boat hulls, interspersed with warm light reflected off the water and adjacent boats, helps to create interest and excitement.

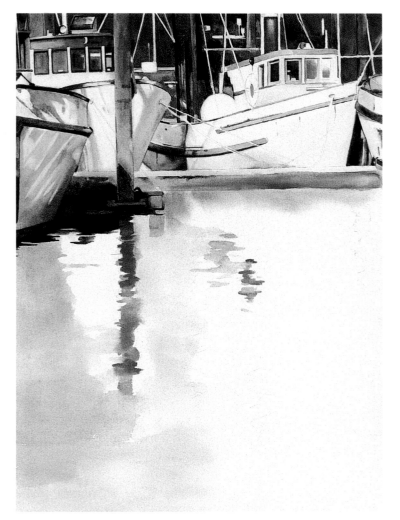

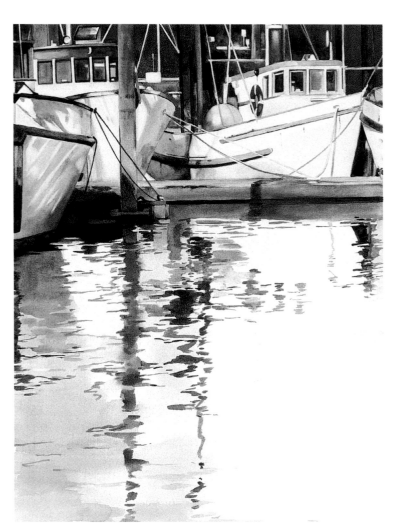

4 Continue the Background and the Dock

As you continue to finish the background, don't concern yourself with whether the objects in this area are recognizable. It is more important to vary the proportions, values and colors of these intervals and simply have them appear as interesting, albeit undetailed, shapes. The wooden boat dock needs to appear as unpainted, weathered wood and look substantial enough to keep these large tethered fishing boats in place. Another layer of interest is added by placing a bit of bright red at the edge of some objects. This also repeats the red of the ball (a functional detail that prevents the hull of the boat from coming into contact with the dock).

5 Begin the Waterway Reflections

The dark shadows at the base of the pier post and between the wood walkway and the water give a sense of weight and make the dock feel substantial. Add ropes to further anchor the boats. Add interest to the boat area with a round, bright pink float and a red-orange life preserver.

The largest portion of this painting, the bottom two-thirds, is the water in the harbor. It's imperative that this area mimics the natural movement of water and that it has enough visual energy to invite the eye to explore it. Finish defining the reflections of the posts and masts, noting that their colors and proportions vary, as do the intervals between them. The shapes of space need variety, too.

6 Finish the Reflections

Continue to add broken squiggly lines to denote reflections and to give the impression of a slightly disturbed water surface. This adds enough interest in the foreground to counterbalance the top third of the composition. The complex shapes (those of unequal dimension) of the boat hulls, combined with the strong horizontal and vertical lines, create interesting intervals of form in this painting.

Docked at Noyo Harbor
Linda Erfle | Watercolor
36" × 29" (91cm × 74cm)

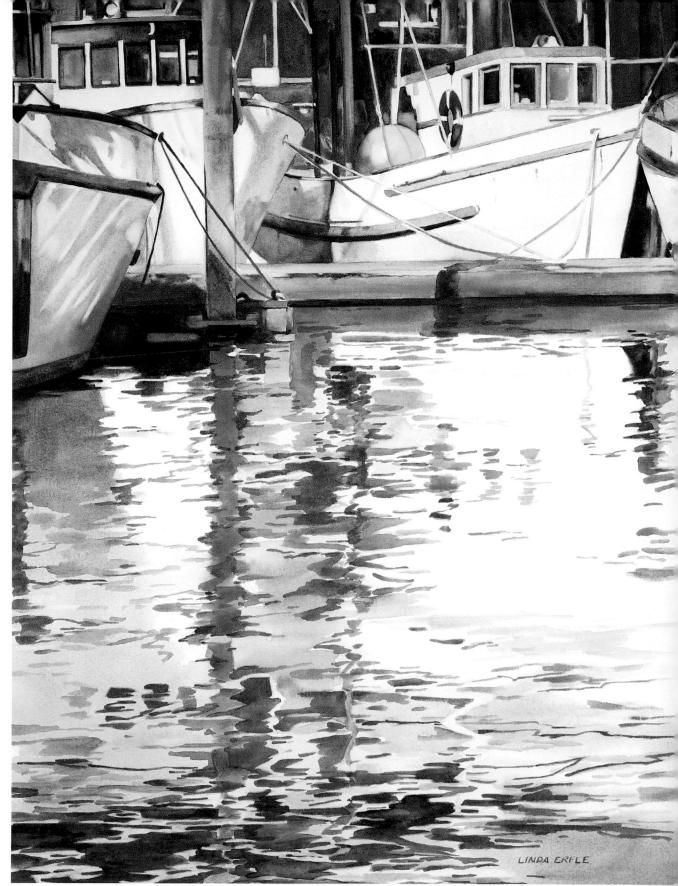

CONTRAST AND EMPHASIS

Contrast *is* emphasis. The sharpest contrasts should be where you want the eye to go first. Contrast comes in many forms, including value, color, detail and line.

Value contrast. The most important element is value; the most influential of the principles is contrast. Put them together and you have the kind of contrast that packs the most punch. The painting that uses value contrast effectively draws eyes like a magnet picks up pins.

Color contrast. This usually refers to contrast in hue or temperature, but intensity also can play a role. A power struggle ensues when hues are equally intense. One must dominate, or the eye won't know where to look. For example, all things being equal, the intensity of pure blue beside a muted orange makes the blue dominant. But if we gray the blue and use full-strength orange, then orange dominates. We emphasize one by de-emphasizing the other.

Contrast in complexity. Just as brightness is enhanced by neutrality, detail, texture and pattern are more exciting next to areas of simplicity. Every painting needs quiet passages: clean segments of color or of neutrality.

Contrast in line. A landscape with entirely horizontal lines is effectively no landscape at all. When even a minimum of diagonal and vertical lines is added, the improvement is dramatic. A line that runs quietly for a distance then unexpectedly changes direction is like a sudden summer storm: We may run for cover, but we watch, fascinated.

So, zero in on the focal point and turn up the contrast. If you see you have essentially told the story you were interested in, stop: Don't tell all. Resist the impulse to "embroider" your painting.

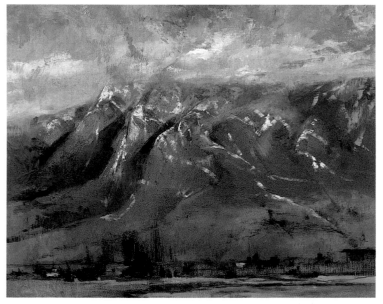

Contrast in Value

Handell brings mystery and dominance to the majestic mountain by deepening the values of the clouds and the flat fields in the foreground. The flood of light at the top of the mountain dramatizes the contrast between its bright peaks and dark valleys, commanding our attention. The cloud shadow cast across the top of the mountain gives the light still greater emphasis.

Taos Mountain
Albert Handell | Oil
24" × 30" (61cm × 76cm)

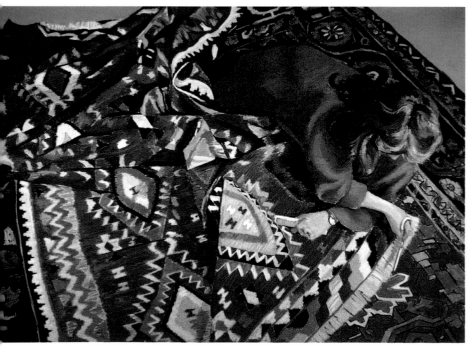

Complex Versus Simple

The artist brings importance to an unpatterned, solid-colored shape by completely surrounding it with vivid pattern.

The Rug Mender
Martha Bator | Pastel
30" × 38" (76cm × 97cm)

RHYTHM AND MOVEMENT

Music exists in time; visual art exists in space. Yet, the two have much in common. It's intriguing to find music texts speaking of "directional lines through space," and of intervals and other terms we would have thought were exclusive to visual art. Likewise, visual artists speak of rhythms, tempos and movements—all better known as musical terms. Many concepts overlap, and the overlaps have things to tell us.

Variations in tempo create rhythm. Intervals of space or size have a similar impact in visual art. Anything of similar nature that appears in sequence but can be broken or separated at irregular intervals—a line of clouds or mountains, a border of foliage—also creates rhythm. Repetition is the key. When you look at a row of trees or pickets in a fence and each is lined up with military precision, with no variations in the intervals of space, there are no surprises, nothing to take your breath away. But suddenly one tree or picket steps out of line or leaps above the rest. Something is happening, and we watch to see what comes next. The effect is subtler than its equivalent in music, but the impact is significant.

Movements may be diagonal, horizontal, vertical, pyramidal, circular or perhaps convoluted. These are lines of sight through a picture plane—directional lines through space! They are created by edges of contrasting value or temperature, by objects of repeated shapes or colors, or applied line. The eye follows up, over and around, wherever those lines of sight lead. How rapidly the eye follows may be determined by how straight and unencumbered the line is, how hard the edge is, or, with implied line, how widely spaced the objects are that form it. Straight lines that converge have the effect of "zooming" the eye along toward their junction; if the line stops, the eye stops, too. Remember, you, the artist, make it happen. All this is under your control.

Compositional schemes are varieties of movements meant to move the eye through the painting. The eye flows along one applied or implied line until redirected. In Western culture, we read left to right. Horizontal and diagonal patterns tend to lead the eye out at far right, rather than turn them around to revisit the entire picture plane. So to block the eye from making a rapid exit, we add an eye-catcher, otherwise known as a "stopper."

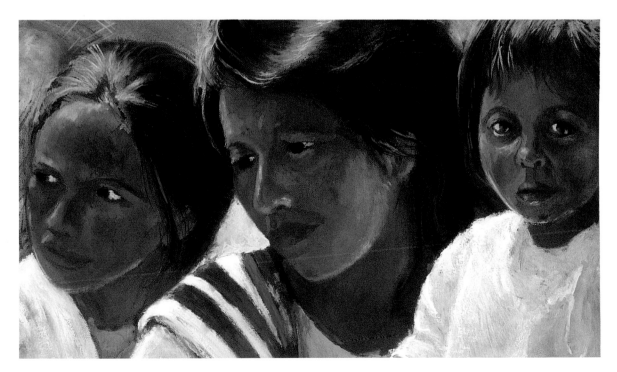

All About Rhythm
Undulating rhythms flow from left to right across the dark mass of the mother's and daughters' faces and hair. The eyes of the small child confront the viewer, acting as a stopper and redirecting the movement down her arm to the striped shawl—and around again.

Guatemalan Mother and Children
Margot Schulzke | Oil
12" × 18" (31cm × 46cm)

HARMONY AND DISCORD

Sound like a lecture on marriage? Well, in a sense it is—a marriage of design elements. There are several ways to harmonize a composition.

Wise use of color is probably the most essential. Earlier we discussed various methods of uniting color, such as the use of planned color schemes or beginning with an overall underpainting. An alternative is to add or enhance a key color throughout. To harmonize her oil colors, Anita Wolff adds a tiny dab of one common color to each pile of pigment on her palette.

Control of edges is a high priority. The eye must be able to move across lines, from foreground into background and back again, throughout the painting. Lost and soft edges make that possible.

Value control is critical. Determine whether any given shape is part of the shadow mass or the light mass. Minor variations in temperature or value, to add interest and define form, are fine, but harmony is served best when light and shadow masses hold together.

Consistent handling of strokes is also important. Some artists want the entire work to progress "in concert" to ensure that unity; others develop the primary focal area first, then determine how far to take the rest of the painting. Whichever route you choose, the painting should look as though it was executed by the same artist throughout.

As for discord, this is not necessarily something to be avoided. In music, a composer may write a piece in, say, the key of B minor. If a sharp or a flat is used that isn't in that key, it's called an *accidental*. It's written into the score on a per-use basis—on loan, so to speak. This is literally a musical discord. It doesn't really belong, so it disturbs the listener's expectations. In visual art, we may drop in a bit of unexpected color or an unanticipated shape to provide surprise, just as accidentals in music do.

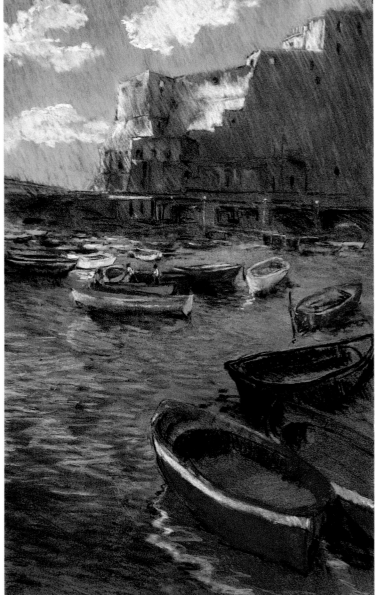

Unity of Style
From front to back, this harbor scene is harmonious in style; larger strokes toward the front, smaller toward the background. It is consistent all the way through.

Naples
Anita Wolff | Pastel
16" × 12" (41cm × 31cm)

No Discord Here

The very natural positions of the two figures provide an easy flow of line—the connecting glance of the couple providing yet another, an implied line, which helps move our eyes around the composition. The simple blues and blue-grays of their attire also help the harmony, as well as the repeated reds of their hat bands. The uncluttered foliage background complements the low-key, relaxed mood.

Lovers in the Park
Jan Kunz | Watercolor
22" × 30" (56cm × 76cm)

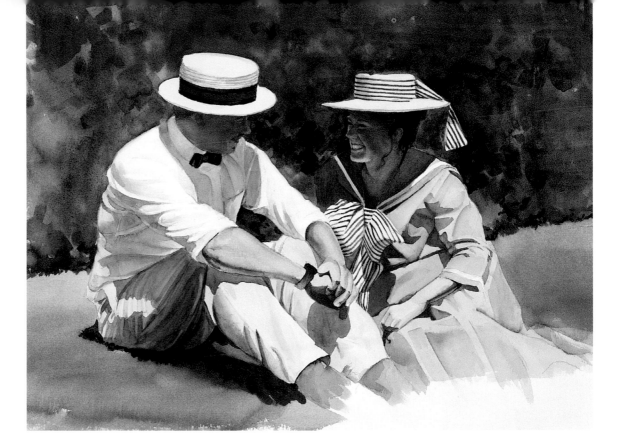

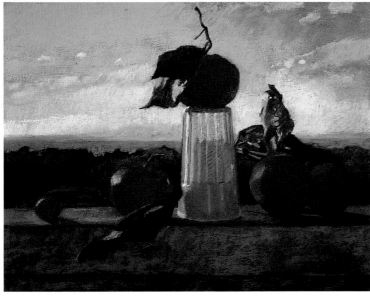

Complementary Harmony
The luxurious red-orange, last-light-of-day glow of this painting flows throughout—into the background trees, the clouds and the sky itself, a unity balanced by the blue-greens of the glass and sky.

Still Life With Tangerines
Sally Strand | Pastel
14" × 18" (36cm × 46cm)

United by Rhythm and Line
Color plays a major role here, but the lively flow of shadow lines, connecting to the undulating patterns of the sage, are the major force in creating a graceful harmony.

Desert Arroyo
Richard McKinley | Oil
11" × 14" (28cm × 36cm)

BALANCE

Balance is the even distribution of visual weight from left to right on the picture plane. This principle seems simple enough, but it's often overlooked.

Symmetrical balance refers to work that is centered and matched item for item, left to right. Superficially, it is the easiest to achieve. While it can be done effectively and elegantly, the trick is to avoid being predictable and stiff. See James Toogood's *1700* (page 92) and Daniel Greene's *Brooklyn Bridge—City Hall* (page 79) for symmetry well done. Toogood gives the illusion of complete symmetry while throwing in subtle surprises; Greene simply flaunts the convention against it.

Asymmetrical balance is by far the more common form used in painting. It requires an off-center focal point, with enough interest or visual weight on the opposing side to keep the work appearing equally balanced. Because it relies on an uneven division of space, it is more suggestive of movement and, in most cases, is more interesting to the

TRY THE SEESAW TEST

Imagine your painting poised—compositionally speaking—on the tip of a triangle, with your hands steadying it. Ask yourself: If you took your hands away, which direction would it fall? What needs to be added, subtracted, lightened or darkened, or made more interesting to provide the needed balance?

eye. Whether the shapes, colors and textures employed keep the weight scale even is determined by how visually heavy the objects appear to be. The more they contrast with their background, the more weight they seem to have: bright versus neutral, dark versus light, and so on. There are an infinite number of variables. Even "dead" space in which nothing is happening can have weight.

Japanese Teacups, Version 1
Marbo Barnard | Pastel
8" × 22" (20cm × 56cm)

Difference Equals Weight
Visual weight is not a question of size. Wherever it is placed, the red cup is most important here; it's the only brightly colored, unpatterned teacup against a dark background. The black cup, which would appear heavy against a light background, loses importance (weight) against the black background.

Japanese Teacups, Version 2
Marbo Barnard | Pastel
8" × 26" (20cm × 66cm)

Portraying Scale and Achieving Balance
James Toogood · Watercolor

On a recent visit to the U.K., I spent several days in the Cotswolds, an area known for its open fields, rolling hills and lovely valleys. The region gets its name from the combination of two old English words: *cote*, which roughly means sheep shed, and *wold*, which means barren plateau, bare hill or, as I prefer, "God's high open land." The Slaughters, Upper and Lower, are a pair of ancient villages in the Cotswolds. The scene depicted in this painting is from the top of one of the area's many plateaus or wolds. From this vantage point, the view seems to go on forever.

It was clear to me early on that to capture the essence of this place, I needed to create a feeling of open vistas and deep space. Scale and proportion were going to be important.

MATERIALS

Watercolors
Burnt Sienna • Burnt Umber • Cerulean Blue • Chromium Oxide Green • Cobalt Blue • Dioxazine Violet • Hooker's Green • Lemon Yellow (Nickel Titanate) • Prussian Blue • Quinacridone Gold • Raw Umber • Sepia • Ultramarine Blue • Venetian Red • Yellow Ochre

Brushes
1-inch (25mm) and 4-inch (100mm) flat • nos. 3, 6 and 20 round

Surface
140-lb. (300gsm) cold-pressed paper

Other Materials
"F" grade pencil

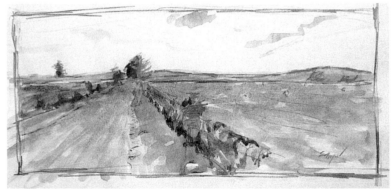

Plein Air Sketches
While sketching on location, I didn't worry too much about the final composition. I focused on capturing several elements I knew would be part of the finished watercolor: the road, the open field and the view of the valley. The straight lines of the road would be a good counterbalance to the more curvilinear shapes and ground contours found throughout much of the rest of the composition. I also knew that, in the interests of scale, the field needed some sheep.

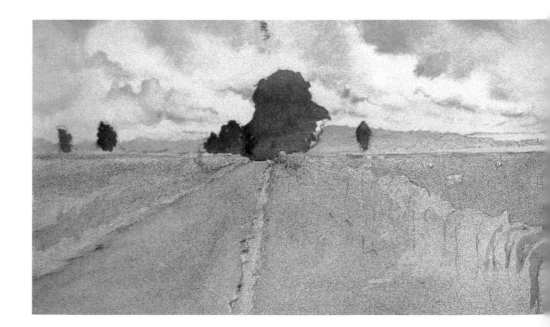

1 Finalize the Drawing

To express the vast openness and sheer volume of space visible within the scene, make the picture plane horizontal and very wide, almost panoramic—a nearly 3:1 ratio of width to height. The horizon line, which is at eye level, occurs about two-thirds of the way up the composition. Even though the sky has a lot of visual interest, this proportion gives the land mass portion of the painting more visual weight than the sky, grounding the composition.

LET THE PICTURE PLANE PROPORTIONS SPEAK TO YOUR SUBJECT

Something as simple as paying attention to the proportional relationship of your painting's height and width can emphasize and reinforce important characteristics within the painting.

2 Establish a Sense of Scale and Deep Space

The "parallel" lines of the road appear to converge in the distance, causing the road to diminish in scale as it moves back toward the trees in the middle ground. Linear perspective is also used in the sky, where cloud formations diminish in scale as they recede into the distance.

Apply a mix of Cerulean Blue and a little Dioxazine Violet, grayed with a little Burnt Umber, to the entire sky with a 4-inch (100mm) flat. Then, using a no. 20 round and the same sky colors with the addition of Ultramarine Blue, begin to develop the cloud formations. Use smaller rounds as needed to further develop them. With a 1-inch (25mm) flat, block in Quinacridone Gold for the entire land mass, then apply a second wash over the middle ground and the foreground, the sheep included. With your largest round, apply more Quinacridone Gold to the foreground only. This time do not paint the sheep.

3 Balance and Counterbalance

Because of their wide proportions, paintings like this can easily become fragmented. To avoid this, make sure shapes are balanced against one another. The rounded shapes of the sheep in the lower right foreground repeat and counterbalance the rounded shapes of the trees in the middle ground. They also give the painting more visual weight on the lower right, preventing the wall along the road from becoming too dominant.

Use a no. 6 round to further develop the land mass. Introduce Burnt Umber and Raw Umber—along with Chromium Oxide Green and Burnt Sienna here and there—to the field, road and stone wall. Use those colors along with Hooker's Green, Sepia and Prussian Blue to paint the trees and dark grass areas along the wall.

4 Develop With Aerial Perspective in Mind

As you look ever deeper into the painting, the colors should appear cooler and grayer. Values begin to compress; deep darks and bright whites, as seen in the foreground, move closer to the middle of the scale as you work your way toward the background. Use less intense mixtures of the previously mentioned colors to paint the middle ground and background. Begin to mix Cerulean Blue with those colors to cool them down. Use the cooler and less intense Cobalt Blue to further develop the darks in the middle ground and background, instead of the Hooker's Green, Burnt Umber, Sepia and Prussian Blue used in the foreground. Continue using a no. 6 round, and begin to use a no. 3 round as needed.

It is crucial that the sheep diminish in size in such a way that is consistent with the diminishing lines of the road. Working together, they lead your eye from the foreground to the middle ground.

5 Finish

To enhance the illusion of deep space, continue to develop the darks of the sheep and field along the road and in the trees. Because the illusion of surface texture diminishes with distance, use more texture in those same areas but not in the middle ground or background. Use thicker applications of Chromium Oxide Green along with Yellow Ochre and Lemon Yellow (Nickel Titanate) throughout the foreground, and a little Venetian Red here and there.

Early on I considered including a figure somewhere along the road, then quickly realized it would hurt what I was trying to do with this painting. The painting is meant to invoke a sense of place. Universally, the one shape that is more interesting for us to look at than any other is another human being. There is a time and place to include figures, and we need to be sensitive to that. I realized that a figure, even at a diminished scale some distance down the road, would dominate the composition and upset the balance of the painting, changing the focus.

Upper Slaughter
James Toogood | Watercolor
11" × 30" (28cm × 76cm)

16 Components of Great Composition

By studying paintings you admire with the design elements and principles in mind, you can discover much that will be helpful. Scrutinize the handling of edges, bleeding of color from one shape into the next, the strokes and textures. Refer to this list of design components commonly found in great compositions. Popular myths to the contrary, a great painting is seldom all spontaneous, mysterious and free-flow. It just looks that way. Successful artists know what they are doing, and they know how to repeat it. If they know it, you can learn it.

As you view art in books or exhibits, practice identifying these components. Then consciously incorporate them into your own work.

1. **A strong value pattern (illustrations A, B).** This means the work has connected light and shadow shapes that unify and give power to the painting. One rule of thumb is that 80 percent of the dark values (shadow shapes) should be connected to each other.

2. **A compositional scheme.** A good painting is usually not without its surprises, but it should have an overall organizational plan. We'll learn more about compositional schemes in chapter two.

3. **A dominant focal point or center of interest.** There should be no question where to look first.

4. **An overall mood.** The scene may be upbeat or solemn, peaceful or haunting, joyful or angst-ridden. However subtle or strong, you should feel something about what you are seeing.

5. **Balanced shapes (illustrations C, D).** Compositions can be symmetrical or asymmetrical. Bright color, high contrast, detail and direction of line all affect the balance of shapes.

6. **Balanced temperatures.** We generally don't want to be cold. Therefore, a painting that is overwhelmingly warm still draws the eye, but one that is predominantly cold often repels it. Find ways to introduce warmth into cool subjects.

7. **A sense of freshness.** The painting should breathe as though fresh off the vine—not appear overworked.

8. **Interesting intervals (illustrations E, F).** This commonly refers to the spacing of similar objects. Intervals should be irregular, not perfectly repetitious.

9. **Varied edges.** Edges should shift from lost to found, or soft to hard, depending on their purpose and placement within the picture plane.

A Connected Light and Shadow Patterns

B Disconnected Light and Shadow Patterns

C Symmetrical Balance

D Asymmetrical Balance

E Boring Intervals in Spacing and Size

F Interesting Intervals in Spacing and Size

10. **Places for the eye to rest.** The eye needs a place to go where it is quiet. That is particularly true in a heavily patterned work.

11. **Repeated colors and shapes.** These elements should help lead the eye through the work.

12. **Simplification where elaboration isn't necessary.** A real pro knows what and how much to leave out, eliminating excessive detail.

13. **Established planes of depth.** In traditional painting, you usually need a foreground, middle ground and background.

14. **Contrast in color intensity.** All the colors should not be equally intense, for the purposes of variety. Subtle tones, shades and tints can enrich a painting.

15. **A skillful stroke.** The artist's brushstrokes can impact the sense of movement, the mood or sense of space in the composition. They should vary enough to be interesting, but still cohesive.

16. **Something left to the imagination.** Art that leaves something unsaid, instead of spelling everything out, is more powerful.

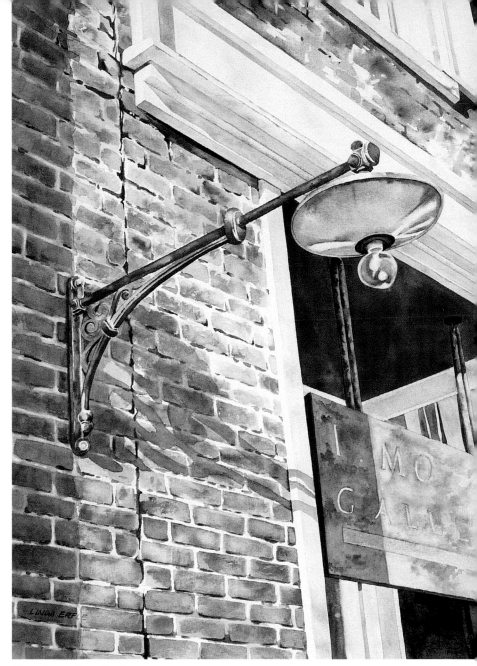

Creating a Sure Path
The artist leads the viewer's eye into the painting from the left margin out to the end of the light fixture, where we drop down into the only splash of vivid color, moving to the left again via the shadow of the fixture. Direction and line make clear the visual the eye is to follow.

St. Helena Fixture
Linda Erfle | Watercolor
22" × 16" (56cm × 41cm)

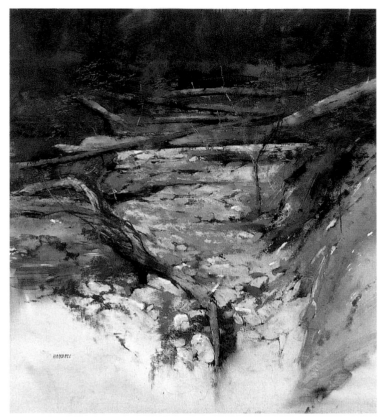

Keeping It Fresh
Handell's painting is a prime example of saying just enough. He retains freshness and vigor in the work by stopping just before the work is technically finished.

The Dry Season
Albert Handell | Mixed media
18" × 17" (46cm × 43cm)

EXERCISE ECONOMY OF MEANS

The overall idea or primary goal of most paintings is to create variety within unity. An "economy of means" is also often discussed as an ideal. All design elements will not necessarily carry equal weight in a painting. It is better to emphasize one design element over all the others. This does not mean the others are eliminated, but only one abstract element is allowed to dominate. Otherwise, in emphasizing everything, we emphasize nothing at all.

Though you should constantly consider all the principles as you paint, you can bend one or ignore another when it serves your purpose. However, this only works well when you've compensated enough with other design principles to safely do so.

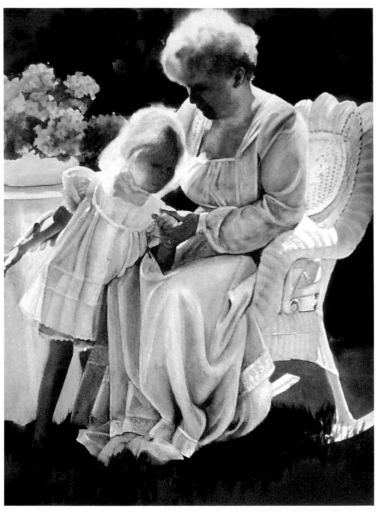

Mastering Control of Value
Value control is always important, but even more so when the value range is narrow. Except for the dark background and skin tones, this painting is relatively high-key. The artist plays lights against lights by controlling temperature as well as value. The dark values of the background, contrasted with rim lighting, serve to unite the two figures and thrust them forward on the picture plane. Carefully reserved whites and well-placed dark accents make the painting sing.

Summer Afternoon
Jan Kunz | Watercolor
22" × 30" (56cm × 76cm)

Using Movement to Create Drama

This painting is active and dramatic. We see the auctioneer pointing to an unseen bidder to our right, and his helper to our left, holding the vase. The opposing figures become an unlikely unit, joined at shoulder and hip, magnifying visual tension. Repeated segments of dark red, starting above the auctioneer's head, carry the eye down to the frame of the chair, into the white apron of the helper, then farther on, up his torso and extended arm—and around again. The movement is reinforced by the brightly lit but barely seen second helper, a woman just beyond the podium.

Dutch Vase
Daniel Greene | Oil
50" × 50" (127cm × 127cm)

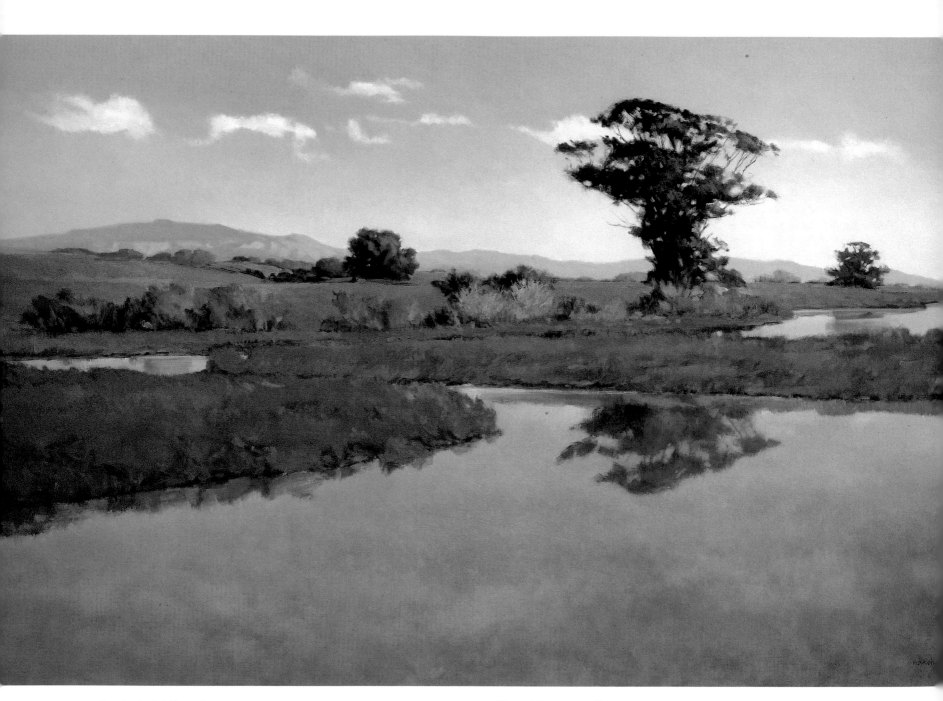

An Artist's Thoughts

"No matter how interesting the choice of subject matter, no matter how skillful the technique, no matter how inventive the style, a successful painting ultimately depends on composition and design," says Wakeham. His appreciation of the underlying role of design markedly increased when he was teaching art history. "As I stood in front of a screen and analyzed the composition of paintings for the students, I became increasingly aware that abstraction is the basis of all pictorial composition."

Near Moss Landing

Duane Wakeham | Oil
48" × 72" (122cm × 183cm)

How Artists Think as They Create

2

INSIGHTS LIKE THIS THAT OPEN A WINDOW ON WHAT AN ARTIST IS THINKING as he creates hold a wealth of knowledge for fellow artists. Approaches and preferences may differ, but learning how others navigate the painting process will undoubtedly help chart your own route. A lifetime of lessons can be found inside the brains of successful artists. Those whose work appears in this book replied in detail to questions about the creative process; their responses, summarized in this chapter, reveal much about the crucial decisions that occur as a painting unfolds.

My motive for painting is to share a way of seeing, one that is thoughtful, contemplative and imaginative. . . . I would like viewers to feel that the place that I depict or create is accessible, a place they can enter, and that there are no barriers to keep them out.

—Duane Wakeham

Getting Inspired

Artists are inspired by a wide variety of things. Penny Soto is "constantly looking for unusual shadow colors," while Dawn Emerson has a passion for horses. For others it may be vivid color, geometric planes, linear patterns or faces in a crowd. Our heads may swivel before we know what caught our eye. Regular visits to exhibitions and museums, as well as frequent interaction with other artists, offer countless opportunities for painting inspiration.

How do we nurture that inspiration to get to the finished painting? Some key observations:

We are always on the prowl for potential subject matter. It makes our lives richer and more vibrant than could possibly be the case for those whose eyes see indifferently.

We don't wait for ideal circumstances to materialize. We work where and when we have to. We routinely carry sketchbooks and "take our cameras exploring," as does Carol Harding. Also, memory probably plays a greater role than most of us realize.

Imagination is a big player, along with contemplation. Claire Miller Hopkins mulls over her ideas for "a good while," remaining open to intuition as she works.

We plan—and plan—for success. The majority of these artists continue to take all or most of the planning steps even though they have years of painting experience. It's not uncommon for them to complete a number of thumbnails, value studies and color studies to set a course for the finished piece.

We choose the method of development that works best for us. Albert Handell says, "I start with the placement of my center of interest, and design the rest of the painting around it," while Clark Mitchell works over the whole painting. Duane Wakeham's first objective is developing his painting by manipulating shapes and colors as abstract elements. "Only after those elements work," he says, "do I concern myself with imagery."

We experiment. Being willing to fail is necessary for growth.

The Drama of Line
This evocative work makes dramatic use of line, the arms of the image on the upper left being repeated in the line of the arm on the lower right. The sepia background tones play sensitively against the minimal use of detail.

Jessica in the Sun, Twice
Claire Miller Hopkins | Watercolor and pastel
22" × 14" (56cm × 36cm)

Painting on Location

Painting "en plein air"—outdoors or on location—is considered both a rite of passage and an end in itself. While it's viewed by its advocates as "necessary to be taken seriously as an artist," artists are not unanimous in that viewpoint.

I don't view painting outdoors as the Holy Grail. But I cannot overemphasize the importance of having "been there." With that experience, the sense of place, the atmosphere and the history become a part of the painting. Richard McKinley completes nearly half his work outdoors, while starting another 35 percent outdoors but finishing in the studio. "The tactile relationship outdoors between artist and subject can't be beat," he says. "You get spoiled; everything else is just a vague reminder. Having all of my senses involved is another factor."

Plein air painting is not without its pitfalls. With the changing weather and lighting conditions, notes Albert Handell, it is easy to "lose

sight of your first impression, especially on a sunny day." Handell, who completes about half his work outdoors, brings up another challenge: "looking for the perfect picture all day long, finding nothing and coming up with nothing." When something stops him, he knows there is

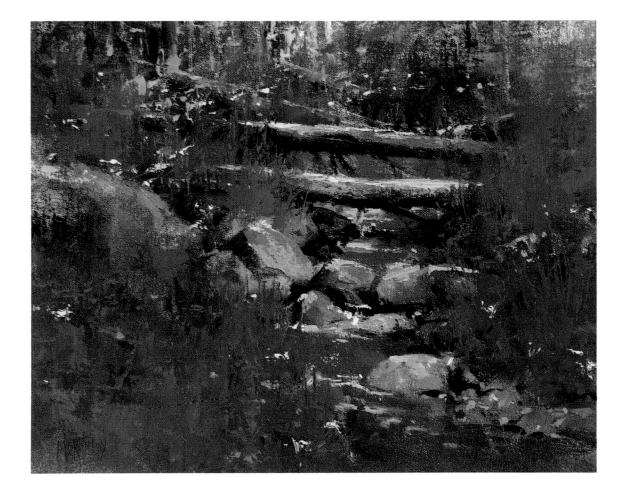

The "S" Curves Have It
Fresh, sensitive and free, this plein air painting leads our eye up the streambed with a gentle S-curve composition.

Along Big Tesuque
Richard McKinley | Oil
10" × 12" (25cm × 31cm)

something worth examining. He may spend five minutes looking for something better, but if nothing presents itself, he says, "I follow the first impulse."

Many artists find great benefit in plein air painting as an exercise. Challenging as it may be, it can be quite liberating. You can abandon extensive planning and simply plunge in. None of the artists in this book work exclusively en plein air, but most of them do work outdoors, some extensively, others occasionally. The artists who paint outdoors tend to do smaller works on location, with larger paintings executed in the studio. Several say their plein air works are not intended to become finished pieces, but to improve their "observation and knowledge, and for reference in the studio."

Making smart choices regarding location and time of day are crucial for a productive plein air experience. Handell likes painting outdoors between 11 A.M. and 2 or 3 P.M., when he gets flat light and brighter color. Others prefer early morning or late afternoon. Some prefer familiar locations that are convenient to visit and easy to navigate, but foreign locales also can be stimulating. McKinley notes, "Painting trips are when most of my best work happens." Paintings will grow out of your travelling experiences for years to come.

What to Pack for a Plein Air Outing

Also essential is being well equipped for the occasion. When gathering your materials for a plein air outing, try to keep it light. Your load will only get heavier as you haul it up- and downhill or through cobblestone streets.

WHAT TO PACK FOR A PLEIN AIR OUTING

An easily transportable easel. I take a half French easel, with shoulder straps, if I plan to go any distance on foot. It's a good idea to test-drive your options at a local art supply store before you buy.

A wheeled art box. A luggage carrier (large wheels only) with bungee cords or a wheeled backpack will free your hands and save trips, to say nothing of your knees.

Weights for holding down your work space. Richard McKinley recommends attaching umbrellas to a separate tripod so that wind will not tip your easel. Weight it with a gallon jug of water hung from a bungee cord. Weight your easel, too.

Extra elevated workspace. Maggie Price attaches a tray to a camera tripod for added space and to save her back.

A collapsible camp stool. Who wants to stand all day? Carry it in a shoulder bag.

A lightweight "wet box" to haul work in any medium. These boxes come with slots to separate work. Depending on your medium, you could improvise—for instance, you could protect pastel work with glossy paper freezer wrap, shiny side down, attached with tape or clips.

Several small painting surfaces. 8" × 10" to 14" × 18" (20cm × 25cm to 36cm × 46cm) is about right.

Camera and film. Don't forget extra batteries.

Backpacks for each medium. The contents of each will vary, but universal items to include are: a sketchbook, pencils, felt-tip markers, viewfinders, tape, bug spray, sunscreen, wipes, water bottles, food, a sweater, a plastic poncho and a broad-brimmed hat with a chin strap.

A few safety items. Go with a buddy if you can, take a loud whistle and keep your cell phone handy. (Before relying on your mobile, test it to be sure it works from your location.)

Painting From Life or in the Studio

While spontaneity and on-site observation are viewed as main draws for plein air painting, the studio offers optimum control and allows you the quiet and concentration needed to design a finished work. There you can mull over, combine or edit ideas and references to meet your design needs, to a degree that is impossible out of doors.

Still-life artists often find it involves two to three days to arrange a setup to their satisfaction. Marbo Barnard plans the initial setup in her mind before gathering the materials and arranging them. She leaves it and returns to re-evaluate later, repeating this process several times before beginning to paint. Thelma Davis takes great pains to get the lighting just right. "The lighting of a still life or portrait is so important," she says. "It defines the values and lines to complete the concept."

Regular sessions with live models are considered essential among the figurative artists in this book. Some supplement their sessions with photography if circumstances require. Ruth Hussey works with models in four-hour sessions each week, with follow-up work based on photography. She often does small "idea" sketches in charcoal on newsprint before the model arrives for a session, then executes small studies with the model before her, based on her already formed ideas.

Many of us aren't blessed with ideal north light, or we may work at night. I use track lights with a mix of warm and cool fluorescent bulbs over the easel and work table. Others use balanced "natural" light bulbs to bring the outdoors in. Good ventilation is a must; I use a fan at the foot of my easel that directs fumes and dust toward a HEPA filter. To clean my oil brushes, I use odorless mineral spirits, not turpentine. To spare my feet and legs, I stand on a commercial floor mat of the kind used by checkout clerks, with a washable throw rug over that. And across the room is a sofa, where I can contemplate the success or failure of the last few strokes.

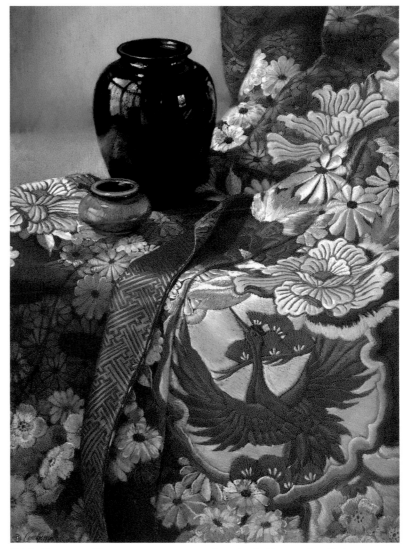

Rich Patterns Versus Elegant Simplicity
The sumptuous textures of the embroidered silk contrast vividly with the black urn and solid orange ribbon. The limited number of objects allows the rich patterns of fabric to work without sensory overload.

Symbols From the Orient
Carol Harding | Pastel
25" × 19" (64cm × 48cm)

Working With Photo References

The camera is a legitimate artist's tool. What matters is not whether you use it, but how well. Forget the old canard that people "can always tell a painting done from a photo" versus one done from life. That depends entirely on the artist's skills. And lots of terrific subject matter is accessible only through photography.

Virtually every artist in this book uses photo references, anywhere from "rarely" to "usually." They use only their own photos, though a few very occasionally use those taken by friends or family members, with the proviso that they have themselves been present at that site. "Having been there" is considered critical to artistic authenticity.

Although I treat my camera as a first-phase sketchbook, framing the shot carefully and getting the best I possibly can out of the source, photo references are never more than a take-off point. The camera is a tool to expand my resources for creativity and for recording fleeting impressions. I've combined elements from different photo references for one composition, while manipulating margins, placement, color, shapes and values.

Duane Wakeham, who paints entirely in his studio, estimates his slide collection at over ten thousand. "Mostly bad by all photographic standards," he admits, "but sufficient to provide me with the kinds of information that I want." Bill James does not paint outdoors either. "When I come across a scene I like," says James, "I take several photographs from different angles and then come back at sunrise to get a more dramatic lighting effect."

Linda Erfle, who spends a great deal of time getting just the right photos in just the right light, says, "Even then I often delete some and add parts of others to create something I think will work." In mixed media, Albert Handell works outdoors, with just "fine-tuning" in the studio, but his larger oils are done primarily indoors, usually with

SHUTTERBUG HINTS

Buy a good, recent-vintage camera. Features you may appreciate include autofocus, manual override and a powerful zoom lens.

Choose the right film speed for the task. Current options make a substantial difference in the images possible. I use 800 ISO to shoot cathedral interiors, with wonderful results.

When using a digital camera, always have a backup battery at the ready. The last thing you want is a low battery to prevent you from getting the perfect shot.

When traveling abroad with a digital camera, be aware that currents and outlets will vary. Make provision to charge the battery and a backup ahead of time, and get good advice on what you'll need if you must recharge batteries in a foreign locale.

If you are flying, have all film (exposed or otherwise) hand-inspected on every leg of the trip. The effects of radiation from airport screening machines are cumulative. The new, higher doses of radiation can kill your film (even low-speed). Security staff are required to grant your request for hand inspection, and I've found them courteous wherever I go. Allow extra time for inspection or have your film developed at a local lab before returning home.

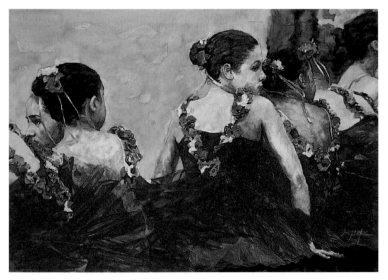

Capturing a Fleeting Moment
With his camera, the artist caught a subject he could neither have posed nor painted on site. The freshness and vigor of life is here—bolstered by his impressive composition, particularly the massing of color.

Cornucopia Ballerinas
Bill James | Transparent gouache
19" × 27" (48cm × 69cm)

photos. "My paintings do not look like my photos," he notes. "Yet with no initial photo to inspire me, there's no studio painting."

Doing sketches on location to complement your photos is a good idea; as Jann Pollard points out, "If you don't do both, you may wonder why you took the photo."

1 Cool the distant greens to make them recede.
2 Shift the image margins to the left for a more interesting off-center placement of the focal point.
3 Eliminate the structures along the river to simplify and unify the masses of foliage.
4 Extend the tower to provide a visual bridge over the river.
5 Maximize the value contrast at the focal point.
6 Change the scale and tilt of roof to act as an eye-stopper, keeping the viewer's eye within the painting.
7 Undertone the entire painting with a thin oil wash of the rooftop color, creating harmony.
8 Paint the foreground foliage with large strokes and intensified yellow-greens to make them appear closer to the viewer.
9 "Juice up" color of rooftops for interest and color harmony

Reference Photo
Use your artistic license to turn decent photos into unforgettable paintings.

Durnstein III
Margot Schulzke | Pastel
21" × 16" (53cm × 41cm)

Placing and Simplifying a Subject
Richard McKinley · Oil

I've been drawn to these cliffs and areas of erosion along the Pacific coastline for a long time and find their flowing forms and textures fascinating. Surfaces and planes are so apparent, as is the feeling of solidity. The cliffs are looming above, standing against the weather and constantly changing. Never quite the same when I return, they speak to the transitory nature of most things. It is as if they are alive in a strong, lonely way—not sad, but slightly melancholy.

Psychology comes into play when choosing the angle of vision to be portrayed in our paintings. Consider the placement of the eye level in a landscape to have a similar effect to the tilt of the head in a portrait. A head tilted down suggests introspective thought; it is looking to the earth. A person looking to the sky above us may be lost in thoughts of infinite possibility. Similar feelings result when we place the eye level high, making it about the earth, or low, emphasizing the sky in our landscape paintings. In this painting, even though the physical eye level is low, the angle of vision is high, facilitating a sense of introspection.

Reference Photo
This cliff is located at Point Lobos State Reserve near Carmel, California, where I've worked many times. All my tactile memories help when referring back to a photo.

MATERIALS

Oils
Alizarin Crimson Permanent • Cadmium Red Light • Cadmium Yellow Deep • Cadmium Yellow Light • Cobalt Blue • Prussian Blue • Raw Umber • Titanium White • Transparent Earth Red • Ultramarine Blue • Viridian • Yellow Ochre

Brushes
Assorted bristle brushes, sizes 2 to 12

Surface
Oil-primed linen

Other materials
Odorless paint thinner • alkyd resin medium • 1½-inch (38mm) diamond-shaped painting knife

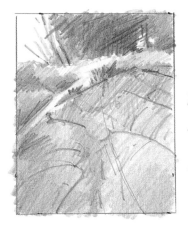

Thumbnail Sketches
By doing a series of thumbnails I often get a surprise and find that an unexpected composition will work best. I change the eye level at least once and try both vertical and horizontal formats.

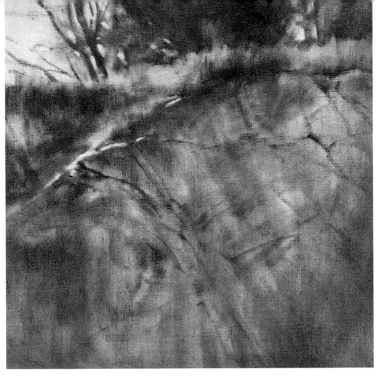

Value Study

I chose the square format because it didn't reinforce the strong vertical or horizontal nature of the subject. Square compositions create more of a monocular—or tunnel vision—quality, adding to the conceptual statement about the subject.

Loosely block in the map using no more than four major values. This strengthens the design and allows you to make additions or subtractions to reinforce the movement and balance of the value plan. Refer to this study often as you paint.

1 Make the Underpainted Drawing

For the monochromatic underpainting, cover the entire canvas with a thin wash of a neutral warm tone, as the temperature of light is warm. This will help to harmonize and unite the colors with the light. Wipe out the lightest masses with a rag, and strengthen the darker masses with more tone. Only draw a minor amount of detail.

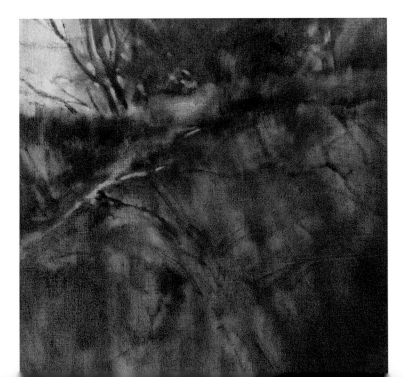

2 Block In Masses of Color

Thinning the paint to a stain, start blocking in color. Much like a stained glass window, you are merely placing the large areas of color to have something to respond to. Apply a warm rose combination, Alizarin Crimson Permanent and a little Cadmium Red Light, to the sky, followed by a more intense mixture of Cadmium Yellow Deep and a little Alizarin Crimson Permanent. Paint the cliff face using a variety of warm mixes with the addition of a cool blue-green (Viridian and small amounts of Cobalt Blue) in the shadow areas.

Don't worry about the lights at this point; most of this subject is middle-dark and dark, so begin there, creating a foundation.

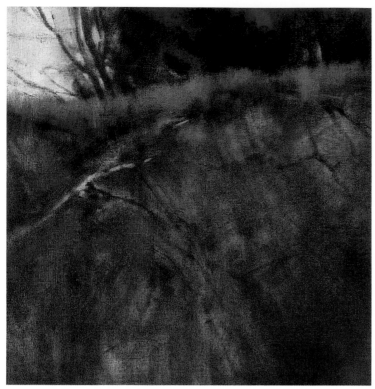

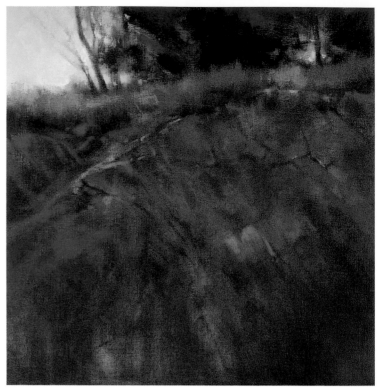

3 Build Value and Color With Thicker Paint

Set what is important and compare all your other choices to this. Work a little everywhere on the canvas, and don't finish anything until you've started everything. Place a dark and a light near the area of interest in the upper left to help you properly establish values elsewhere. Commit to a color sense now as well; the dominant color family is warm, allowing for cool accents. Apply grayed blue and violet tones to the shadow areas; intense yellow will act as a strong accent in the lighter areas. Darken the bottom of the cliff to ground it and to lead the viewer up to the crest.

4 Fill In and Repeat Colors

Start filling in the canvas, being sensitive to how the colors relate and adjusting temperature as needed. Repeat colors to help harmonize before pulling something out for attention. Solidify the cliff face by adding more color and chroma, keeping things soft but allowing yourself room to incorporate more detail and focus where needed. Use color mixtures analogous to the base color of the cliff; in this case, Yellow Ochre is made warmer with Transparent Earth Red and cooler with a little Cobalt Blue.

It is paramount to indicate the sky before going any further; the sky dictates value and chroma choices in other areas from this point forward. Make the sky a warm blue, made by graying Cobalt Blue with a mixed orange of Cadmium Yellow Light and Cadmium Red Light, and lightening it with a warm white (the mixed orange plus Titanium White).

Now analyze the movement and balance of line, value and color. Strengthen the shadow areas with more blue and violet-gray, made by mixing varying amounts of Ultramarine Blue and Alizarin Crimson Permanent, weakened with a little Transparent Earth Red and Titanium White. Introduce the sky's blue mixture into the grasses to help harmonize the painting and represent the reflected sky light. Use negative space to create interest and balance in the tree mass.

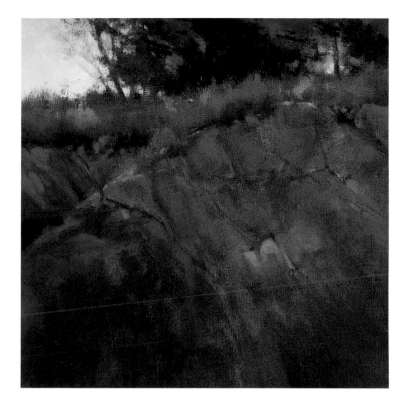

5 Add Texture and Continue Adjusting

Use a painting knife to create some texture, which will add volume and act as an accent to help lead the viewer around the painting. Continue to adjust values, colors and chromas to help strengthen this. Apply areas of reflected light to develop even more form and surface. Thicker paint is applied and greater blending of edges is happening. Develop the cracks and crevasses of the cliff, and pay greater attention to the texture and rhythm of the foliage. Darken the lower-right area of the cliff to help balance the tree mass and give weight to the painting, which helps to lead the viewer up to the area of interest above.

After this stage, it will be technically difficult to change direction. Turn the painting upside down or look at it in a mirror to help you spot weaknesses in the design before proceeding.

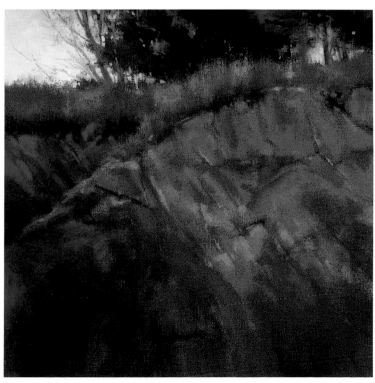

6 Further Develop and Refine

It is as if the image has been out of focus and is slowly sharpening. A maturing is happening, and exciting things start to develop—like thicker glints of paint dancing from the grasses to the trees, and added depth evolving in the tree mass with the use of cooler violets played against warmer greens. A sculpting of the surface of the cliff begins to happen as the play of cool and warm tones are strengthened, giving more radiance to the bare earth's surface.

7 Strengthen and Define

Review the initial concept to get perspective on the painting. As you strengthen the colors, values and edges, ask yourself what could be added or subtracted to make a stronger statement. Refine the cracks and crevasses, using the undertone as the dark and painting the lighter parts around them. Too many people treat the cracks as lines instead of what they are—areas that recede. What you actually see is light falling on surrounding form, not lines.

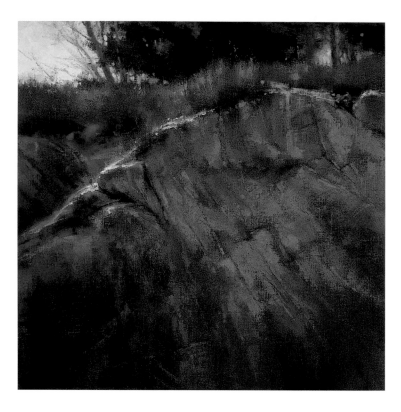

8 Soften Overly Defined Areas

At this point there seems to be a little too much definition. Generally soften the unimportant areas that exist outside the focal area. Lighten the sky where it meets the cliff, and strengthen the lightness and brightness of the grasses. Add movement and rhythm by pulling out more nuances in the trees and painting floating leaves. Bring attention to the focal area by adding a green bush, which counterbalances the edge of the cliff. It also helps to create volume by having something float out toward us, creating air between it and the cliff.

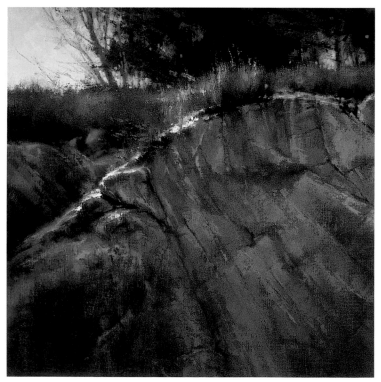

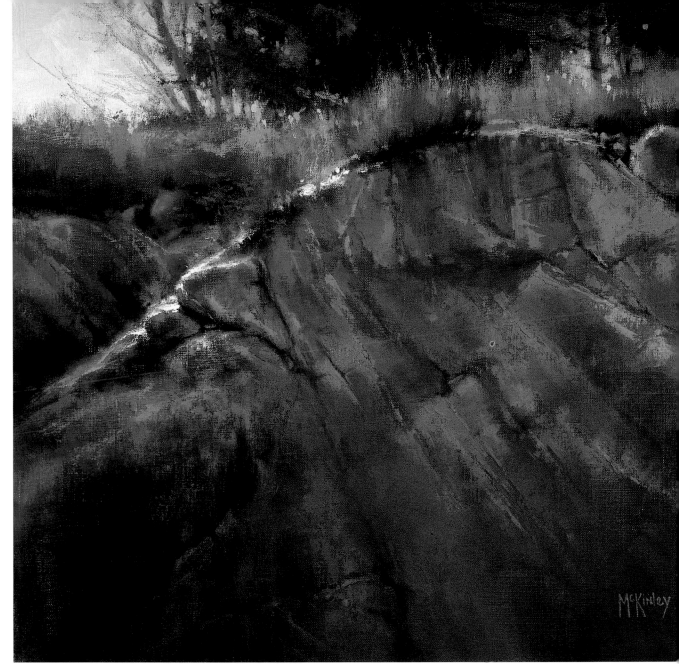

9 Evaluate and Make Final Adjustments

Walk away from the painting for a while, then re-evaluate it. I need to do just a few things to finish. First, I rethink the grass. Initially I wanted it to be strong and colorful, but now I decide it is competing with the edge of the cliff and the trees. By softening edges and graying its chroma, the grass recedes and becomes a transition between the protruding edge of the cliff and the trees behind. I strengthen the edge of the cliff with more highlights and small accents of color. I pull the cliff face together even more by softening lines to get rid of the "drawn" feeling. I finish with a few very soft shadow cracks to lead the viewer into the painting and to subtly heighten the depth.

Pacific Ochre
Richard McKinley | Oil
16" × 16" (41cm × 41cm)

Laying It Out: Compositional Schemes

Compositional schemes or design formats establish a visual path for the eye to follow through the painting. The pattern that path takes identifies the format. These schemes organize and refine structural elements. They're created by the edges of dominant shadow masses or contrasting colors. They can be strengthened by repeating various elements, such as colors and shapes.

Discovering the existence of compositional schemes was an eye-opener for me. It pleased me to no end to see a dozen more ways to go. Composition became more of a chess game than a roll of the dice. I hope it does the same for you.

A compositional scheme allows you to strengthen the value pattern by identifying it, which in turn allows you to simplify it. It limits line and mass "palettes" in roughly the same sense that a limited color palette defines a range of color.

Do artists really take such patterns into consideration when working out a design? We do, either consciously or intuitively; however, after years of exposure, their use usually becomes intuitive. I tend to "back into" these patterns. I divide space as it pleases my eye, the same way I usually select color. But when I see that with added emphasis to the secondary focal point, the design would become, for example, a steelyard composition (page 81), then I know what I have to do to make it work, or make it work better.

Identifying a composition in terms of a particular value pattern or compositional scheme allows you to sort through your options. You'll

Golden Section
Also called the Golden Mean, this pattern is based on an ancient Greek method of devising ideal proportions. We need not concern ourselves here with the formula. Dividing the picture plane equally in thirds both vertically and horizontally comes close enough. The focal point is placed at one of the resulting intersections—in this case, the upper right. The intersections are all desirable focal points. In this painting, there is no question that the dominant eye is the center of interest: We know exactly where to look.

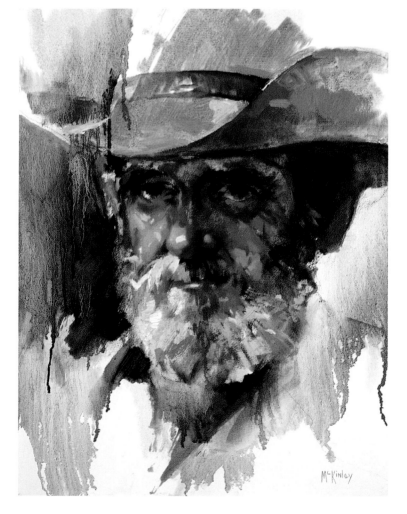

Rawhide
Richard McKinley | Oil
16" × 12" (41cm × 31cm)

solve problems that otherwise would go unrecognized and unresolved, getting a clearer picture of what is essential, what is extraneous, what is missing or simply misplaced. Keep in mind, the composition is right if it works, even if you can't categorize it. Use compositional schemes or formats to resolve questions, not to squeeze your work into shoes that pinch.

On the next few pages are paintings illustrating selected compositional schemes. There are many more options where these came from. Note the prevailing value patterns and dominant lines in these works, and how fully the shadow patterns connect within the paintings.

GO COMPOSITION-SPOTTING

Take this book, a sketchbook, a pencil and a black felt-tip pen to the best art exhibit available to you. (Most museums allow people to sketch.) See how many compositional schemes you can identify without doing any drawing. Then do small, simple studies of line and mass as you see them in the works you are most attracted to. Forget the details. Pay particular attention to the edges and values of the shadow masses, and the directions those masses seem to go. Attempt to give those patterns a name, as I've done in this section. Some will be hybrids, and others impossible to classify. Don't be discouraged if you can't assign a design scheme to every one; you'll be able to recognize many of them. The more you identify, the more confident you will become in using them yourself.

Horizontal Bar
In this format, the focal area falls along a line that divides the space horizontally. Placing the center of interest on either side of center or all the way across is acceptable. Shorelines, storefronts or peaceful landscapes with a dominant left-to-right movement—such as this simple but stunning piece—would typify this scheme.

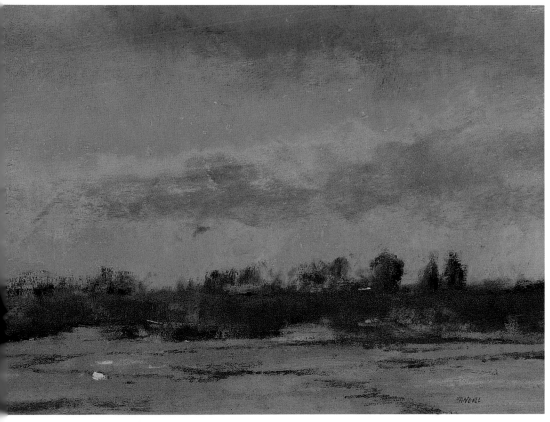

Quiet Landscape
Albert Handell | Mixed media
10" × 14" (25cm × 36cm)

Cruciform

This is a simple "T" or "cross" form, with one dominant line of light or shadow set at right angles to the second. There may be no line running from the center of the cross to the top margin. Bill James uses the cruciform here in classic pattern, the column of the figure being the support, and the wall ornamentation being the crosspiece.

The Orange Robe
Bill James | Pastel
19" × 28" (48cm × 71cm)

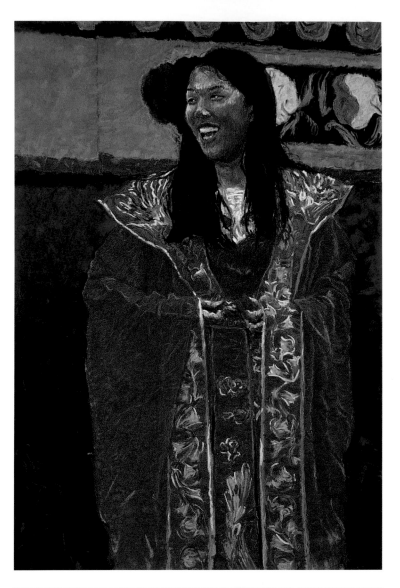

A Tunnel Composition

The focal point is framed by a dark passage—it could be a doorway, a tunnel, dark foliage, a window frame or buildings in shadow, opening into a brightly lighted area. While the archways along the passage introduce light, the rhythm of their forms moves the eye through the work to the distant archway.

Mercado
Margot Schulzke | Pastel
25" × 33" (64cm × 84cm)

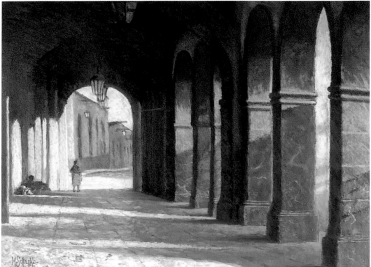

An "L" Pattern

The "L" shape of the shadow on the side of the building, falling across the street, defines this compositional scheme. It is underlined and supported by the storefront of "Champ's Corner" and the crosswalk leading to it. While we see elements of the radiating line format, the "L" is dominant.

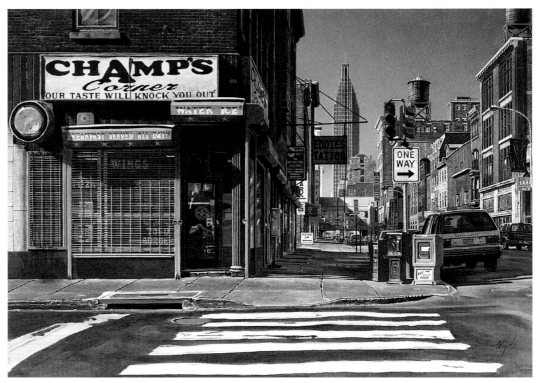

Champp's
James Toogood | Watercolor
22" × 30" (56cm × 76cm)

An "H" Pattern

This striking piece spells it out: The letter "H" is written in tile on the subway wall. This work could also be described as a balance scale. The focal point is the dark tile pattern in the center. Focal points, contrary to the popular mantra, don't always have to be off-center to be effective.

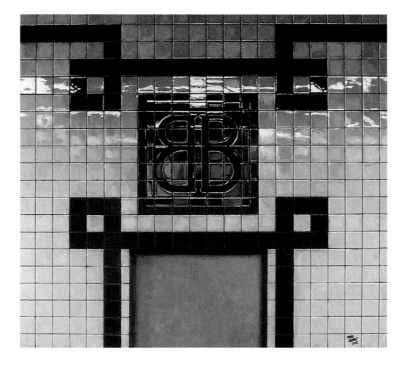

**Brooklyn Bridge—
City Hall**
Daniel Greene | Oil
42" × 48" (107cm × 122cm)

A "C" Pattern

The lines of the sunflower draw our eyes to a stunning spot of blue in its center, but the essential light-shadow pattern is a "C" curve, encompassing the blossom and extending to the leaf on the right. As the only instance of that color in the painting, the blue-violet has even more punch because it is the direct complement of the yellow-orange.

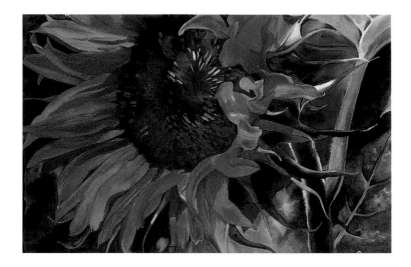

Summer Sun
Linda Erfle | Watercolor
18" × 30" (46cm × 76cm)

Pyramid

This pattern is one in which the dominant line runs left to right, rising and then falling, roughly in pyramid form, somewhere near center. The woman's dark hair merges subtly with the dark background, establishing a striking setting for the face. Against a lighter background, the dark blouse in turn sets the figure off as the feather boa defines the movement.

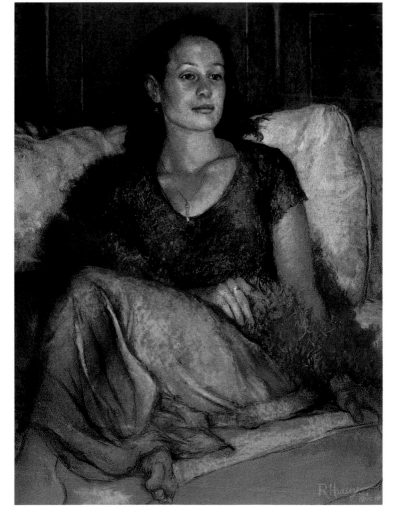

Megan
Ruth Hussey | Pastel
28" × 22" (71cm × 56cm)

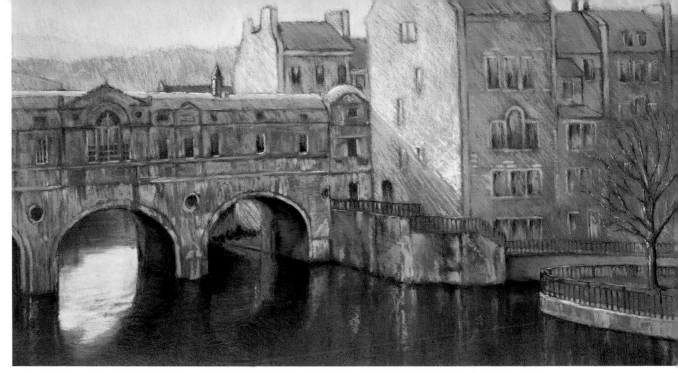

Steelyard

This scheme has a main focal point just off center, below the bridge, with a secondary focal area to the opposite side, near the edge of the work. The pattern takes its name from an old-fashioned balance scale of that name, like what you used to see at the doctor's office.

Bath, England: Afternoon Light

Margot Schulzke | Pastel
14" × 24" (36cm × 61cm)

Overall Patterning

A seemingly random placement of objects of similar nature, shape or color leads the eye through the picture plane. The objects could be sheep grazing on a hillside, people playing on a beach, flowers in a garden and so on. Establishing interesting intervals is extremely important, as shadow patterns do not provide the continuity. Here the artist has scattered crayons around a jar of bubble-blowing soap; the viewer's eye moves from cluster to cluster throughout the work.

Kids' Stuff

Penny Soto | Watercolor
22" × 30" (56cm × 76cm)

Backing It Up: Choosing a Background

Backgrounds provide not only the backdrop but also the ground before or on which the drama of an artwork takes place, as well as the space and context of the work. Backgrounds often determine the mood. While they rarely should call attention to themselves, they are critical to a painting's success.

The best background for a particular subject may be one that is blank: little if anything other than color. In other cases, the background may need to say more. Background can create an illusion of distance in a landscape. In portraits, they might hint at the history or status of the individual portrayed. The acid test is always whether it supports and enhances the foreground. The background must be treated as integral to the whole painting, not as an afterthought.

What do we consider background, relative to foreground? Both placement and importance are factors. Commonly, we consider what overlaps in front to be foreground, the forward plane versus the planes behind it. Since foreground generally overlaps background, background is typically established first, so you'll have it to key the rest of the work—not the reverse. The background is the terrain or foundation on which the structure of your painting sits. Inserting a foundation after a house is built is going at it backward. Yes, later you'll need to touch up, tone down and adjust, but start with it in place or at least in mind.

Yet, wherever it is placed, whatever is subordinate is effectively background, and whatever is dominant is foreground. Background is negative space surrounding focal areas. The hair is almost always background for the face, even if it falls across the cheek, while the wall is background for the entire figure.

Backgrounds help direct the eye by providing contrast. Contrasting or subduing the value, color temperature or color intensity of negative space brings the positive shapes forward. For example, a lighter area behind a dark-haired figure will bring the hair, which silhouettes the face, forward.

Contrast in definition, or soft focus versus sharp focus, also comes into play. If we're looking directly at an object, it's in focus, while our peripheral vision is blurred. Determine how you will treat the background while focusing your eye on the center of interest. What is background will not be in sharp focus. Consciously select what is important; downplay or eliminate what is not.

> *There are backgrounds so well made you have no consciousness of them.*
>
> —Robert Henri

Alternating lost, found and soft edges allows foreground and background to merge, interact and disconnect at intervals, while keeping the foreground "in the fore."

Rough textures suggest that an area is a short distance from the viewer's eye, so a sky that has conspicuous strokes or is heavily textured may compete with the foreground. Be wary of precious passages—in backgrounds as well as anywhere else. No matter how rich an area is, if it's fighting for attention with your true focal point, be a good editor and cut it or play it down.

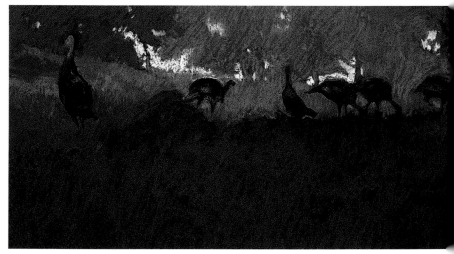

Foreground as Background
Here the artist uses the foreground as a foil for the brightly lit middle ground, silhouetting and focusing your eye on the line of wild turkeys. In its subordinate role, the foreground becomes in effect the background.

Wild Turkeys
Anita Wolff | Pastel
8" × 15" (20cm × 38cm)

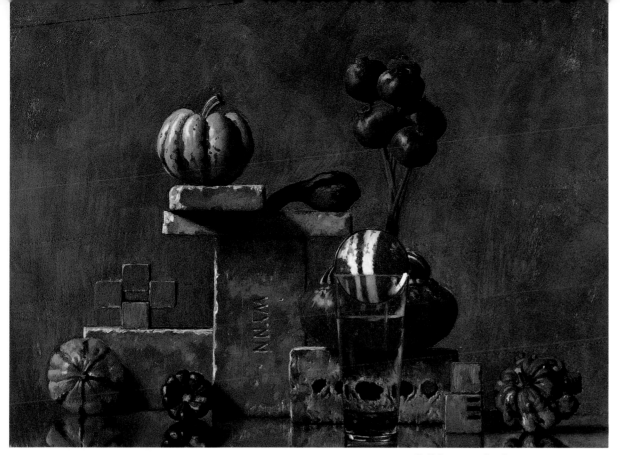

Background as Contrast in Simplicity

Making the background solely a matter of color and value, sans detail, Greene rivets the eye on the unusual assemblage of objects. Nothing competes with them, while the harmonious but toned background color repeats and unifies the work.

Children's Blocks, Pomegranates and Gourds
Daniel Greene | Pastel
24" × 30" (61cm × 76cm)

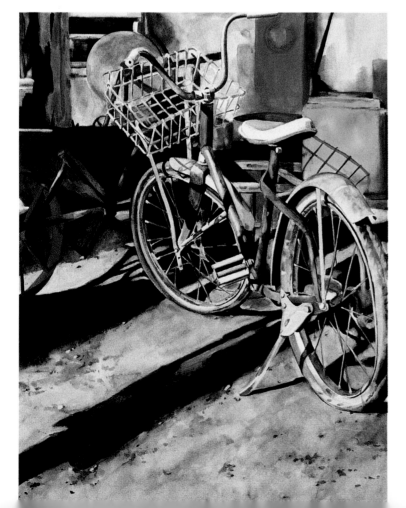

Background as Contrast in Complexity

Linda Erfle uses the opposite concept to make her work provocative and original: The uncluttered foreground, with its striking shadows and high value contrast, is undoubtedly the focal point. Its stark simplicity is made more effective by relatively complex shapes and colors arranged in the background.

Antique Yard
Linda Erfle | Watercolor
20" × 14" (51cm × 36cm)

Color Strategies

Long years of experience have made color selection largely intuitive for most of these artists. The decision process has evolved from the conscious to subconscious.

Penny Soto observes that while color schemes are instinctive for her now, they were not so earlier in her career. "It took me time to learn what color temperatures and pigments do," she says. Likewise, Richard McKinley suggests a line of progression: "I don't think of this much now when I paint. My gut pushes me more." But earlier he thought about it directly. Other artists report continuing to plan schemes entirely in advance, or working somewhere in between conscious planning and intuition. This is as it should be; approaches to such decisions should vary.

Much can be learned from how these artists approach color. A few of the most revealing observations:

While color preferences run the gamut, timidity is nowhere in evidence. Bill James leans toward "yellow, orange and pink, with a complementary Ultramarine Blue or Viridian." Martha Bator's colors vibrate, with bright, solid focal areas contrasting with intricately patterned backgrounds. Anita Wolff's colors are lyrical, upbeat and lively, consistent with her stroke and style.

There's a reason for their preferences. Jann Pollard is drawn to warm colors because "they draw the viewer into the painting." Dawn Emerson prefers deep, rich tones and complex neutrals, with this purpose in mind: "They make the more pure colors sing."

Color decisions are purposeful, even when not planned entirely in advance. "I am more concerned about color relationships and color composition," says Duane Wakeham. "I'm very concerned that color holds its place in space." While Wakeham's initial choice of colors is intuitive, he becomes "more calculated in the process of resolving each painting." James, who works with equal authority in oil, watercolor and pastel, says, "I am always conscious of color schemes as I paint. Sometimes I'll create a color scheme to improve a painting."

Color opportunities are present everywhere—even in the unexpected. Penny Soto is fascinated by colors she sees in shadows, which often become the concept of her paintings.

Experimental Color
Accurately descriptive color is not always the point. On occasion, I'll reverse color entirely, using red, orange and yellow in place of greens of equivalent values. Here, I've changed gray stone to rose-mauves and exchanged a blue sky for one of pale pinks and greens, to harmonize with the colors of the stone and the oxidized copper roofs. Magenta strokes brighten the edges of the domes. None of this is as it really was.

Salzburg IV
Margot Schulzke | Pastel
18" × 23" (46cm × 58cm)

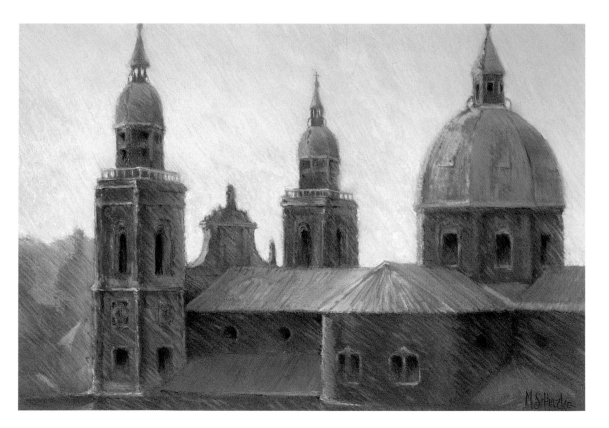

Color may not always take center stage. Claire Miller Hopkins, who regards herself as a "tonal" painter, is more interested in value than in hue. It seems natural, then, that she is a master of monochromatic color, her first preference in terms of color schemes. She notes this approach seems "to convey mood best." Blues and earth tones are her favorites.

If color schemes are not yet second nature to you, give serious consideration to doing color studies in the planning stage. They allow you to resolve color questions before you touch the final surface. Mine often end up framed as miniatures, so they do double duty.

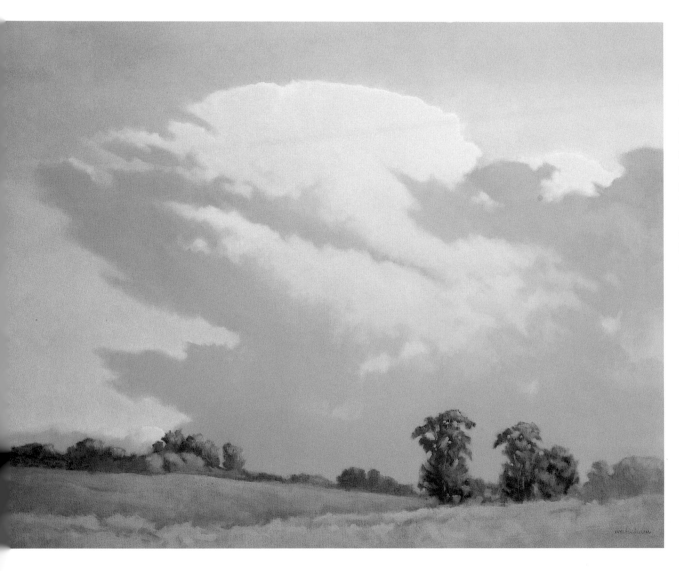

Color Recession in Space
Wakeham puts a high priority on the recession of color in space. Here we have the opportunity to see that principle at work in terms of a "skyscape." The blues progress from cerulean tones at the horizon line to cobalt directly overhead, while the clouds grow either deeper in value or warmer in hue as they approach overhead, at the top of the picture plane.

Cumulonimbus
Duane Wakeham | Oil
34" × 44" (86cm × 118cm)

Making It a Series

Working in a series is desirable for various reasons. A series allows you to acquire a second-nature familiarity with a given subject. For instance, how many landscapes or still lifes should you expect to paint before you're ready to exhibit? Of course, that depends on where you are right now, but try fifty or, better yet, a hundred.

Either number takes a while. However, an artist willing to make that level of commitment gains a mastery of subject matter that comes no other way. There is no substitute for such experience. Repeated exposure allows you to explore and master the subject in representational terms. In terms of knowledge of that subject, you will own it.

Now, that's good, in and of itself. But that depth of familiarity will give you something more than authority with a given subject: It will liberate you from being preoccupied with representational questions, as they will largely have been answered. You can move on to higher

Strong Movement in a Square Format
The artist uses a zigzag movement starting at the lower left corner, to midway right, where it then shoots to the left. McGinley notes, "This is not just a peaceful sleeper, but dynamic. I always move and connect as many coincidences of line that I can, keeping additional directional lines to a minimum."

Julia I
Sydney McGinley | Pastel
17" × 19" (43cm × 48cm)

A Close-Up Experiment
Using a close-up view, McGinley spreads the width of the image to the edges of the rectangle, even chopping off the elbow. She observes, "The movement goes softly from lower right to midleft. Here it shows opposition in the direction of the pillow."

Julia IV
Sydney McGinley | Pastel
21" × 17" (53cm × 43cm)

expression—saying something through, about or beyond the subject, not just depicting it.

Most serious artists limit their subject matter. They commit themselves to what equates to long-term series. These are carried on throughout their careers, or developed in succession. Most of us are aware of Monet's haystacks, water lilies and repeated treatments of the face of the Rouen Cathedral, in every sort of light and weather. For years, I've limited my subject matter to three categories: mountain streams and seashores; architectural subjects, and Hispanic women and children. I try to do the genres in sequence—for example, one waterscape after another, then a series of cathedral subjects. James Toogood has done America's big-city streets. Daniel Greene's subway series works are legendary, as are his auction paintings. Penny Soto has done an extensive series of bicycles and children's wagons. This doesn't mean these artists don't do any other subjects, but they wisely concentrate their efforts.

Shown on these pages are three of a five-part series by Sydney McGinley on a narrowly defined portrait subject: a woman sleeping or, in one instance, awakening. Each uses essentially the same colors. The artist's exploration of various angles, movements, dimensions and proportions has valuable lessons to offer. Because of the continuity of subject matter, the design impact of the changes is clearly evident. In the process, McGinley moves past the demands of subject matter and into the adaptable qualities of design.

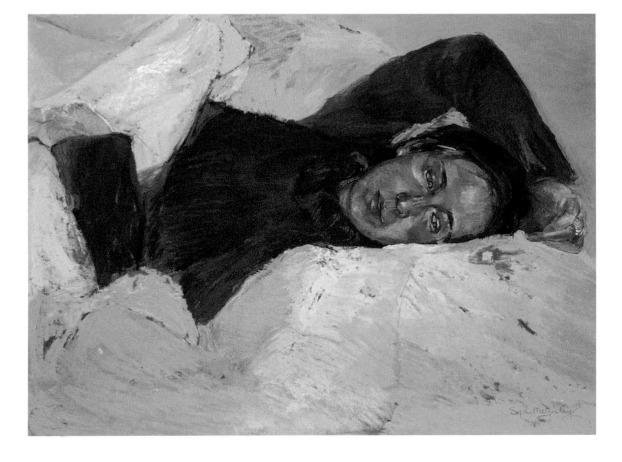

A Study of Opposing Directions

The strongest diagonal is from the upper left through the edge of the woman's sweater to the top of her hand on the right. The opposing thrust is from the raised elbow to the lower left shoulder, with a sudden directional change in the left forearm, repeating the direction of her right forearm. "There is one solo performer," McGinley says; "the identical directional thrusts repeated as often as possible." Depicting Julia is neither the objective nor the concept; she is merely the raw material used in the compositional structures here. The result is a valuable exploration of line and direction.

Julia III
Sydney McGinley | Pastel
17" × 22" (43cm × 56cm)

21 Pointers for Better Composition

There's an exception for every rule. But it is knowing what the rules are—and adhering to most of them most of the time—that allows artists to break selected rules successfully, and thereby to make the stunning, memorable exceptions! Here is a laundry list of pointers to keep in mind. Note how many of them apply to the planning phase.

1. **Paint only what you love or what intrigues you.** If you are bored, your viewers will pick up on it—and they may share your opinion.
2. **Thumbnail sketches are worth the trouble.** Thumbnails quickly give you a sense of the compositional possibilities. Do several.
3. **Think three-dimensionally as you design.** Consider all planes: foreground, middle ground and background.
4. **Work on drawing skills.** One hundred percent of the artists in this book use drawing in one form or another. Drawing is user-friendly. Well-developed drawing skills give you freedom to rearrange, to manipulate shapes, lines and color, and to be loose without losing believability.

A painting is a thing that requires as much knavery, as much malice, as much vice as the perpetration of a crime.

—Degas

5. **Avoid drawing from projected images.** Relying on projected images in lieu of freehand drawing skills hampers an artist's ability to control design qualities.
6. **Take advantage of value studies, which go beyond the thumbnail.** Value studies don't consume time, they save it. They tell you whether this painting is worth the bother.
7. **Simplify.** If you can get along as well without an object or detail, eliminate it.
8. **Include quiet places for the eye to rest.** Contrast between open and busy spaces adds interest.
9. **No two intervals should be the same.** But, that doesn't mean the differences have to be major.

Don't Say It All
The remarkably evocative character of this painting grows out of its saying the minimum, and leaving the rest to the viewer. It leaves us room to ponder and feel.

Dreamer II
Claire Miller Hopkins | Pastel
14" × 22" (36cm × 56cm)

10. **Mood is best made, not happened onto.** Decide what feeling you're after, and support it with every stroke.

11. **Consider color early on.** Color schemes can develop along with the painting, but it's best to give yours some thought beforehand.

12. **Either warm or cool color should dominate.** Keep in mind that the human eye is more attracted to warm colors.

13. **Watch format proportions.** Beginners often attempt to reestablish a drawing on a surface not equal in proportions to the original drawing, ending up with distortions they did not intend. (See "How to Maintain Proportions When Scaling Up," below.)

14. **Start with big, simple shapes.** Don't hamstring yourself with detail early in a painting's development.

15. **Massing light and shadow areas comes next.** Everything within the picture plane needs to be assigned to light or shadow masses.

16. **Keep edges varied.** Take edges from lost and found to found and lost, depending on their purpose and placement within the picture.

17. **Leave something to the imagination.** Omitting detail requires much greater discipline and skill than putting it all in. This also keeps the viewer's mind engaged.

18. **Remember the finishing touches.** Highlights, dark accents and bright jewels of color bring your painting to peak condition.

19. **Retain freshness.** Know when to quit. If the last stroke went too far, applying another rarely will make it better. Blow it away, scrape it down or lift it out. Or leave it alone.

20. **Step away from the easel after every few strokes.** Painting is a two-step process: application alternated with evaluation.

21. **When you think you are through, give it time to cool.** Turn the painting to face the wall and revisit it later—once, twice or several times more.

Remember the Accents
Erfle uses the full value range, including darkest accents and lightest highlights, a final step often neglected. The work sings as a result. It's easy to settle for less—and fail to reach the work's optimum impact.

Our Dogwood
Linda Erfle | Watercolor
19" × 27" (48cm × 69cm)

HOW TO MAINTAIN PROPORTIONS WHEN SCALING UP

Securing your value study precisely in one corner of the intended painting surface, draw a line diagonally through the outside corner of the sketch and its opposite inside corner. Carefully extend that line across to the opposite edge of the final surface. The resulting surface proportions should be identical to your sketch. Crop off or eliminate any excess painting surface.

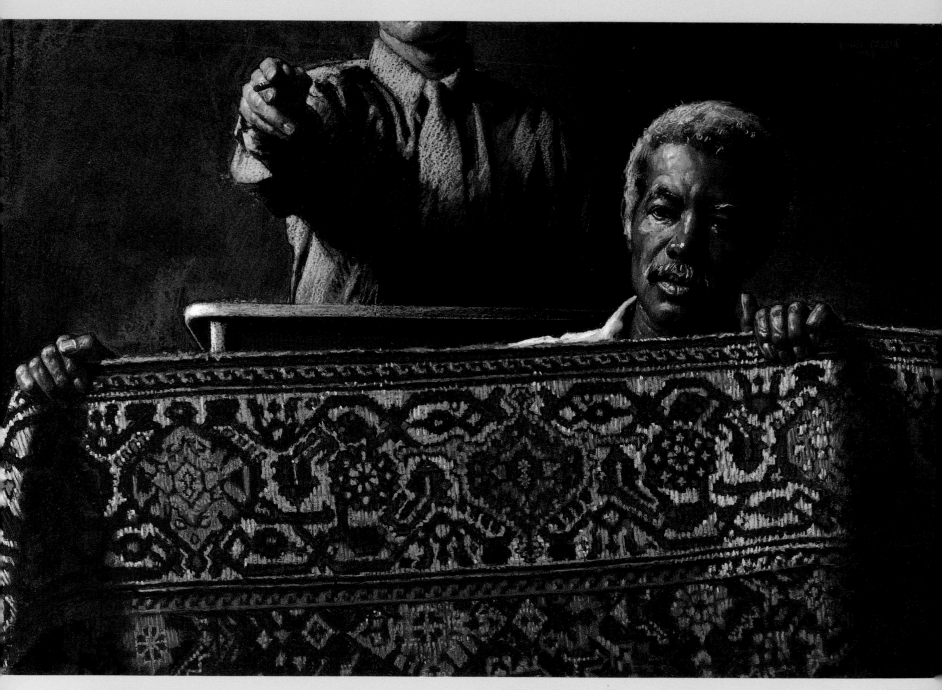

A Distinctive Vision

Greene's stunning piece is bold and experimental. To lop off the head of the auctioneer, only to replace it with the head of his assistant below the podium, is a master stroke. The cool simplicity of the background is the perfect foil for the warmth and complexity of the Oriental rug.

Antique Rug
Daniel Greene | Pastel
28" x 35" (71cm x 89cm)

PART II

MASTER CLASS

EVEN WHEN AN ARTIST REACHES THE LEVEL OF GENUINE MASTERY, THERE IS always more to learn and higher goals to seek. Complete satisfaction with one's work is a rarity, even (some might say *especially*) among the world's most renowned artists. And that's a good thing. The dissatisfaction so many of us feel with our work is an asset, not a curse. I call it divine discontent.

The expansion of our artistic vision always precedes the advancement of our skills. We should not only expect, but *hope* to feel some degree of dissatisfaction with our work; it spurs us on to greater things. Cezanne wrote to Emile Bernard, "Time and reflection modify little by little our vision. And at last comprehension comes to us."

That modified vision is what we must struggle for. The following pages aim to bring you one step (or perhaps many steps) closer to refining your own unique artistic vision.

Masters are very faulty; they haven't learned everything and they know it.

—Robert Henri

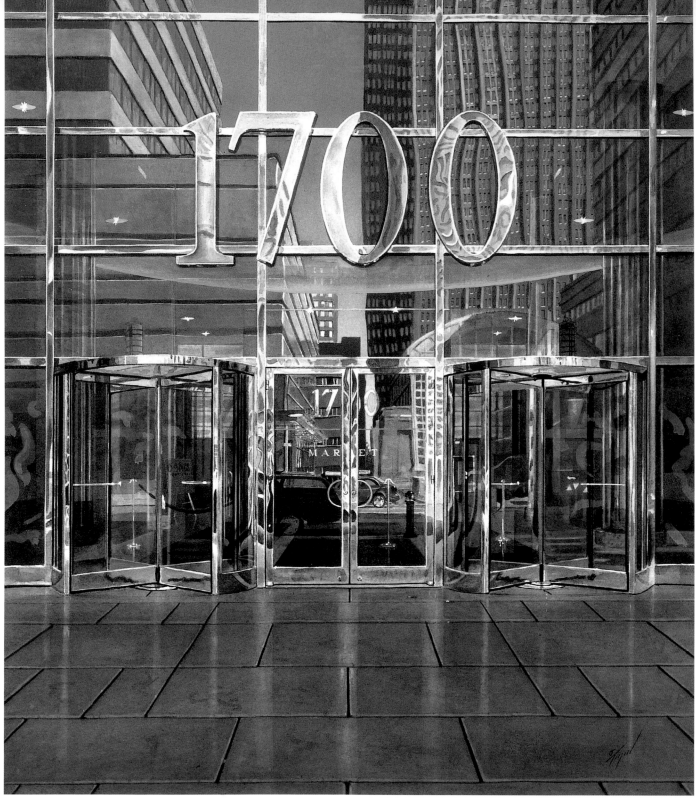

Asymmetrical Symmetry

Toogood pushes the envelope here, his focal point directly centered left to right. The doorways are also exact matches to the left and right; the walkway is perfectly aligned. Ho-hum, rigid design? Not at all; Toogood throws us a curve. The reflections in the glass are perfectly balanced, but they are anything but symmetrical. The surprise is the theme of this painting.

1700

James Toogood | Watercolor
22" × 19" (56cm × 48cm)

What Takes a Painting Beyond "Good"

3

THIS PORTION OF THE BOOK IS NOT ABOUT MERELY TAKING YOURSELF TO THE next level. It's about making your way up from one plateau to another . . . to yet another. For the majority of serious artists, excellence is an achievable dream. I wouldn't describe it as merely "a decision"—it's a series of decisions. But there is effectively no limit to our capacities if we are willing to work, to study, to stretch and to focus.

Much is made of putting in the time behind the easel, and rightly so. But "putting in the time" goes only so far. It is doing it with thought and wit that counts. Thoughtless repetition of the same exercises is like mowing the grass; it just gets you back to how things looked a week ago. Setting distractions aside, push your mind and eye as far as you can, focusing on what it is you want to learn or to achieve. As you focus selectively, you'll arrive at greater and greater depth of understanding in that specific area, seeing as you have never seen before.

It's the difference between snorkeling, which anyone can do who swims and has a dive mask, and scuba diving, which takes intensive training. Is it worth the effort? Ask any scuba diver about the difference between what you see close to the surface and sixty to eighty feet below. Going deep is good, and it will help make your paintings great.

Getting Focused

For years we were told that brain capacity was fixed by about ten years of age, and we just had to deal with the hand—or mind—we were dealt. We now know that as we push to the margins of our mental capacity, new neural pathways are formed. Actual physiological change takes place, and expanded potential is ours.

And so comprehension builds, literally layer upon layer. These deeper insights have multiple applications: to artistic vision or to an endless variety of other forms of knowledge. It equates to new intelligence—because it is.

When we identify certain kinds of information as important, the brain's filtering process goes on alert. The sentinels of the mind that screen out irrelevant stimuli lower the bar to admit items that are now relevant. To accommodate them, new neural pathways are created as added connections between the neurons. More is more, in this case—not less. Thousands of neurons are involved in recognizing and interpreting any given object. The broader the array of connections we have to a certain bit of information, the more ways we have to access it. Like the roundhouse on the railroad, lines lead in and out from many directions. As a result, we connect one stimulus with another, seeing relationships we would have otherwise missed.

Years ago, as a young inner-city art and English teacher, I saw this happening in my own students. It was as though a light turned on in their minds. To my delight, in most cases, once it was turned on, it remained lit. This occurrence isn't limited to the young; I've seen the same transformation happen in adults.

How is it done? More than anything else, it's about getting focused. Here are a few things that might help:

Force yourself to go through steps you had previously glossed over or ignored. Complete half a dozen thumbnails or more, instead of one or none; do value and color studies. Do these steps consistently, concentrating fully on what you are doing.

Seek new inspiration. This may require pursuing a higher level of art instruction, traveling, visiting museums and reading more broadly and deeply (or having conversations with people who do). Get out of your comfort zone.

Write down ideas, goals or objectives. They may be career related or with regard to a specific painting. Forcing yourself to articulate those ideas will help you focus.

Decide what subject matter you respond to most as an artist, and zero in. Learn everything you can about it.

"Revisit" new information soon, to embed it in your memory. Write it out, discuss it with someone and/or experiment with it. Connect it to other ideas.

Be aware of your optimum learning mode—visual, auditory, kinetic/tactile and so on. When you're aware of how you learn best, you can take steps to ensure you process information in a way that makes it stick. Like many artists, I'm a visual-kinetic learner. The physical act of taking notes in a class or demonstration helps me process information. Then, as soon as possible, I store my newfound understanding more permanently by putting it to use.

Treat art instruction books as tools, not sacred objects. Reread them until they are dog-eared. Make them your own by highlighting key points and making notes in the margins.

Set aside your ego at workshops. Workshops are places to learn, not to compete.

Take risks. Raise the level of your expectations. Ask, "Why not?" instead of the self-defeating, "What if it doesn't work?" There is no possibility of success without a parallel risk of failure.

Here's to new neural pathways! To the "a-ha" moments! May they take you places you never dreamed of going before.

Concept and Mood

Concepts are strange ducks. They are neither design elements nor principles, nor are they subject matter—they are a leap of the imagination beyond all these. Although concepts may not be the reason for every painting's being, they are the means by which you convey that essential information.

When you settle on a subject, you see something that strikes you as significant or evocative, or you would not consider painting it. It follows that there must be something important you have to say *about* it. Remember, you aren't painting "things," but your response to them. Your concept is what conveys that response to the subject to the viewer, while it carries you, as the artist, beyond mere representation.

There should be one essential visual idea your painting is about. To that end, you'll use shape, line, a deep sense of space, repeated motifs, minimal or flamboyant color, the movement of light in a certain direction, dramatic chiaroscuro or subtle lighting effects, or something of similar nature. One of these should dominate. Which approach best accomplishes your purpose? While your approach will surely involve using several of the design elements and principles, the principle or element that is dominant is central. It is basically your concept. Keep that emphasis firmly in your sights throughout the execution of the work

You may realize, for example, that what drew you first to a certain woodland waterfall scene is its dramatic value contrast. Therefore, everything you do will support an exploration of value contrast. There may also be stunning dark reds and purples in those shadows—but the hues will merely enrich the shadows and make them more evocative, not overpower them. If you see the colors and shadows competing for attention too much, you'll rein the colors in.

Mood, like concept, should be determined at the outset of the work and be maintained with every stroke. Most artists represented here have a mood in mind when they begin, although some who plan a mood in advance say it may evolve as they work through the painting. Others take pains to follow through with the original intent. As artist Ruth Hussey says, "The mood is part of the inspiration that caused me to want to produce the painting in the first place. Of course I want to retain that."

Hushed Anticipation
An air of quiet exploration invites us into this small but expansive piece. We are alone in the woods; we stand still and hear the birdsong. The lively colors, high contrast and long morning shadows underscore a gentle, pastoral mood.

Little Stone Bridge
Carol Harding | Pastel
12" × 17" (31cm × 43cm)

As you ponder the mood you intend for a painting, bear in mind all the things that can affect it:

Good music helps tune your mood—and your concentration. Choosing music you know will relax or energize you, or help set the mood for you as you paint, is a good first step.

You must feel it to express it. Don't paint anything you feel ho-hum about, or a ho-hum painting will result.

Mood is affected by format—horizontal or vertical. A horizontal format is more restful, more expansive, while verticals can be emphatic, static or spiritual.

Lines support mood. The above-mentioned impacts of horizontals and verticals on mood apply equally to lines within a painting, while diagonals convey action, drama and speed. Keep this in mind as you try different compositional schemes in the planning stages.

Underpaintings have significant impact. Getting rid of a white surface right at the start can create more warmth, mystery or drama and depth of mood.

Every brushstroke adds or detracts from the mood you seek. Strokes may be energetic or languid, bold or subtle. Stand back from your painting and evaluate each one in those terms, as it is applied.

Color has vast emotional content. Muted colors may be elegant, subdued, somber or mysterious; bright colors may be cheerful, daring, aggressive or passionate.

Deep shadows convey a sense of drama and seriousness. Chiaroscuro is almost always used with this intent.

Like bright colors, a high-key value range can convey a sense of lightheartedness, enjoyment, peacefulness or anticipation. Lighter values are prevalent in many Impressionist works.

Edges speak volumes. Crisp edges suggest action and vitality; soft edges slow the action and promote a sense of mystery.

A solitary figure gives a completely different sense than a couple or a crowd. Two heads together could suggest romance—or a conspiracy.

A figure's head placement suggests various qualities. Placing the head high on the canvas lends a sense of dignity and power to the figure, like a judge looking down from the bench. Placing it low suggests approachability or vulnerability, or being on a more equal status with the viewer.

Concept Is Minimal Color

The tall column of tan on the left, created by the basket of materials, the sewing-machine table and the wall, is braced by the edge of the cutting table, barely visible beyond the swath of fabric. The gray coat hanging above the tailor's head plays against his gray trousers, while the expanse of white fabric is echoed in the shirts worn by the tailor and his helper. The white fabric provides an island of quiet in the midst of an otherwise busy composition. There is virtually no color in this painting, but we aren't aware of this until we study the painting carefully. With lots of visual tension, this painting is both unified and eye-catching.

Tailor, Third Avenue
Sally Strand | Pastel
19" × 27" (48cm × 69cm)

A Pattern That Moves

This painting flows, aided and abetted by the repeated motif of the blooms and leaves, and the shadows of those leaves, running diagonally across the fence. The only area not in motion is the focal point in the upper right, doing double duty as a stopper to keep our eye from exiting the scene.

Lost Loves
Penny Soto | Watercolor
30" × 40" (76cm × 102cm)

A MOOD EXERCISE TO TRY

With a notebook in hand, visit a major competitive exhibit or flip through a book representing a range of fine artists. Assess the mood of the paintings, making notes on how the following facets of each work impact its mood.

Value range: Is the value range narrow or broad? Is the painting high-key or low-key? Are the lights or the darks dominant?

Focus and edges: Are the edges and overall focus predominantly hard or soft?

Color versus tone and value: Is brilliant color dominant, or is tone and value?

Format and direction: What impact do format and the direction of line have?

Figures: If there are figures, what effects do you read from their body language and facial expressions?

Strokes: Does the brushwork evoke a sense of calm, urgency, vitality, languor, etc.? Do the strokes contribute to or detract from the mood?

By writing down your observations and what you learned, you'll remember it longer, even if you never look at your notes again.

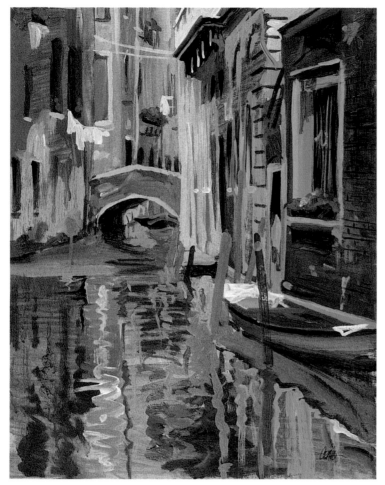

Restful Quiet

Here the sleepy pause of the midday siesta hour pervades the air. No one is about: It's warm; it's peaceful. Vertical lines and shortened shadows give us both the time of day and the feeling. Time to take a catnap or get out a good book; the shops are all closed.

The Lonely Canal
Craig Nelson | Acrylic
20" × 16" (51cm × 41cm)

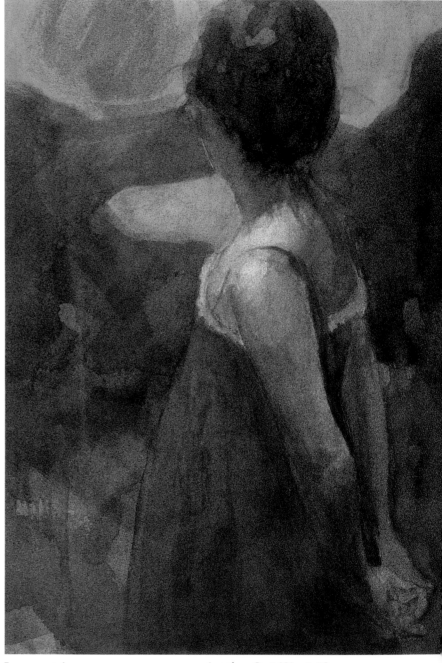

Innocent Awe

We are invited into the mind of a child. As she contemplates the wonders before her, she is unconscious of self and oblivious to others. She merges with her surroundings. Brighter color here would not do nearly as well.

Jessica Out West #3
Claire Miller Hopkins |
Watercolor
18" × 14" (46cm × 36cm)

Conveying an Energetic Mood
Dawn Emerson · Pastel With Watercolor

I love the energy and expressiveness of wild horses. I am amazed at how they move and interact in groups. In this image I want to show the gray horse as the uncontested leader, and the group of four mustangs following behind him in a pack. I hope to make the viewer feel the power, the breathing and the dust, and be pulled into the contest of speed and forward movement.

MATERIALS

Pastels
Hard and soft, in a variety of colors

Surface
Masonite prepared with four coats of gesso and pumice ground mixture

Other materials
Soft vine charcoal • white Conté • sponge • soft paper towels • silver and gold metallic watercolor powders (Daniel Smith)

Reference Material
I took a photo of these horses in the field, then enlarged, flopped and cropped the image. I am hunting for a great composition, with a sense of the dynamic freedom I feel in these wild creatures.

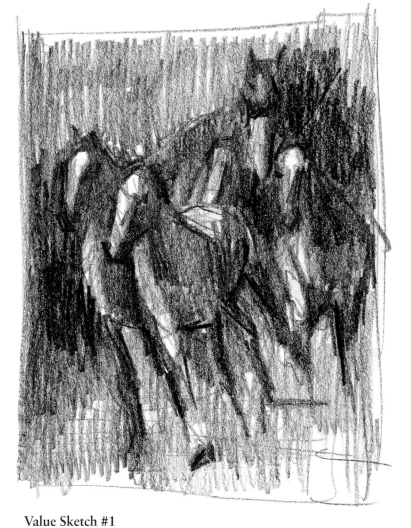

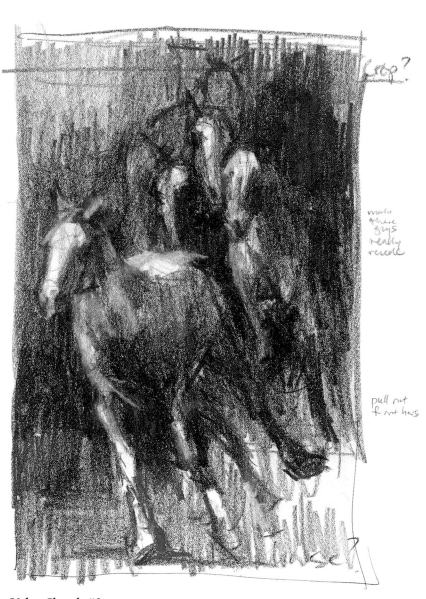

Value Sketch #1

This first sketch is okay, but not dynamic enough. I like that the leading gray horse would be flanked by darker colored horses on either side, but the shape overall is more square than vertical, and the feeling of tension and leadership is missing.

PRACTICE FLEXIBILITY

In some ways each painting is a journey of constant problem solving, and leaving some unresolved issues keeps you vigilant and open to new solutions. The flexibility pastel affords for this approach is one reason why some are so drawn to it as a medium.

Value Sketch #2

This is better. I've eliminated the horse to the left of the leading horse and made the design more vertical, reinforcing the sense of tension. There is a strong "J" design that expresses movement. The focal point is the face and leading edge of the lead horse.

I don't like the dark background, but I do like the feel of the design. I'll need to create a background that better complements the overall sense of movement. Also, the fifth horse in the back doesn't read well stacked atop the fourth, but I want to keep it because an odd number of horses makes for a more dynamic picture. I decide to move the rear horse up, so I find another reference image just for that horse. Normally I'd do another sketch to work out these details, but I decide to plunge into the painting instead. Sometimes when I have a design concept and plan of attack, I prefer not to know exactly how I'm going to get to my final destination.

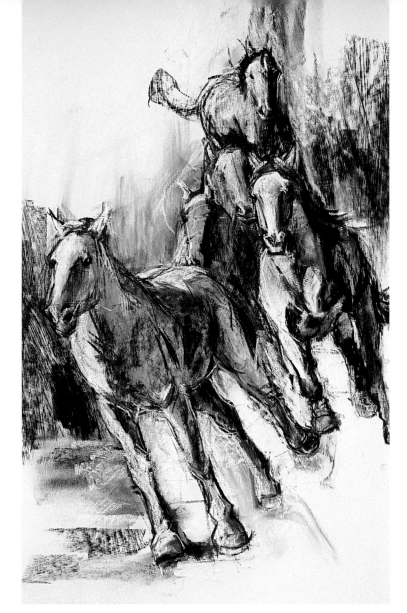

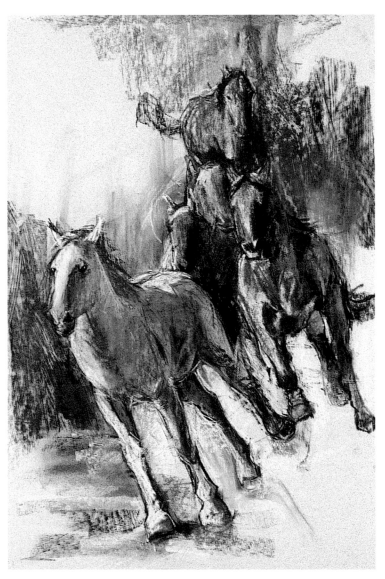

1 Make the Initial Drawing

Draw the horses with charcoal, smearing with a paper towel to suggest values. Emphasize the lightest areas with white Conté. The background echoes the dynamic "J" shape of the horse grouping. The placement of the horses' eyes is critical to carrying the viewer from one horse to the next; no two pairs of eyes should line up horizontally or vertically. Vary the head angles and aim all the rear horses' eyes at the leading horse. The curving sweep of hooves creates an implied line that moves the viewer's eye through the image.

Make sure the image is not too centered or too tight. The front horse has breathing room to the left of his head; the second horse's tail swishes off the right edge of the board. This underdrawing will virtually disappear as pastel is added.

2 Scumble the Darks

Scumble dark colors in layers directly atop the charcoal. Keep the background tones fairly neutral, but also aim to create a subtle change of color and temperature from left to right, foreground to background. Apply warmer tones at left and in the foreground, cooler tones at right and in the background. Scumble ochre and sepia onto the background on the left, and purples and blues on the right. The colors of the horses are just the opposite, with a cool-toned lead horse and a warm-toned rear group. This goes against the theory that warm colors advance and cool colors recede; be careful to avoid creating visual competition. Also, avoid neutralizing the tension by having equal amounts of warm and cool.

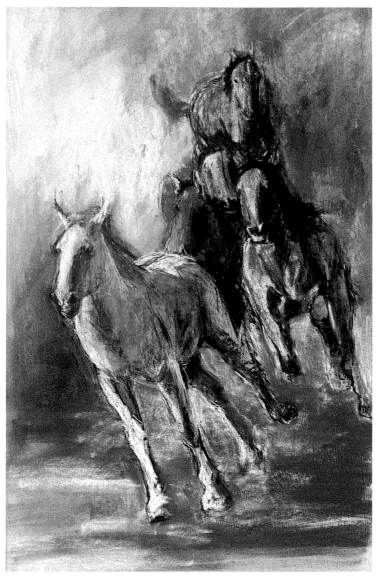

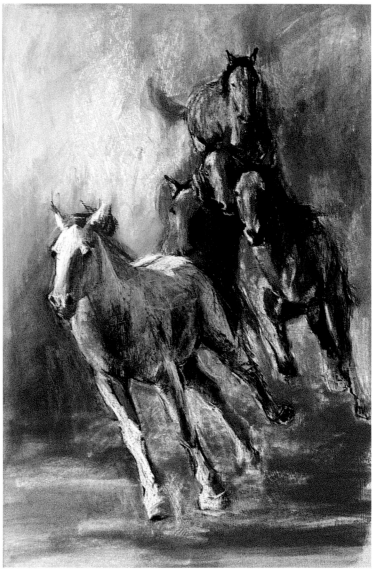

3 Blend, Create Midtones and Refine the Horses' Features

Blend the background tones with a soft paper towel. Work on the middle values a bit, and add some more midvalue ochre to the foreground. Use the pastel residue on the paper towel, a neutral midtone, to fill in areas. Pick up a little tone here and put it there to lend unity to the painting.

Refine the faces of the horses—the ears, eyes and nostrils especially. Change ear positions if there are any awkward tangents of ears to other body parts. Every tilt of the eye or ear either contributes to or takes away from the tension and movement.

4 Develop Diminishing Details

Add some warmth to the shadows on the lead horse, suggesting reflected light and keeping it from becoming too cool overall. Because it is the focal point, refine the head and face of the lead horse and harden its edges against the background to make it stand out. Work on the midtones of the rear horse grouping, refining shapes and forms. As the horses recede in the distance, their faces should become less detailed and their edges less sharp.

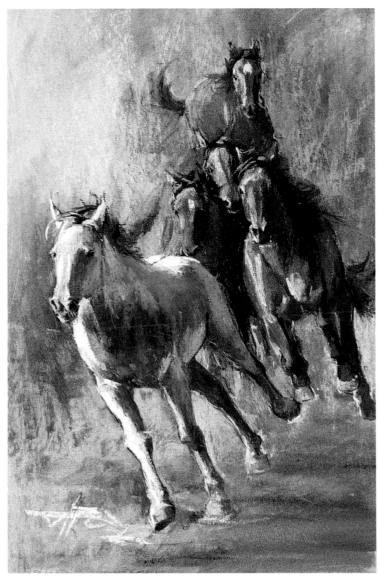

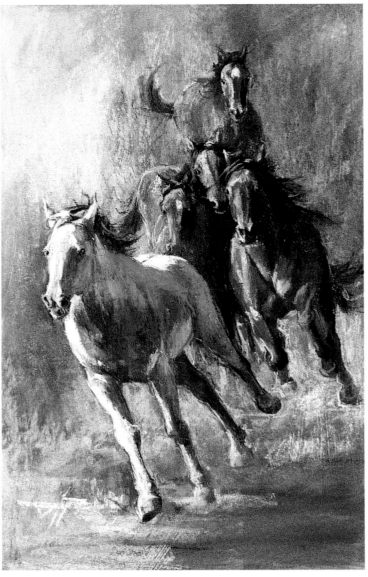

5 Adjust and Refine the Horses

The legs of the lead horse seemed rigid; I want the right foreleg to feel more extended and the other foreleg to move backward a bit more. In striving to fix the legs, I inadvertently end up darkening and flattening the shadow side of the lead horse, so I scumble the warmth back into this area. Work on the highlights as well.

Consulting with anatomical references and horse sculptures to get the legs more accurate, I refine the second horse's legs and haunches. I end up shortening here and there, trimming excess hoof width and simplifying overcomplicated areas. Scumble an off-white color onto the ground to lend a more dusty feel to the landscape.

6 Evaluate and Tweak

Slow way down at this point as you approach the finishing stage, and try to be supremely critical and objective. I want the viewer to almost feel the drumbeat of the horses' hooves. Tweak the interplay of values and color and the rendering of muscles and forms. I decide that the surface texture is very busy; rarely is there any area that is made up of solid, unbroken color. Blend with a paper towel in a few places, letting the contrast between highly textured scumbling and smooth blending keep things interesting. Remove unwanted marks of any kind, and generally give everything a final once-over.

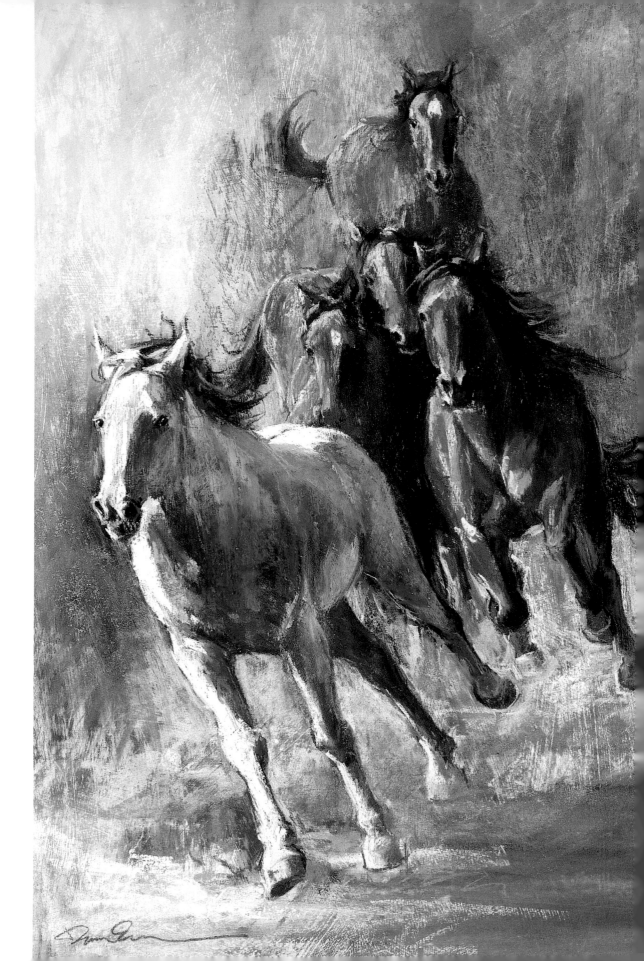

7 Make Final Adjustments

Leave the painting for a while, then check the color priorities one last time when you return to make sure the focus is clear and the overall movement of color is how you want it. Soften and harden a few edges where needed, and add marks and flashes of color to bring attention to surfaces or edges that may have become dull. Finally, take a sponge and apply gold and silver watercolor to areas of the background and wherever you want to emphasize the metallic quality of the dust.

Leading Edge
Dawn Emerson | Pastel with watercolor
31" × 21" (79cm × 53cm)

More on the Edge

Edges are a hybrid element we find hovering somewhere in the artistic ether between technique, drawing and design. How they are handled probably reveals the level of an artist's skills more than any other element of design. It's difficult, if not impossible, to overstate their importance. While we touched on them early on, there is more to know.

How We See and Interpret Edges in Art

Edges are commonly described as "lost" or "found." To recap, "lost" means they are absent altogether at a given point; found edges are well defined. A lost *and* found edge vacillates between the two conditions—and, in most cases, that's exactly what we want. "Soft" edges are not altogether lost as they are still visible, but they are broader and less defined than the hard, found edge.

To fully understand edges, it's essential to know lines. Lines consist of direction, dimension (length and width) and quality (straight, curved and combined or convoluted). They have two dimensions but never three. What appears to be a line in nature may in fact be the edge of a mass or three-dimensional object, or the long dimension of a tube, such as a telephone line or a narrow tree branch. When the planes of an object turn away from our view, we see only its edge, which may appear to us as a line, but the form continues out of our view.

Peripheral vision is always blurred. If the edges in a given area are crisp, the eye tells the brain, "This area is important," and our focus lingers. But, as pointed out previously, if everything is equally in focus, nothing dominates, so nothing commands our attention. It's your role as the artist to direct the viewer's eye where you want it to go. Control of edges is one of your greatest allies in that effort.

What Edges Can Do

When edges ebb and flow, they lend to the unity, harmony and rhythm of a painting. Edges in different forms serve multiple functions:

Crisp edges create emphasis. As mentioned above, hard edges indicate importance—an area on which our eyes should remain for a while.

Edges establish dimensionality. A hard edge thrusts an object forward in space, ahead of its background. Soft edges tend to make an object or area recede, or connect it with adjacent areas.

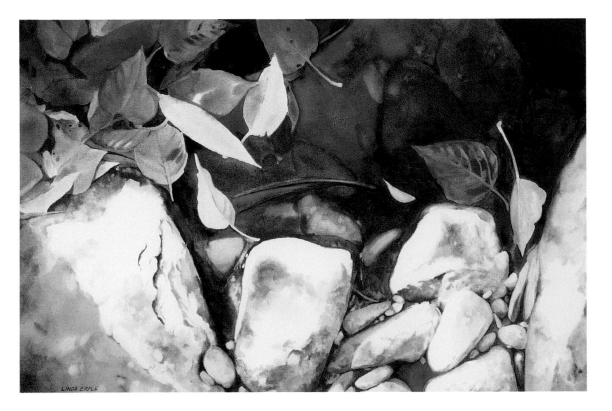

Hard Versus Soft Edges
The artist gives sharp definition to the leaves floating on the surface of the water, with soft edges defining the underwater rocks. Thus, we are sure of the place of each, in terms of depth on the picture plane. We are also informed—by the sharp edges, along with the brilliant color and high contrast—that the focal point consists of the leaves above the surface rocks.

October Sky Reflected
Linda Erfle | Watercolor
18" × 28" (46cm × 71cm)

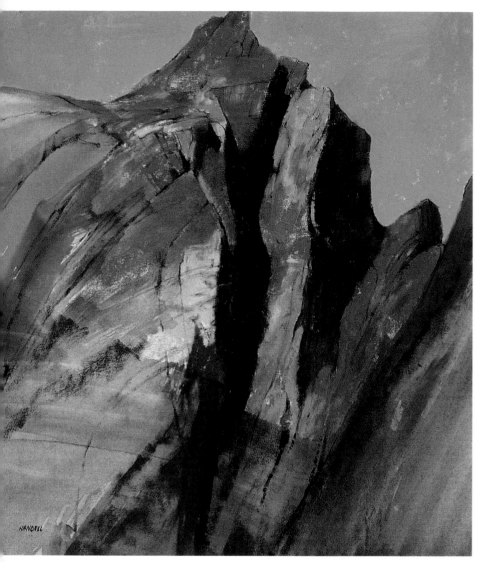

An edge that is primarily "found" also gives momentum. Because hard edges block the eye from meandering into adjacent shapes, they effectively speed the eye along.

Soft or lost edges have the opposite effect, allowing the eye to move freely between foreground and background. They also allow the eye to move effortlessly from one foreground shape to the next, forming bridges between shapes. They model forms and appear to ground them.

Varied edges create interest. Alternation between lost and found edges gives rhythm and tempo to the work.

Edges may be internal or external. An external edge defines the outer margins of an object or shape. An internal edge describes folds or overlaps, or other fine distinctions within the body of a shape.

Bleeding color across an edge is a variation of the lost edge. This involves a little color from one area spilling over into an adjacent area, connecting and relating the two. Repeated through the entire work, this acts as a unifying device.

Edges and Value Contrast

This artist makes an emphatic statement, with sharp value definition backing up crisp edges. The sharpest edges are those involving strong value contrast. By creating an internal edge with a shadow margin angling down to right across the deep crevasse, the artist blocks the eye from escaping the frame at the bottom.

At Smith Rock

Albert Handell | Mixed media
16" × 15" (41cm × 38cm)

Color Bridges or Prismatic Color

These are edge-related terms I use alternatively, depending on the application, for richly colored halftone areas where light and dark overlap or connect. These can be seen where sunlit areas emerge from cast shadow on the side of a building, or along the curve of a cheekbone, or where fabric folds. "Prismatic" color isn't a technically accurate term, but it suggests the intensity of hues in such areas.

These narrow, halftone areas are rich sources of color opportunities. For instance, one time I was studying an old brick wall that stood in the shadow of a nearby tree. In the shadows, the bricks were maroon, purple or brown, while in the fully sunlit part of the wall, the same bricks were pale tints of orange and rose. No corner was turned, but in the narrow edge between light and shadow, I saw a lively, brilliant band of luscious red and burnt orange. It was simply light and shadow struggling for control, with a narrow band of color escaping from their grasp. Be alert to such color opportunities in your art—and don't hesitate to manufacture them yourself if you can't see them in reality.

Applied Line

This phenomenon leads us to applied or reapplied line, in which the artist goes back into the work when near completion to accent or give definition with free and expressive line. These are not necessarily edges; however, they may be used to suggest an edge where none had existed before.

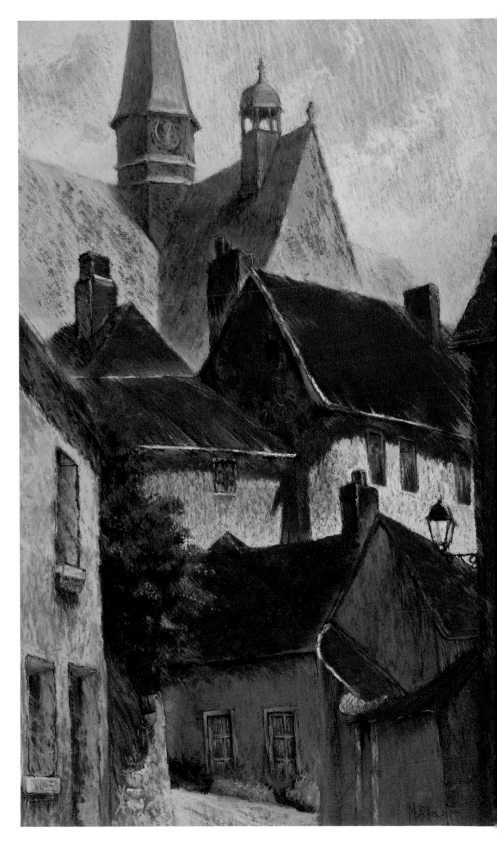

Ebb and Flow
The eye enters on the lower left via the street in this French village, with lost and found edges opening the path for the eye to move from one adjacent geometric shape to the next. Color bridges connect some shapes; prismatic color accents margins of others. A visual path flows clockwise up through the middle distance, across to the right and down to the roof below the street lamp—and around again.

Montresor
Margot Schulzke | Pastel
36" × 21" (91cm × 53cm)

Planes and Masses

Planes and masses are the two-dimensional building blocks of composition. Understanding their role is critical to achieving success.

Masses First

Unified, interesting masses of light and shadow give a painting power and solidity. Ralph Mayer, the widely recognized authority on art terminology and author of *The HarperCollins Dictionary of Art Terms and Techniques*, defines mass as "any area of significant size or importance to be a significant element in the design, for example, a building or group of trees against the sky."

Following are some key points to remember regarding mass:

Everything in a representational painting should be viewed as a part of the shadow mass or light mass. Halftones, as the merger of those two, also need to be taken into account. We must actively assign these roles to various parts of the composition.

Therefore, *massing* essentially means to unify shapes by simplifying values and eliminating unnecessary detail. This results in large, connected units of either light or dark value.

A shadow mass may include objects that are intrinsically dark but not necessarily in shadow, such as a bank of evergreens, along with their shadow sides, cast shadows and anything in their path. The result is an extended, conglomerate shape—a mass.

Sometimes you can help the cause along by extending or creating cast shadows to link one shadow mass with another, as illustrated by Bill James' painting *House on Prince Street*.

Objects within the shadow mass may not all be of uniform darkness, but nothing within that area will be as light as the darkest portions of adjoining light masses. The best test of whether a mass is holding together is to look at it with squinted eyes. If the area merges, with nothing jumping out, you are on base.

Light and Shadow Masses
The roof and the deep shadow it casts on the wall to its right are part of the larger shadow mass, including the shaded garden and the tree overhanging the house. The late afternoon light catches the front structural planes of the house and fence full-on, creating a large, flat, firmly connected light mass.

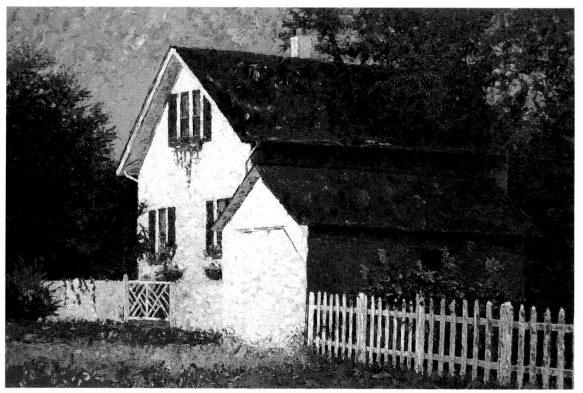

House on Prince Street
Bill James | Oil
24" × 36" (61cm × 91cm)

Plane Considerations

Planes come in a wide variety of shapes, sizes and meanings, so we need to clarify some terms and concepts:

The picture plane is the natural starting point. Think of the picture plane as a pane of glass, between you and the subject, of the same dimensions as your painting. It is also the physical area within the margins of your painting surface.

This area is in turn divided into foreground, middle ground and background planes. In normal perspective, the area near the bottom of the picture plane is foreground, while the area near the top is generally either sky or background. The foreground is the entry point for the viewer. Middle ground is most often the location of a painting's focal point.

Zones of recession: In the language of linear perspective, the foreground is the first of the three "zones of recession," background being the third, with middle ground being the area between the two. The lines of perspective (which determine scale) diminish with astonishing speed in foreground and middle ground, less so in the far distance. Colors, values and focus (aerial perspective) are also affected by the zones of recession.

Light and shadow planes: A shadow plane is simply an area across which shadows extend, including the body shadow, cast shadow and whatever is in its path. A light plane is an area in which they don't. We may also refer specifically to the shadow planes of a house or nose. In such cases, this refers to the angle or side of the object itself that is in shadow. Whether we call it a plane or a mass is, in this usage, largely a function of size. Planes can be quite small.

Structural Planes

As suggested above, planes are also the surface angles of an object—in human anatomy, in man-made structures and in nature. Shadows occur when a structural plane has interrupted the flow of light. (When a carpenter uses a planing tool, he eliminates rough spots on the wood to create a flat plane, across which light can move without interruption.) The nature of the plane is revealed by the way light traverses its edges. An angular object, such as a building, has crisp edges, while a rounded object—think beach ball—has less defined angles, thus softer edges. Within major planes, there may be smaller divisions or subplanes that further describe the shape of the object. We may call these *structural planes*, as opposed to *shadow planes*.

Quintessential Zones of Recession

We could not ask for a better illustration of the zones of recession than this. The warmth and crispness of the clump of trees and field in the foreground, at the bottom of the picture plane, brings them close to the viewer. The grove in the middle ground is cooler, grayer and less defined, as is the field beside it. The background, in the upper third of the picture plane, is grayer still and less defined, the distant hills almost merging with the hazy sky.

Above (Right)
Clark Mitchell | Pastel
44" × 30" (118cm × 76cm)

Here are a few points to remember when establishing structural planes:

Where you can use a straight line, don't use a curve. A curved line represents an infinite number of miniscule subplanes or angles. Each turn in an edge or line weakens its thrust and slows its movement. Simplify rounded shapes by squaring off the curves, thus reducing the number of planes.

Facial planes are a subcategory of structural planes. Understanding the bone structure of the face and figure is a boon to convincing portraiture. Study a face, modeled by angled or side lighting; try to count all the planes it contains: the upper and lower eyelids, the lid above the fold over the eye, etc. The brow alone comprises several planes. The nose is all about planes—multiple and miniature. The skull and the hair that covers it also consist of planes. Think planes of the head first, hair last; resist the impulse to portray hair in detail.

Water also has planes. When we are dealing with still, transparent water, we can often see several planes. In some cases, we will see the rocks, sand and debris under the water, then the body of water itself, then surface effects—movement, ripples, and reflections from whatever is on, beside or above the surface. Painting these water planes in the sequence in which they occur naturally works best, with surface effects last.

I often see students attempting to build form piecemeal: flowers one petal at a time, or a stone wall one agonizing stone after another. That's going at it backward. The process is tedious and, sadly, so is the result. The excess of detail it produces saps the strength of the masses.

Think of a broad sweep of Alpine meadow, backed by the upward thrust of the Matterhorn, with all the drama and power of line that affords. Then imagine the same meadow divided into postage stamp plots, topped by look-alike houses, with the view of the mountain obscured by telephone lines. The massive shapes remain, but they have lost their power. Simplify and unify masses.

Powerful Masses

Toogood uses the power of unified masses of both shadow and light, combined with linear perspective, to command our attention and draw us in. Squint your eyes to see how effectively they hold together. By maintaining the integrity of the masses, the artist is able to introduce detail without triviality.

Canyon

James Toogood | Watercolor
14" × 20" (36cm × 51cm)

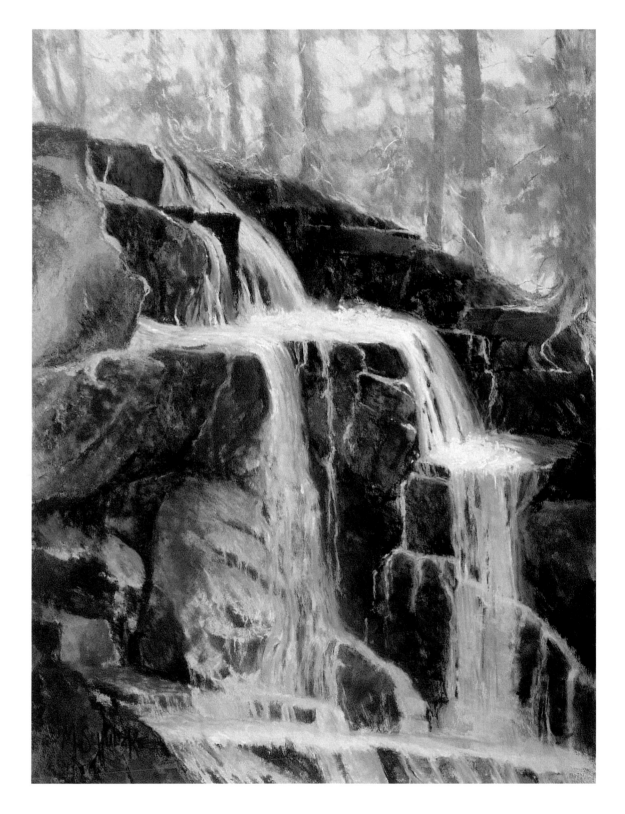

All About Planes and Masses

The dark mass of the rocks contrasts with the larger, background light mass—the copse of trees at the crest of the hill. The marked contrast in value of the smaller light masses—the horizontal planes of the cascade that gather light from the sky above—against the dark rocks makes them the focal point of the composition. More light filters into the rocks as they move away from the deepest shadow, revealing sharp, multifaceted structural planes.

The Source

Margot Schulzke │ Pastel
25" × 19" (64cm × 48cm)

The Rhythm Section

Some years ago as I stood before a Monet painting, I found myself shedding unexpected tears. In content, it was only an ordinary landscape, but when Monet painted it, it ceased to be ordinary. It was not sentimentality that I responded to; it was sensitivity and exquisite subtleties: visual music. Likewise, it is the verve, the flowing lines and explosions of brilliant color—with an effect so like the clash of cymbals—in Miro's work that give it such a celebratory air. You can hear the marching band. It's the varied tempos, the rhythms, that create a sense of drama and movement.

Most visual artists are aware that music is an abstract artistic medium of sound rather than sight. And if the word *rhythm* appeared in isolation, the vast majority of us would, without hesitation, connect it with

music rather than visual art. Yet rhythm is both a subtle and powerful factor in visual art.

What Creates Rhythm?

Rhythm in visual art grows out of repetition and alternation—from the intervals between repeated elements, such as the drumbeat of repeated shapes and colors, to the slow-and-go of alternately lost and found edges urging the eye along at varied speeds. Why do we need it? Repeated shapes or motifs, colors, patterns or dissimilar shapes of similar size assist the sense of movement. The eye instinctively looks for such repeats, moving on to the next as it occurs, finally coming full circle—and around again. Alternation of warm and cool, large and small, dark

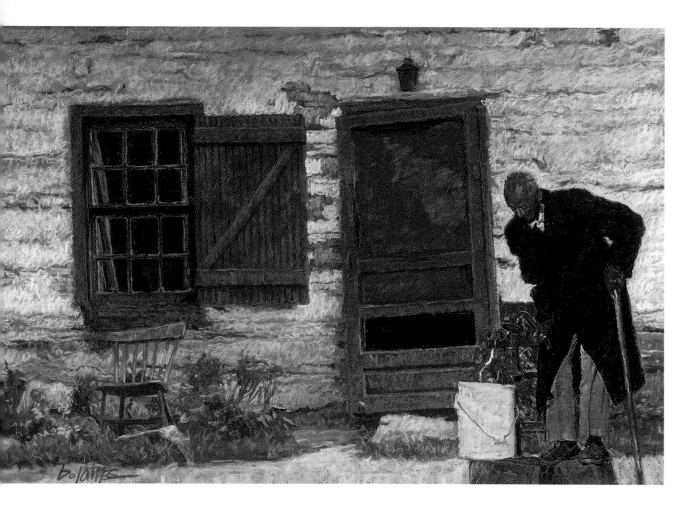

Syncopated Rhythm
Repeated shapes of the same local color, but with subtle variations in surface patterns and proportions as well as varied spacing, lead the eye to the figure, in the same colors. The syncopated rhythm created here is marked. The monochromatic color scheme gives added emphasis to the delightful subtleties.

Colonial Shack— Waterford
Bill James | Watercolor
19" × 28" (48cm × 71cm)

and light, dull and bright, simple or complex—any of those creates a sense of pulsing life.

Tempo, or momentum, is found in the direction and flow of lines, including edges. Converging straight lines have a sense of speed, like a rocket with its trail. Interrupting such lines with a sharp vertical line or shape is like the clap of cymbals: It abruptly stops the action or redirects it. Or an undulating line may slow the action. Since we read left to right, diagonal lines seem to be rising, increasing in "volume," if they tilt up toward the right. They fall or become deeper in "pitch" if the tilt goes the other way. For the same reason, momentum increases on lines falling "downhill" to the right.

One of the most important sources of rhythm and tempo in painting is the treatment of edges. We've discussed how, when edges

A Grand Finale

While the rhythms in Wakeham's painting are languid and expansive, Hopkins's work brings us rapidly to a powerful climax. Our eye goes immediately to the figure and then her shadow, which leads us to the edge of the main shadow. This line quickly curves back around to the figure. Only then does the eye probe the echoing line of the sanctuary window, bringing us back to the figure a third time.

Sanctuary (Mariah's Daughter)
Claire Miller Hopkins | Mixed media
18" × 24" (46cm × 61cm)

Unsettling the Viewer's Expectations

The most conspicuous rhythm here is in the placement of the oak trees. The largest tree is the focal point. Note the intervals. The tree to the far right is not placed at an "expected" interval, but well beyond. As our eye enters the picture at the lower left, the point of land brings us into the largest area of water, which then narrows dramatically, slowing the movement, or tempo, as the eye approaches the great oak—the focal point.

Marin Wetlands
Duane Wakeham | Oil
34" × 44" (86cm × 118cm)

appear and disappear, the eye is urged along a hard or found edge, and comes to a halt when the edge becomes lost. If the edge is picked up again immediately, the eye is recaptured, and the tempo resumes.

Variation is always the key to interest. A steady rhythm does not command attention. If you ever took piano lessons as a child, you practiced scales. Your fingers marched up and down the keyboard with no surprises in pitch or timing—just boring repetition. Obviously, this is not what you're after as a visual artist. Every element used in composition requires variation as well as unity.

Color areas that subtly shift from cool to warm, or vice versa, within a given hue also provide a sense of movement, such as an area of red that changes from blue-red to true red to orange-red, while maintaining the same value. The pickets in an old fence look more interesting than those in a new one for one reason only: Some of them have worked loose, or broken, varying the rhythm. Likewise, spaces between trees along a country road should be uneven, as should their height and width. Objects of similar shape, size or color should be placed at varied intervals, repeating the motif but not the cadence. Syncopate your rhythms! And throw in a few sharps or flats.

Another element that impacts rhythm and tempo is what we may call visual "rests." Hickok, the author of *Music Appreciation*, wrote, "No less important than musical sound is musical silence." Quiet spaces for the eye to rest add importance to.busy areas because they change the rhythm and provide contrast.

A Circular Flow

This painting is a subtle repetition of triangles, merging into a circular, rhythmic, waltzlike movement. We enter the scene by way of the strap attached to the full-face mask, and at once we get the strange sense that it may be about to don the jester half-mask above it. The mask to the right looks away disdainfully, distancing itself from the antics of its fellows. The curved line formed by the feathered headdress drops the eye abruptly down again to the strap—and our eye swings back up again to the triangle of masks.

After the Ball
Ruth Hussey | Pastel
27" × 22" (69cm × 56cm)

Creating Rhythm With Color and Repetition
Penny Soto · Watercolor

When taking a trip recently, I came across a beautiful tulip tree. I was intrigued by the orchidlike shape and exquisite color of the flowers. I took out my camera and began to compose through the viewfinder, the easiest way for me to "prospect" for potential painting compositions. I took several photos that I would eventually cut and tape together to create my design.

All too often, artists get so excited about the overall picture that they forget to plan. True, I was motivated by the challenge, and by my desire to share with the viewer the vivid colors and the radiance I saw when I first encountered that tree, but the planning is what makes the punch.

MATERIALS

Watercolors
Bamboo Green (Holbein) • Bright Violet • Cadmium Orange • Cadmium Red Deep • Cadmium Red Orange • Golden Lake • Green Blue • Indigo • Payne's Gray • Perylene Maroon • Quinacridone Purple • Rose Lake • Sap Green (MaimeriBlu and Winsor & Newton) • Tyrian Rose • Violet Grey

Brushes
Princeton no. 4 bright flat bristle (a durable brush for lifting) • nos. 8, 10 and 12 round

Surface
300-lb. (640gsm) cold-pressed paper

Other materials
No. 2 pencil • kneaded eraser

1 Sketch the Composition
Design the painting, creating three planes: the focal point flower, the secondary flowers and leaves, and the sky.

Repeat various different shapes to create rhythms and to move the eye around. The swirling petals' shapes are ideal for this purpose; repetition is key to rhythm. Make sure nothing splits the painting in half either vertically or horizontally. Observe the light and shadow patterns and shade them in.

2 Redraw on Watercolor Paper
When you are satisfied with the sketch, redraw it on watercolor paper with a no. 2 pencil. The reason for doing three-value shading is so you can concentrate on color when you paint and you don't have to constantly refer to your photo. After you have done your three-value drawing, erase enough graphite to leave only a "ghost" of the image—just enough for you to follow.

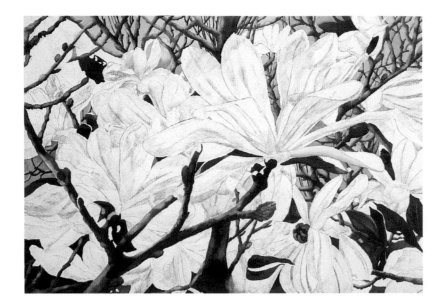

3 Paint the Branches and Leaves

Now is the time to use the underpainting; use cool colors in the shadows and warm colors in the light. Follow the values from the "ghost" image. Create rhythms with variation and contrast. Concentrate on different shapes, values and colors to make a more interesting painting—no flat colors. Use warmer colors in the foreground, making it come forward, and cool browns in the background to help it recede.

Do the underpainting on the leaves using Cadmium Orange, Sap Green (MaimeriBlu), Green Blue, Perylene Maroon, Cadmium Red Deep and Bamboo Green. Do the overpainting with Sap Green (Winsor & Newton) and Indigo mixed together, and another mixture of Sap Green (MaimeriBlu) and Perylene Maroon.

4 Paint the Focal Point

Paint the focal-point flower using your brightest colors, mostly warm, relieved with just a few cools. I used Bright Violet, Tyrian Rose, Quinacridone Purple, Payne's Gray, Violet Grey, Cadmium Red Orange, Golden Lake, Rose Lake and Perylene Maroon. Place the darkest darks around the focal point or close to it, and use the brightest colors to make the focal point stand out above all.

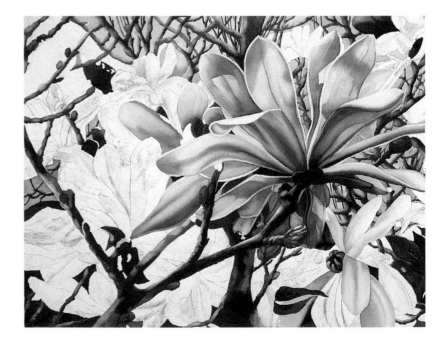

MAKE NEGATIVE SPACE INTERESTING

Make sure no negative shape is all one color or value. A subtle gradation of color and value, even in the smallest places, adds interest and movement.

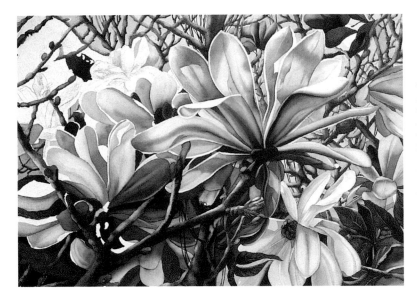

5 Paint the Secondary Flowers

Begin filling in the secondary flowers. For these flowers, tone down the colors using complements so the colors are a little darker and grayer in value, which will help the focal point stand out. Keep the lightest lights of the pinks on the focal area. Constantly compare the values and color to the focal point to assure that it dominates. The white flower is grayed down considerably—in the four-to-six range on the value scale—using Payne's Gray, Indigo, Bright Violet and Quinacridone Purple.

6 Add Leaf Veins and Soften the Edges

Create veins on the leaves with negative painting. You can draw the vein line first using a small thickness of the vein, then overpaint the negative shapes behind the veins using the darker, greener mix. The undercolors will shine through and the veins will be light enough to show and give texture to it. Soften the edges by using the no. 4 bright flat bristle to gently lift out color, creating a softer and more natural look.

Set your painting up and study it. A good painting should show up well far away as well as close up. Look for places to touch up by glazing or lifting out, changing a few shapes here and there or adding brighter color.

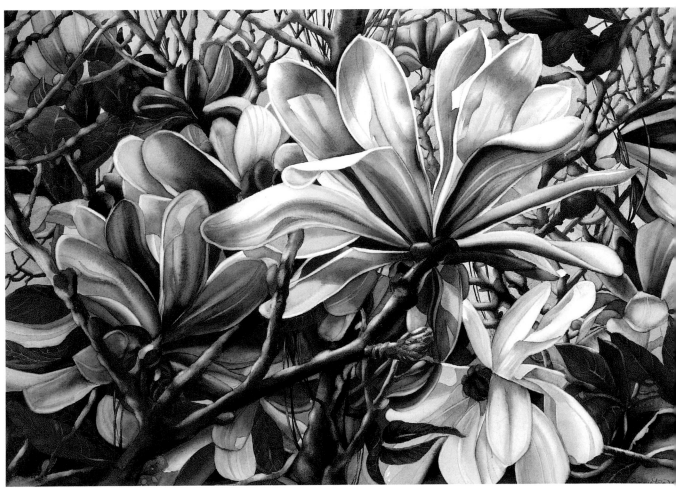

Day Radiance
Penny Soto | Watercolor
22" × 30" (56cm × 76cm)

The Role of Enigma

Some people can't stand suspense, so they read the last chapter of a mystery before they read the rest of the book. Yet most of us read a mystery specifically *for* the suspense. We want to be kept guessing. We want to be mentally engaged.

In the same vein, the most powerful artists in any hierarchy of greats are those who don't tell everything. Turner, especially in his later works, says so much exactly by saying so little. Rembrandt's work is full of unanswered questions. And da Vinci's *Mona Lisa* has captured the world's imagination for many reasons. But one ranks above all others: Her smile is impossible to read.

Viewers want to be challenged. If everything is spelled out, there is no enchantment. In *The Art Spirit*, artist-philosopher Robert Henri asks, "Have you not seen many pictures that bowled you over at first sight . . . and did not stir you thereafter? Artists have been looking at Rembrandt's drawings for three hundred [now four hundred] years. Thousands upon thousands of remarkable drawings have been made since, but we are not done looking at Rembrandt. There is a life stirring in them."

Where there is life, there are still unanswered questions, still a feeling of fluidity, of incompleteness. When everything is all spelled out, tied down and wrapped up, it is lifeless. We want to feel fresh air blowing and the current flowing! Henri notes, "There are always a few who get at and feel the undercurrent, and these [artists] simply use the surface appearances . . . as tools to express the undercurrent, the real life. . . . It is this sense of the persistent life force back of things which makes the eye see and hand move in ways that result in true masterpieces." The mysterious "undercurrent" adds power and authenticity to any work. It separates merely competent art from work that is significant.

With Sensitivity Comes Power

Do you have what it takes to "get at and feel the undercurrent"? You probably do. Assessing your abilities based on prior accomplishments often leads to underestimation. You have no idea of your own depths, your own capacities until they have been plumbed and used. And perhaps not even then! Beethoven was deaf, but he heard. In a sense, we are blind until we see. As our eyes acquire more sensitivity, who knows what we will see eventually?

To see sensitively, we must feel with sensitivity. Rembrandt, da Vinci, Monet, Vermeer and other greats expressed deeply because they felt

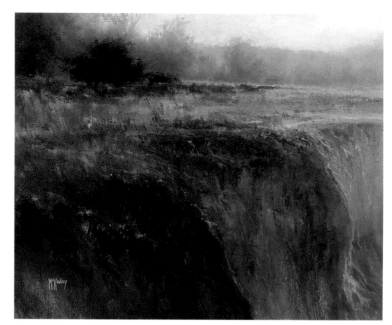

Simplicity and Understatement

There is power in leaving thoughts—and images—hanging in the air. The lines of this cliff plunging into the Pacific lead us back in space, but they do more than that: They engage our imagination, primarily because of their deliciously lost edges. We feel a certain magic because things are left suggested and undefined.

Pacific Silver, Mendocino Gold
Richard McKinley | Oil
20" × 24" (51cm × 61cm)

deeply. They were not preoccupied with the opinions of others, but focused intensely on being and doing. They lived outside themselves. They found themselves by losing themselves in their efforts.

In terms of artistic accomplishment, consider Turner, the quintessential example of living outside himself. He had himself tied to the mast of a storm at sea while tumultuous waves crashed over him because he wanted to paint that experience. Such passion is alive and well in every late Turner painting. But—and this is the crux of the matter—Turner's earlier work does not convey that depth and power. Which of us can

possibly know what lies in our artistic futures if we measure them merely by what we have done thus far?

How to Establish Enigma in Your Paintings

How do we bring such passion across to the viewer? What gives our work this sense of enigma?

First, forget about making pretty pictures and about what markets well. Paint what you feel a passion for. Otherwise, the process will not transport you to any great height artistically, nor will it expand your vision of what you can do in the future. Paint because you feel something in your gut about what you are attempting.

Familiarity with the subject is also essential. You paint it first because you love it. But the more you paint it and know it, the deeper your feelings for it usually become, whether you are painting squash or Spain. A depth of knowledge of your subject cannot do you anything but good—not because you acquire a list of facts, but because you acquire a depth of feeling.

Keeping things suggestive rather than defined contributes to an enigmatic effect. Use selective finish: Leaving certain areas "unfinished" dramatizes the importance of areas where the work is more fully developed, while giving the viewer a sense of involvement and discovery in the painting process.

Elusive and Evocative
Seeming to emerge out of the air, an ancient Mexican cathedral vibrates against an unlikely green sky. The rosy hues of this sandstone church arise out of the sienna-toned surface, creating a sense of mystery.

Parrochia
Margot Schulzke | Pastel
19" × 25" (48cm × 64cm)

Individuality and Style

How do you achieve originality? How do you determine your style? Every artist in the early stages of his or her career wonders about these things. The answers to both questions, as most serious artists learn over time, are the same. Originality and style grow out of your individuality. You are an original. Just as your handwriting is distinct, so your "signature" in painting is also distinct. And due to the expansive and delimiting nature of painting, individuality is revealed there far more than it is in handwriting.

As artists, we can't expect to know what our mature style will be until, lo and behold, our skills have matured. It takes considerable experience to develop full freedom of expression, and until that time comes, we are still a work in progress. Further, our style continues to evolve as skill grows, because growth normally doesn't cease until we put down the brush the final time.

You Are What (or How) You Paint

As I look around at the work of my artist friends, I see a distinctive quality that is almost always a clear expression of the person. Two who have a high energy level have a short, crisp stroke. Another, a gracious and elegant woman, produces work that reflect her own qualities. Early in your development, when you are still discovering your artistic identity, you may expect some wide variations in style. However, that will sort itself out, and people will begin to recognize your work before they read the signature in the corner. Whatever that style is, it should be authentic to you. It cannot become your identifying style unless it is genuine, because it will be inconsistent.

Don't be taken in by the fad of the week; "fashion art," as British art historian Paul Johnson calls it, and fine art are not synonymous. And don't worry about becoming any manner of "-ist." Become yourself. For much of the twentieth century, slavish attention was given to what was "new." Unfortunately, what is new this week is, by definition, old the next.

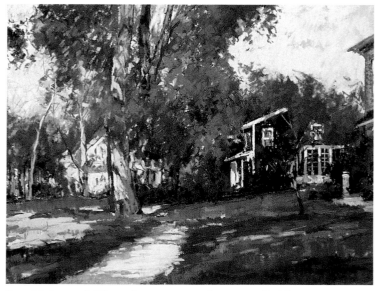

Sensitivity and Warmth
Frank Zuccarelli's sensitive nature and warmth come through clear as a bell in this tender yet lively rendering of a New England village. The analogous-plus-complement color scheme sustains the sensitive quality, gently melding one color into the next.

Autumn Gold
Frank Zuccarelli | Pastel
16" × 20" (41cm × 51cm)

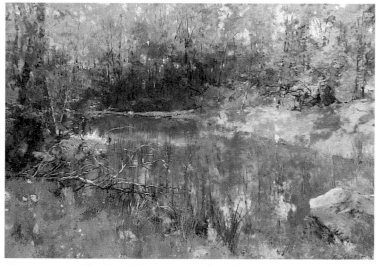

Elegance and Authenticity
Anita Wolff's characteristic style is open, gracious and elegant, as she is in person. Her work has a lightness of touch, freshness, charm and authenticity.

Pond
Anita Wolff | Oil
24" × 36" (61cm × 91cm)

Beyond-the-Brush Style

Style goes beyond the characteristic stroke. The medium, choice of subject matter; the use of flat, two-dimensional space versus deep space; color preferences; degree of attention to detail; characteristic lines; textural qualities; and so on all contribute to style. Each of the artists in this book has a clearly defined style, one that emerges from who they are. Clark Mitchell looks for deep space; Penny Soto prefers close-ups. Claire Miller Hopkins's figures have a haunting, mysterious quality. Martha Bator's still-life paintings are filled with vibrant color and texture. Daniel Greene is interested in the division of space and the placement of objects and lines.

Who we are and what our life experiences have been contribute more to our expression than any superimposed, artificial style ever could. The good and bad experiences that come our way, whether or not we seek them, have their impact.

My visit to the burn unit in the National Children's Hospital in the former Soviet Republic of Moldova in January of 1992, less than a month after Gorbachev's resignation, visibly impacted my work. After seeing little amputees suffering without painkillers, antiseptics or antibiotics, and visiting with their brave young mothers, I left the room fighting tears. Those images have never left me. Ten years passed before I could speak of that visit without losing my composure.

The unintended effect Moldova had on my work was remarked by countless people in the year or two following, who claimed to see new depth. Many of you have survived far more. While we don't wittingly seek such experiences, they deepen our souls and broaden our views. Perhaps you are not aware of how you have grown as a result, but as your skill matures, your work will benefit directly. The enlarged view and keener sensitivity effectively cut across all boundaries. Count it as a silver lining in the clouds. Great art does not come from small people.

While you paint, study and focus on developing skills, give your style time to emerge. Our ability to create, even to be ourselves, is often buried within us by the less positive experiences and influences in our lives. This doesn't mean your distinctive identity—as an artist or otherwise—isn't there. "Latent" is not the same as "nonexistent." If you see yourself here, view those qualities as you would a dormant tree in winter, waiting for a change of seasons. You can effect that change. To emerge as an individual, an original, involves some risk, which we'll talk about next.

Art is nature as seen through a temperament.

—Jean-Baptiste-Camille Corot

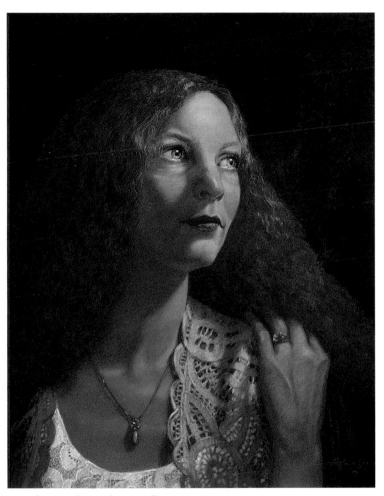

Candor With Understanding
Like the striking treatment of Mary we see here, Thelma Davis's work reveals an interesting mixture of honesty and sensitivity. Although this artist paints a variety of subject matter that includes figures, still life and seascapes, there is a distinctive approach that unites her work.

Mary
Thelma Davis | Pastel
20" × 16" (51cm × 41cm)

Expansive, Unaffected and Genial

Such describes the tone of this charming miniature, as well as much of this artist's work. Based on the mood this painting generates, its tiny dimensions take us by surprise.

Southern Lady

Jan Kunz | Watercolor

7" × 10" (18cm × 25cm)

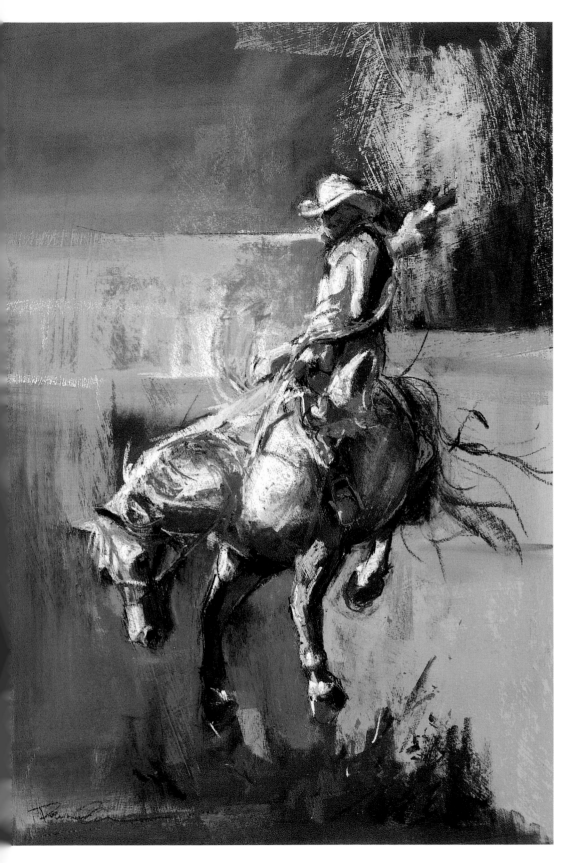

Characteristic Mood

With these horses' great sense of life, looseness and vitality, you sense the passion Dawn Emerson feels for her subjects. No one mistakes her horses for those of any other.

Buckaroo!
Dawn Emerson | Pastel
28" × 18" (71cm × 46cm)

Strongly Stated, Detail Oriented

A friend of many years, Marbo Barnard, and I have done a lot together, including travel. Marbo keeps a clear mental list of what comes next, while I forget a lot but never get lost. The standing joke between us is that Marbo tells us what to do, and I just tell us how to get there. Her work is as well organized as she is.

Samurai Headdress
Marbo Barnard | Pastel
22" × 18" (56cm × 46cm)

Taking Risks

If Modigliani or El Greco had been intimidated by the idea of elongating figures, would we ever have heard of them? What if Matisse had not played with pattern and tilted his perspective? If Monet had decided not to experiment with mixing color in the eye, would he still have become the titan of Impressionism? All those choices involved risk.

There is little to lose in taking artistic risks, and much to gain. Giving in to fear blocks growth, to say nothing of what might otherwise be noteworthy contributions to the history of art. Confronting the hazards involved in *not* sticking our necks out is the most persuasive argument for doing so.

No one would argue that stopping before a painting is overworked is a bad idea. But too often, due to either an excess of caution or lack of vision, novel approaches are never tried. Work that might ultimately be exciting and significant never gets off the ground.

In the film *Chariots of Fire*, British runner Harold Abrahams loses for the first time in his life to Scotsman Eric Liddell. Devastated, Abrahams tells his girlfriend he will never run again. Sybil's reply is classic: "Harold, if you don't run, you can't win." Acquiring a philosophical attitude toward failure is one of the greatest favors you can do for yourself. Taking a specific risk, or a series of them, may open a whole new world—as it did for Abrahams, who went on to become an Olympic champion.

All art is an experiment. But we are not chemists who are likely to blow up the lab if our experiments fail, finding ourselves in pieces on the studio floor. If you're reluctant to experiment, it may help vanquish the "demons" if you ask yourself why. Some possibilities:

Fear of disapproval. When you get uninvited or unwarranted criticism, consider the source. If the comments are premature or unqualified, tell the individual, with a smile and a shrug, "This is a rough draft, and I'll let you know when I'm ready for input." Of course, that may be never!

Thinking inside the box instead of out. You may have been taught as a child to color inside the lines, a mindset many struggle to

Stark Simplicity, Powerful Statement

All eyes are on the brilliant red tree, which is almost dead center—but with a statement like this, who cares? The drama of the red-violet sky and roof play second fiddle to the brilliant, sharply defined tree. The artist could have included more detail, but by leaving much unsaid, he said far more.

Church on Readus Road
Bill James | Pastel
19" × 28" (48cm × 71cm)

overcome. To get beyond it, recognize it and dismiss it. Yes, that *is* easier said than done, but persistence pays. Keep trying.

Misapplied thrift. Thrifty painters may worry about wasting time, paint or paper. Worry instead about wasting your talents by being stingy with materials and time.

Insecurity about what is good design. Degas broke the rules with stunning effect because he knew them, inside and out. So can you.

Lack of familiarity with methods of correction. Understand those in your medium. How liberating that is! John Singer Sargent achieved the fresh, bold look of having put each stroke down once, but in fact he put them down many times—and scraped them down just as many—minus one.

Insecurity about drawing skills. If we have the drawing right and think we may not be able to get it back again, who's to dare making changes? Solution: Take a drawing class. And practice, practice, practice.

Thinking Outside the Box
The artist has given us the simply unexpected: a bit of refreshment in a dry river bottom. The shadow mass is minuscule. The only full-intensity color is that small piece of blue sky reflected in the tiny pool of water. Doesn't sound like much, but it's a real eye-catcher. The artist took a risk and won.

A Patch of Blue
Linda Erfle | Watercolor
21" × 29" (53cm × 74cm)

BECOME A RISK TAKER

Beyond understanding the fundamental causes of artistic cold feet, here are a few keys essential to gaining an experimental attitude:

Approach every artistic effort as an experiment. Some fail, some succeed. Build upon successes and learn from failures.

Experiment with paintings that are "lost causes." When the end result no longer matters, you'll feel free to play.

Start fresh projects, with experimentation as the entire object. Try materials, surfaces and techniques you'd never dare try on an ordinary day.

Set the stage for creativity. Purchase the necessary equipment to allow you to paint unfettered. Establish a permanent, organized work space.

Take the workshops you need. Some are reluctant to attend workshops because they fear looking like an amateur. Don't! People of all skill levels attend.

Be willing to do something extreme—such as amputate. Once I cut off half of a painting that wasn't making it. The surviving half exhibited at the National Arts Club, garnered publication and sold at a nice price.

Don't operate on autopilot. Plan. Make thumbnails, value plans and color studies. Explore possibilities in a nonfinal state when you have nothing to lose.

Make process notes. Later you may forget how you got that great effect. No, you may never look at them again, but remember that writing them helps you retain the ideas.

Play music in your studio that relaxes or jazzes you up. Suit it to the subject matter or mood you are striving for.

Always ask, "Why not?" If it "just isn't done," perhaps you should be the first.

Taking a Chance With Color
Jan Kunz · Watercolor

Carefully controlling values and limiting the palette is critical to making this painting work. Major shapes that otherwise would read separately and break up the continuity and rhythm must become unified masses of warm or cool.

The eye is drawn more to warm than cool, which is why warm colors are typically used in the foreground and cool colors saved for the background. However, I want to maintain the casual denim on the figure—which means retaining a cool blue for the foreground focal point. It *can* be done—if Gainsborough could do it for *The Blue Boy*, I can do it here. As a result, the cool color moves forward on the picture plane, and the painting's warm reds are made to recede.

MATERIALS

Watercolors
Burnt Sienna • Burnt Umber • Cadmium Red Light • Cobalt Blue • New Gamboge • Payne's Gray • Permanent Alizarin Crimson • Permanent Sap Green • Raw Sienna • Ultramarine Blue • Winsor Blue (Green Shade) • Winsor Green (Blue Shade) • Winsor Red

Brushes
1-inch (25mm) and ½-inch (13mm) flat • nos. 6, 8, 10 and 16 round

Surface
140-lb. (300gsm) cold-pressed paper, stretched

Other materials
Pencil • graphite transfer sheet • masking fluid • rubber cement pickup • drafting pen • straight-edge

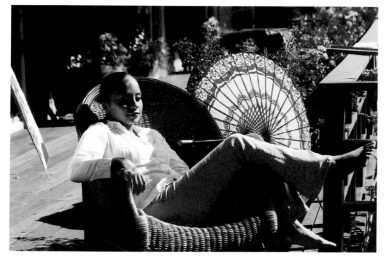

Reference Photo
After making several sketches and taking photos of the model, Rachel, in various positions, I am especially drawn to this pose because of the repeated curvilinear shapes that dominate the scene. The strong diagonals formed by the arms and legs add interest.

Value Sketches
I make value sketches to work out design problems. Round shapes like the umbrella tend to attract the eye. In the first value sketch, the umbrella detracts from the figure. In the second sketch, cropping the umbrella helps to refocus attention on the figure. It also eliminates the "dead space" in the background.

5 Crop the Painting

By cropping the umbrella, Rachel becomes the dominant form in the composition. The viewer's eye then reads the pattern of the cropped umbrella as an arc, echoing the bend of her knees—instead of competing with her face. A final very light wash of tone on the umbrella removes the harsh white of the paper, removing the last potential distraction.

Rachel in Blue
Jan Kunz | Watercolor
14" × 16" (36cm × 41cm)

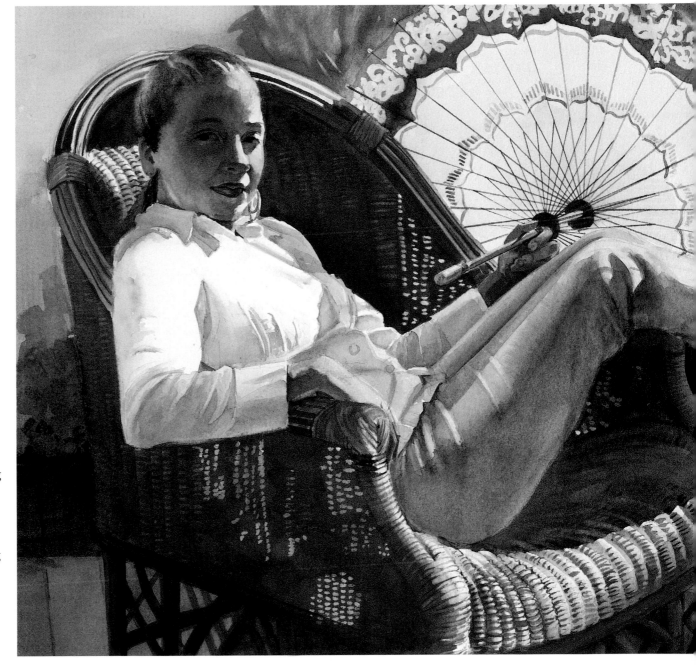

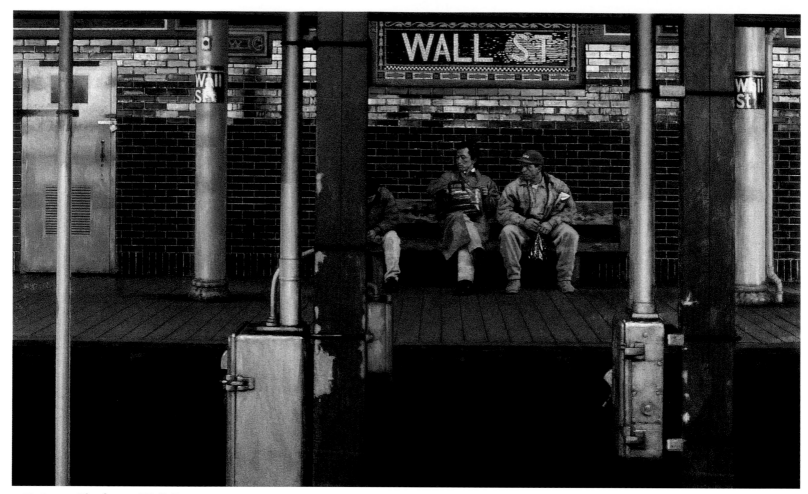

Uptown Platform, Wall St.
Daniel Greene | Oil
36" x 60" (91cm x 152cm)

I use contrast frequently in helping to solve painting problems. From a design point of view, I consider *Uptown Platform, Wall St.* to be a subject that had all of the elements I needed to establish a unique compositional arrangement.

Fundamentally, the design is based on an asymmetrical and irregular spacing of pillars and columns, as well as the ready-made contrasts of shape and size of the metal pipes, boxes and doors. The figures are framed within the verticals that several posts and pipes presented. The frontal view is further divided by a series of separate portions, simulating the triptych compositional format employed by fourteenth- and fifteenth-century Flemish artists.

The juxtaposition of contrasting figures and types, as well as the differences in their posture and positions, add more to the mood of variety and contrast that I sought in this work. This is one of the earliest of the now seventy-nine paintings of the New York Subway that I have painted, and I believe one of the most unusual in diversity and composition.

—Daniel Greene

IN THE ARTIST'S WORDS

4

NO TWO OF US THINK ALIKE, AND THIS IS PROBABLY TRUER OF ARTISTS THAN other segments of the population. While there are obvious commonalities, every artist operates with different motives and on a different philosophical basis from every other. It follows that no one can understand a work of art better than the artist who created it. To see into an artist's thinking is revealing. In this chapter, several of the book's artists share their views on their own work.

Read what these artists have to say about their motivations and their focus, where they agree and where they diverge, and then consider what motivates you and why. Knowing *why* particular categories of subject matter capture your imagination is more helpful than simply knowing that they do. After all, if you don't know where you're coming from, it's difficult to get a bead on where you want to go.

Your primary motivation may be to convey brilliant color, rich or unusual texture, a pulsating rhythm, the effects of light and shadow or something else altogether. Or, perhaps your main objective involves communicating narrative, environmental concerns or historic context. Whatever it is, once you recognize its existence, you'll find it easier to identify themes you can focus on over long periods, around which you can build a unified body of work. And when you know which concepts or subjects motivate you, you can play to your strengths and make powerful, convincing paintings.

Discover What Moves You

There is validity in a wide range of approaches. Look for a pattern in your own; it has something to tell you.

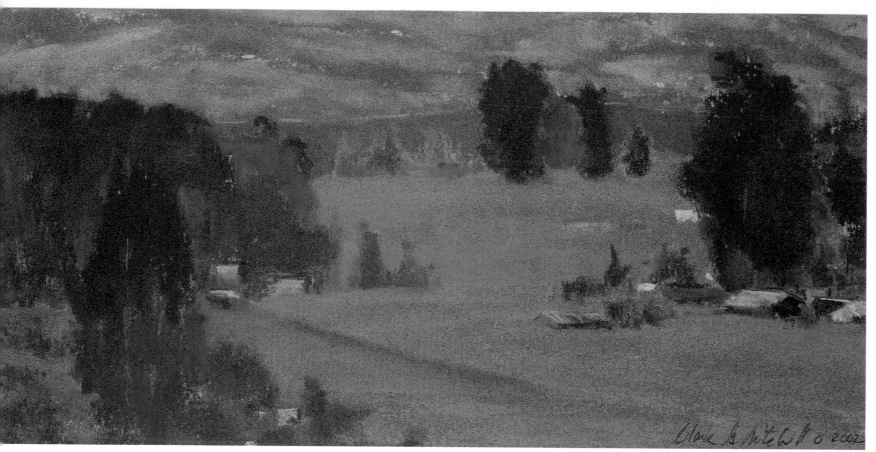

Valley View
Clark Mitchell | Pastel
7" × 14" (18cm × 36cm)

I am so often in awe of the beauty of light moving over or back-lighting a landscape. I'm drawn by the beauty of shadows. I feel fed by this, and want others to know the value of the natural world (and to be inspired to help in its protection) as well as the healing power of beauty.

Though I've done a good many paintings of the valley below our house in every kind of weather, season and time of day, I'm most pleased with this plein air version. Every time I saw this magical and fleeting combination of sun and shadow, I knew I'd have to paint it. As my focus was definitely that magic, I added crisper detail and richer color only to the tall tree in the lower left, while making sure the other two clusters of eucalyptus trees (background center and middle-ground right) were closely related in size and color to keep the viewer's eyes moving throughout the painting. Everything else in the foreground was left in shadow and merely suggested; the sunlit background was left atmospherically distant, and details in the buildings were intentionally subordinated, as the human tendency is to focus on the man-made.

Though I long ago realized that every painting can't be a lush and dreamy sunset scene, I do my best to find the viewpoint, season, time of day, shadow-and-sun pattern and color harmony that will first capture the viewers' attention, and then their hearts.

—Clark Mitchell

Benecia Shadows
Penny Soto | Watercolor
22" × 30" (56cm × 76cm)

I was drawn by the serenity of this scene, the colors and the way the light moved across the room. My intent in re-creating it was to invite the viewer to walk into the restaurant with me, look at the floors, the table and then out the window. Like the town itself, the mood was quiet and pleasant, really just comfortable. I love all the little tables looking at the quiet bay. It seems like a crowd of people just left; no one is in the restaurant—just the tables, the view and the serenity.

Underpainting, including layering color to create the subtle tones in the tile floor, was the technical challenge. I try to enhance color and pattern to make it more challenging for myself and for the viewers, allowing them to see different colors in objects or at least to know they are suggested. For me, that's what painting is about: There is a vast array of value and color in everything we look at; we just have to stop, look and imagine. I want the viewer to see the colors that I see.

—Penny Soto

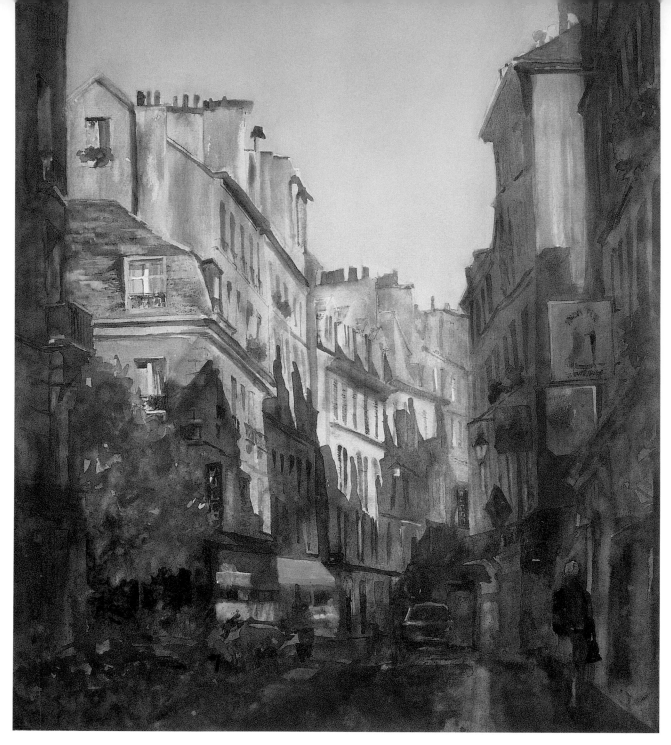

**Shadows of the
Rue Mouffetard**
Jann Pollard
Watercolor
26" × 22"
(66cm × 56cm)

I see light, color and shapes that evoke a feeling that I want to capture in my paintings. In this case, I was walking the streets of Paris on Rue Mouffetard, and the light was forming a wonderful pattern on the buildings. I directed your eye to the shadow instead of the street by deliberately leaving the foreground very impressionistic and void of detail—allowing you to get to the shadow. The light patterns and shapes created are a never-ending source of inspiration for me.

—Jann Pollard

Armour Plate
Anita Wolff | Pastel
20" × 20" (51cm × 51cm)

T he subject matter is what charges me up. I may have to do a lot of rearranging, changing of values, pushing and pulling to get what I want. But I have to get excited about it, like a good meal is straight ahead. It has to be a feast. Hopefully, then, it will be a feast for the eyes. When I saw this armour plate in London and studied its history, its craftsmanship, I knew it had to be brought to the attention of others, in a way only artists would see.

—Anita Wolff

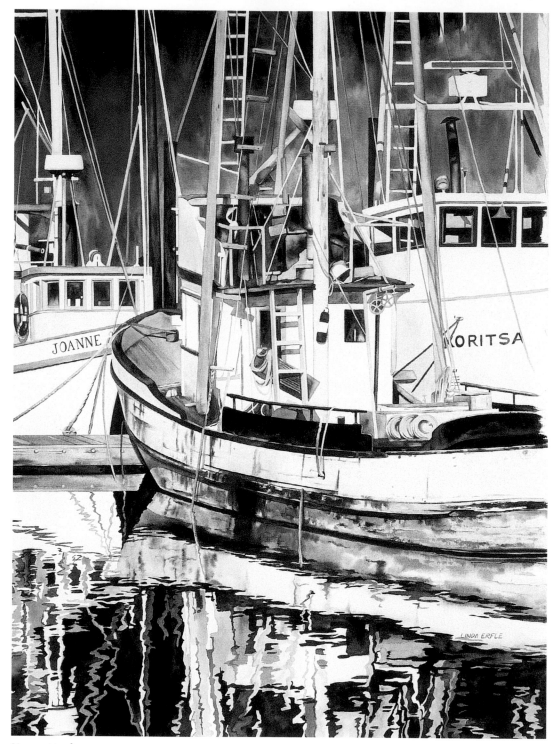

oyo Harbor at Fort Bragg in northern California is a favorite spot of mine. The weathered wood, flaking paint and rusting steel, defined by the salty Pacific air, are usually tempting enough to paint. On this particular weekend afternoon, the peaceful harbor waters and boats were at rest, and there was a quiet, day-off aura that I desired to capture and share with viewers.

As I studied my subject, I found the curved boat shapes and the dominating linear patterns created tension and therefore a more interesting composition. In the background, the gradation of value from dark to light helps to move the viewer through these intervals. The strong value contrast, the conflict between light and dark, actually works to create clarity.

Except for a few punches of color, the palette of this painting is subdued. Lights dominate darks and help to describe a warm, sunny, lazy afternoon.

—Linda Erfle

Noyo Harbor
Linda Erfle | Watercolor
29" × 21" (74cm × 53cm)

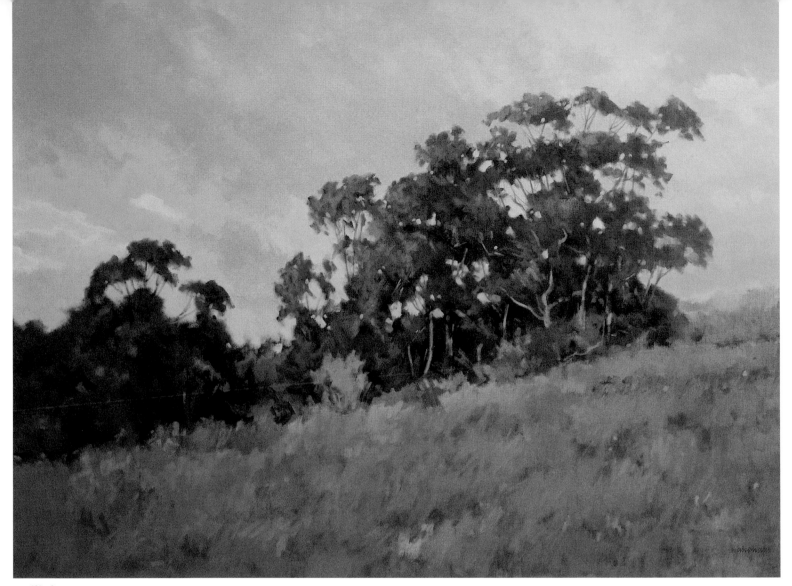

Twilight Fog
Duane Wakeham | Oil
36" × 48" (91cm × 122cm)

I'm more concerned with shapes and color relationships than with representation. The basic composition of *Twilight Fog* is simply a set of parallel diagonal lines. The lower one, which is the line of the foreground grassy field, stretches across the full width of the canvas; the upper one, which is incomplete, defines the height of the tree shapes. As the painting progressed, an opposing pair of subordinate diagonals was introduced into the sky area, most evident in the patches of sky color at the left of the canvas.

Color plays a major structural role, separate from description. Notice how the color of the lower foreground moves through the painting—in the central foliage masses, in the far right background, and then, in a much lightened value, as the major color of the billowing clouds of fog, connecting foreground and background. Solving such problems is why I say my interest lies more in the painting process than in subject matter. Only as a painting approaches completion do I begin to focus on creating a more convincing description of the subject. Until then, landscape forms are thought of as abstract shapes and patches of color.

—Duane Wakeham

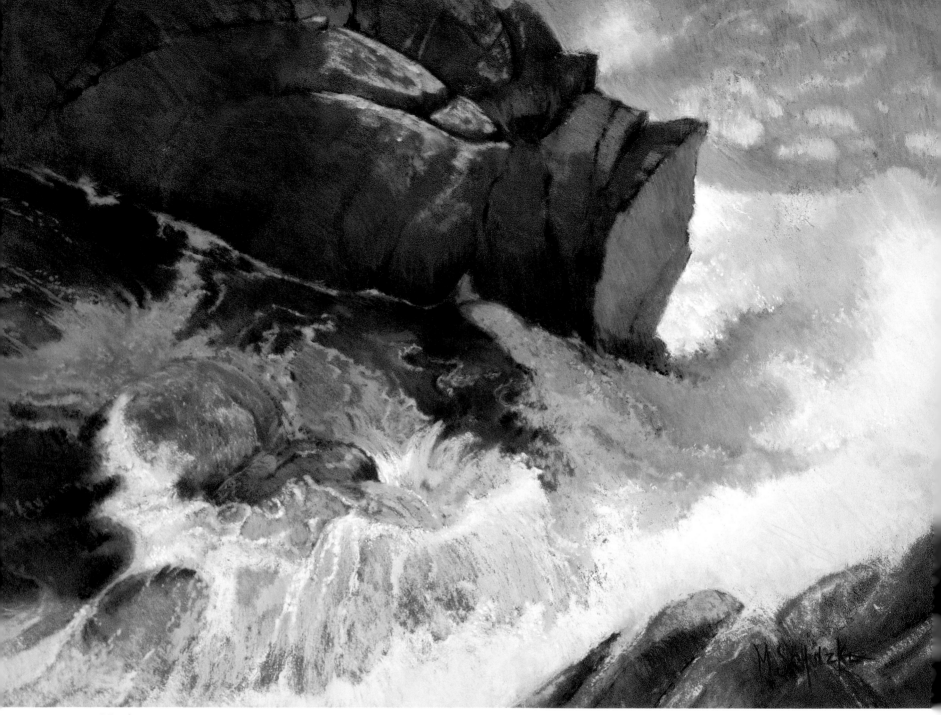

Maelstrom
Margot Schulzke | Pastel
19" × 25" (48cm × 64cm)

Conclusion

Composition runs broad and deep. To master it, continuing to read, observe and experiment is vital. Keep in mind that reading about concepts and applying them are two different things. I hope you won't put this book back on your shelf without putting some of the ideas to work, and that you'll come back to it frequently to review them. Then, one at a time, incrementally, the ideas will become yours. Remember that the "rules" stated here are meant to guide you, but decidedly not to restrict you.

One last word of advice: Getting a vision of your own potential is critical. Doing so is no easy undertaking. Even if you could stand back and view yourself from a distance, as you can with your painting on an easel, you still wouldn't see the whole picture. You can only attempt to see and gauge what is there now. But not what *could* be there at some point in the future with preparation and persistence.

Over my years of teaching, I've seen remarkable transformations. Some have taken place over fairly short time frames, not lifetimes. It seems wiser to assume that the capacities are there, or will be developed in time, than to assume they will not be. After all, who knows what great treasures have been lost to individuals and to the world by negative thought? I expect that far more often than we would imagine, a lack of vision undermines what might have been remarkable contributions to the arts.

When we follow a budding talent to its full bloom—and, for visual artists, that's likely to occur late in life—we'll often be astonished by the mileage covered. Walt Disney comes to mind. Early in his career, he was told by a newspaper editor that he would never make it as a cartoonist. How grateful we all are that he ignored that discouraging and faulty advice!

Earlier in the book, we discussed the way brain capacity expands under the influence of new stimuli. Desire, commitment and experience can enlarge, not just uncover, talent that is latent in you. The greater risk is not in setting the goal too high, but too low.

Now, I'm fully aware that many among us have to deal with the disbelief of others. The most convincing argument is not to argue, but to quietly succeed. Make the concepts discussed here your own. Compete on a local, then regional, then national level. Accept rejection gracefully, because we all get some. Expect it, but don't consider any judge to be the last word on the merit of your work. Read, practice, take workshops and join societies to find mutual support and inspiration. As ribbons pile up on your studio wall and sales occur, disbelief from skeptics will fade. Support will take its place.

Scottish runner Eric Liddell said that when he ran, he "felt God's pleasure." That will mean different things to different people, but the delight to be found in accomplishment is every person's birthright—including yours.

Margot Schulzke

From this hour I ordain myself loos'd of limits and imaginary lines. . . . The east and the west are mine, and the north and the south are mine. I am larger, better than I thought; I did not know I held so much goodness.

—Walt Whitman,
from *The Song of the Open Road*

Contributors

MARBO BARNARD
Page 52, *Japanese Teacups, Version 1* and *Japanese Teacups, Version 2*; page 123, *Samurai Headdress* © Marbo Barnard

MARTHA BATOR
Page 48, *The Rug Mender* © Martha Bator

THELMA DAVIS
Page 34, *Pounding Surf*; page 36, *Fishing Fleet*; page 121, *Mary* © Thelma Davis

DAWN EMERSON
Page 104, *Leading Edge*; page 123, *Buckaroo!* © Dawn Emerson

LINDA ERFLE
Cover and page 37, *Purple Fringed Lily*; page 47, *Docked at Noyo Harbor*; page 59, *St. Helena Fixture*; cover and page 80, *Summer Sun*; page 83, *Antique Yard*; page 89, *Our Dogwood*; page 105, *October Sky Reflected*; page 124, *A Patch of Blue*; page 136, *Noyo Harbor*; page 141, *Betty's Anemone* © Linda Erfle

DANIEL GREENE
Page 8, *Jar, Brick and Roses*; page 43, *Folk Art*; page 61, *Dutch Vase*; page 79, *Brooklyn Bridge—City Hall*; page 83, *Children's Blocks, Pomegranates and Gourds*; cover and page 90, *Antique Rug*; cover and page 130, *Uptown Platform, Wall St.* © Daniel Greene

ALBERT HANDELL
Page 19, *Monterey*; page 31, *Mountain Falls #1* and *Mountain Falls #3*; page 48, *Taos Mountain*; page 60, *The Dry Season*; page 77, *Quiet Landscape*; page 106, *At Smith Rock* © Albert Handell

CAROL HARDING
Cover and page 33, *Etched in Stone*; page 37, *Flowers of the Sun*; cover and page 67, *Symbols From the Orient*; page 95, *Little Stone Bridge* © Carol Harding

CLAIRE MILLER HOPKINS
Page 64, *Jessica in the Sun, Twice*; page 88, *Dreamer II*; page 98, *Jessica Out West #3*; page 113, *Sanctuary (Mariah's Daughter)* © Claire Miller Hopkins

RUTH HUSSEY
Page 80, *Megan*; page 114, *After the Ball* © Ruth Hussey

BILL JAMES
Page 17, *The Red Quilt*; page 36, *Coughlin House—Fall*; page 68, *Cornucopia Ballerinas*; page 78, *The Orange Robe*; page 108, *House on Prince Street*; page 112, *Colonial Shack—Waterford*; page 124, *Church on Readus Road* © Bill James

JAN KUNZ
Page 51, *Lovers in the Park*; page 60, *Summer Afternoon*; page 122, *Southern Lady*; page 129, *Rachel in Blue* © Jan Kunz

SYDNEY MCGINLEY
Page 86, *Julia I* and *Julia IV*; page 87, *Julia III* © Sydney McGinley

RICHARD MCKINLEY
Page 19, *The Point*; page 51, *Desert Arroyo*; page 65, *Along Big Tesuque*; page 75, *Pacific Ochre*; page 76, *Rawhide*; page 118, *Pacific Silver, Mendocino Gold* © Richard McKinley

CLARK MITCHELL
Page 16, *Above*; page 109, *Above (Right)*; page 132, *Valley View* © Clark Mitchell

CRAIG NELSON
Page 98, *The Lonely Canal* © Craig Nelson

JANN POLLARD
Page 134, *Shadows of the Rue Mouffetard* © Jann Pollard

MAGGIE PRICE
Page 37, *Rincon Shadows* © Maggie Price

PENNY SOTO
Page 10, *Tulip Tree*; page 16, *Bicycle Shadows*; page 25, *White Poppy Patterns*; page 81, *Kids' Stuff*; page 96, *Lost Loves*; cover and page 117, *Day Radiance*; page 133, *Benecia Shadows* © Penny Soto

SALLY STRAND
Page 36, *Twilight, Men's Club*; page 51, *Still Life With Tangerines*; page 97, *Tailor, Third Avenue* © Sally Strand

JAMES TOOGOOD
Page 12, *The Chatterbox*; page 18, *Chestnut Street*; cover and page 56, *Upper Slaughter*; page 79, *Champ's*; page 92, *1700*; page 110, *Canyon* © James Toogood

DEE TOSCANO
Page 15, *Fun at Crow Fair*; page 26, *Shadow Eyes* © Dee Toscano

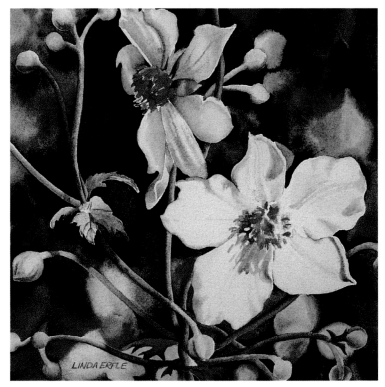

Betty's Anemone
Linda Erfle | Watercolor
8" × 8" (20cm × 20cm)

DUANE WAKEHAM
Page 2, *Spring Clouds, Sonoma*; page 41, *Quiet Summer Evening*; cover and page 62, *Near Moss Landing*; page 85, *Cumulonimbus*; page 113, *Marin Wetlands*; page 137, *Twilight Fog* © Duane Wakeham

ANITA WOLFF
Page 26, *Poppy Fields*; page 42, *The Bench*; page 50, *Naples*; page 82, *Wild Turkeys*; page 120, *Pond*; page 135, *Armour Plate* © Anita Wolff

FRANK ZUCCARELLI
Page 120, *Autumn Gold* © Frank Zuccarelli

EXCERPT AND QUOTE SOURCES
Page 82, 91 and 118, excerpts from *The Art Spirit* by Robert Henri. New York: Harper & Row Icon Edition, 1984.

Page 88, Degas as quoted by Bernard Dunstan, *Painting Methods of the Impressionists*. New York: Watson-Guptill, 1983.

Page 91, Cézanne as quoted by Eric Protter, *Painters on Painting*. Mineola, New York: Dover Publications, 1997.

Page 108, excerpt from *The HarperCollins Dictionary of Art Terms and Techniques* by Ralph Mayer, second edition. New York: Harper-Perennial, 1991.

Page 121, Corot as quoted by Robert Henri, *The Art Spirit*. New York: Harper & Row Icon Edition, 1984.

Page 139, excerpt from *The Song of the Open Road* by Walt Whitman. New York: W.W. Norton & Company, 1973.

Index

Abstraction, 14, 62
 as basis for representation, 137
Aerial perspective, 56
Analogous color scheme, 35–36
Analogous plus complement color
scheme, 35–37
Angles, strong, to create visual tension, 29
Asymmetrical balance, 52, 92

Background
 choosing, 82–83
 keeping separate from foreground, 29
 simple and complex, 83
 softening edges, 45
 See also Receding areas
Balance, 52
 achieving, and portraying scale, 53–57
 contrast and, 12
 in shapes and temperatures, 58
Black and white, combining color with, 37

Center of interest. See Focal point
Chroma. See Intensity
Color(s), 32–37
 broken, 26
 building, 40
 early planning of, 89
 impact on harmony, 50
 influences on, 32–33
 manipulating, 38–41
 and mood, 96–97
 repeating, 59, 72
 and rhythm, 115–117
 strategies, 84–85
 taking risk with, 126–129
 tips, 34–35
 varying, within same-value areas, 31
Color bridges, 107
Color contrast, 48
Color masses, building, 22–23
Color schemes, 35–37
Color study, 21, 39
Color wheel, 32
Complementary colors, 34
Complementary color scheme, 35
Complementary harmony, 51
Composition
 great, 16 elements of, 58–59

importance of first lines, 28
S-curve, 65
sketching, 115
tension in, 136
21 pointers, 88–89
 See also Design
Compositional schemes, 58, 76–81
Compositional studies, 38
Concept, and mood, 95–98
Contrast, 10, 130
 between background and foreground, 29–30
 in color intensity, 59
 in complexity, 48
 and emphasis, 48
 in line, 48
 See also Variety, importance of
Correction, learning methods of, 125
Counterbalance, balance and, 55
"C" pattern composition, 80
Cropping, 129
Cruciform composition, 78

Depth
 creating, with key adjustments, 41
 creating illusion of, 15
 established planes of, 59
 of space, 55–57
Design
 defined, 13
 high-quality, 25
 using abstraction to analyze, 14
Design formats. See Compositional schemes
Details
 selective, 30
 sharp versus soft, 82
 softening, 74
Discord, 50
Distance
 and color, 33
 lessening value contrast in, 25
Double-split complementary color scheme, 35
Drawing, improving skills, 88, 125

Economy of means, 60
Edges, 105–107
 and harmony, 50
 lost and found, 18
 and mood, 96–97
 purposeful, 20–23

softening, 45
 and tempo, 113
 varied, 58, 89
 See also Line(s)
Enigma, to engage suspense and imagination, 118–119
Experimentation
 close-up view, 86
 in color, 84
 willingness for, 64
 See also Risk-taking
Eye
 keeping within frame, with "stopper," 10, 23, 49
 leading, with line, 19
 places to rest. See Visual rests

Facial planes, 110
Focal point
 creating and ensuring, 116–117
 dominant, 58
 highest value contrast as, 25
 intensity and, 35
Focus, sharp versus soft, 82
Foreground
 as background, 82
 keeping separate from background, 29
Format
 choosing, 15
 effect of, on mood, 96–97
 proportions, 89
 square, 21
 wide, 54–57

Golden section, 76
Gouache paintings, 17, 68
Gray scale, 24

Harmony, 21, 50–51
Head placement, and mood, 96
Height and width, proportional relationship of, 54
High key, 24, 26
 and mood, 96
Horizon line, 54
Horizontal bar format, 77
Horizontal format, 15
"H" pattern composition, 79
Hue, 32

Improving, focusing on, 94
Inspiration, 64

Intensity, 32
 contrast in, 59
 and focal point, 35
Intervals
 interesting, 58
 and proportion, 43–47

Journaling, 65

Key, choosing, 24

Light, quality of, and color, 33
Lighting, controlling value through, 24
Light and shadow, 132
 masses, 108
 planes, 109
 simplifying, 25
Line(s), 18–19
 applied, 107
 contrast in, 48
 drama of, 64
 diagonal, 19
 echoing and reinforcing, 30–31, 41
 edges and, 105
 horizontal, with water view, 39
 initial, 28
 and mood, 96
 of movement, 49
 straight, 110
 and tempo, 113
Linear perspective, 55
Local color, 32
Low key, 24
"L" pattern composition, 79

Masking, creating illusion of sunlight with, 127–128
Masses, 108
 blocking in, 71
 building, 22–23, 29
 powerful, 110
Mediums, creating texture in, 42
Midtone, as point of reference, 25
Mixed media demonstrations, 27–31
Mixed media paintings, 60, 64, 77, 106, 113
Mixing colors, 34
Models, working with, 67
Monochromatic color scheme, 35–36
Mood, 58, 89, 122–123
 and concept, 95–98
 energetic, 99–104
Motivation, discovering own, 131

Movement
 circular flow, 114
 to create drama, 61
 creating, 27–29
 opposing directions, 87
 rhythm and, 49
 strong, in square format, 86
 and tension, creating, 101–104
 in water, 47
 See also Rhythm, Tempo

Negative space, 116
Neutrals, 34

Oil, creaturing texture in, 42
Oil demonstrations, 20–23, 70–75
Oil paintings, 8, 19, 26, 33, 34, 36, 42, 43, 48, 49, 51, 61, 62, 65, 76, 79, 85, 108, 113, 118, 120, 130, 137

Paint, thick, building value and color with, 72
Painting
 from life or in studio, 67
 on location. See Plein air painting
 planning ahead, 24
 turning upside-down to assess, 73
Painting knife, adding texture with, 73
Pastel
 creating texture in, 42
 dissolving underpainting, 40
 flexibility of, 100
 in mixed media, 29
 watercolor over, 30
Pastel color study, 21
Pastel demonstrations, 38–41, 99–104
Pastel paintings, 15, 16, 26, 36, 37, 48, 50, 51, 52, 67, 78, 80, 81, 82, 83, 84, 86–87, 90, 95, 97, 107, 109, 111, 114, 119, 120, 121, 123, 124, 132, 135, 138
Pattern, 42
 movement in, 96
 overall, 81
Perspective
 aerial, 56
 linear, 55
Photo references, working with, 68–69
Plane(s), 109–111
 established depth of, 59
 and masses, 110–111

and proportion, 54
Plein air painting, 65–66
 sketches, 53
Prismatic color, 107
Proportion
 format and, 89
 maintaining, 89
 See also Intervals, and proportion
Pyramid composition, 80

Quadrant test, 16

Receding areas, 74, 85
Reflection(s)
 building, 22–23
 creating strong interest and movement with, 47
 line of, 30
Repetition, and rhythm, 115–117
Rhythm, 10, 49, 112–114
 creating, with color and repetition, 115–117
 and line, unity with, 51
 and movement, 49
Risk-taking, 124–125

Scale, portraying, and achieving balance, 53–57
S-curve composition, 65
Seascape, balancing warm and cool in, 34
Seesaw test, 52
Series, working in, 86–87
Shadow(s)
 to break up line, 30
 masses, 108
 and mood, 96
 See also Light and shadow
Shape(s), 17
 balanced, 58
 blocking in, 39
 concentrating on proportion, value, and color, 46
 repeated, 59
 See also Masses
Sketches
 plein air, 53
 preliminary, 20
 thumbnail, 70, 88
 value, 44, 100, 126
Space, 15–16
 depth of, 55–57
Split complementary color scheme, 35

Steelyard composition, 81
"Stopper," to keep eye in frame, 10, 23, 49
Strokes
 creating texture with, 42
 and harmony, 50
 and mood, 96–97
 skillful, 59
Structural planes, 109–111
Studies, 27
 color, 21, 39
 compositional, 38
 value, 24, 71, 88
 See also Sketches
Studio painting, 67
Style
 individuality and, 120–123
 unity of, 50
Subject matter, 135
 familiarity with, 119
 figures, 97
 finding, 64
 placing and simplifying, 70–75
Surface, impact of, on texture, 42
Symmetrical balance, 52
Syncopated rhythm, 112

Temperature, 32
 appeal of warm tones, 35
 balancing warm and cool, 41, 58
 moving warm to cool, 101
 reversing, for foreground and background, 126–129
Tempo, 113–114
Texture, 42
 adding, 73
 contrasting, 103
 increasing in foreground, 57
Theme, variation on, 31
Three-value drawing, 115
Thumbnail sketches, 24, 70, 88
Tone. See Intensity
Triad color scheme, 35, 37
Tunnel composition, 78

Underpainting, 21, 28
 cool and warm, 116
 monochromatic, 71
 and mood, 96
 pastel, 39–40
 taking time to evaluate, 75

Value(s), 24–26, 32

controlling, 27–31, 50
 merging, 26
 varying colors within, 31
Value contrast, 48
 edges and, 106
Value control, 60
Value patterns
 strong, 58
 establishing, 22
Value range, and mood, 97
Value sketches, 44, 100, 126
Value studies, 24, 88, 71
Variety, importance of
 of color, in same-value areas, 31
 in edges, 58, 89, 106
 in intervals and proportion, 43
 to large areas of solid color, 35
 in rhythm, 114
 in underpainting, 23
Vertical format, 15
Viewpoint
 aerial, 56
 determining, 15–16
 linear, 55
Visual rests, 59, 88, 114
Visual tension, creating, 29

Water, planes of, 110
Watercolor
 creating texture in, 42
 in mixed media, 28
 over pastel, 30
Watercolor demonstrations, 44–47, 53–57, 99–104, 115–117, 126–129
Watercolor paintings, 10, 12, 16, 18, 2537, 51, 59, 60, 79, 80, 81, 83, 89, 92, 96, 105, 110, 112, 122, 124, 133, 134, 136
Waterfall, 27–31
Water view, horizontal line in, 39
Whites, saving, 45

Zones of recession, 109

Learn the secrets to great paintings with these other fine North Light Books

Mastering Color
by Vicki McMurry
ISBN-10: 1-58180-635-3
ISBN-13: 978-1-58180-635-9
Hardcover, 144 pages, #33214

This book goes beyond the color wheel for a deeper understanding of the emotional and practical uses of your palette. You'll learn inventive yet easy-to-understand techniques that work for every subject, medium and skill level. McMurry covers the properties of color in depth and illustrates color theory with examples, charts, mini-demos, demos and comparisons. *Mastering Color* is sure to maximize the beauty and appeal of your next painting!

Pure Color: The Best of Pastel
edited by Maureen Bloomfield and James A. Markle
ISBN-10: 1-58180-764-3
ISBN-13: 978-1-58180-764-6
Hardcover, 128 pages, #33433

Pure Color is pure inspiration for all artists. From luminous landscapes to moody still lifes, this stunning collection showcases more than 125 works from over 90 of today's most accomplished pastel artists. Every oversized page features beautiful artwork spanning a diverse range of styles and subjects. You'll also find insightful commentary from all the artists detailing their creative processes and artistic techniques, so you can use the same principles in your own work. Whether you're an artist or an art lover, *Pure Color: The Best of Pastel* will inspire you to let your imagination soar!

Land & Light Workshop: Painting Mood & Atmosphere in Oils
by Carolyn Lewis
ISBN-10: 1-58180-631-0,
ISBN-13: 978-1-58180-631-1
Hardcover, 128 pages, #33203

Elevate your oil landscape paintings from pretty to breathtaking! In this book, Carolyn Lewis shows you how to take your unique interpretations of the outdoors and beautifully communicate them on canvas. You'll learn how to design compelling compositions; how to master color mixing, brush techniques and palette-knife work; and how to accurately portray any season, time of day, lighting situation or weather condition. Lewis also includes 15 step-by-step demonstrations. With the help of *Land & Light Workshop: Painting Mood & Atmosphere in Oils*, every scene you paint will leave a lasting impression!

Realism in Watermedia
by Christopher Leeper
ISBN-10: 1-58180-508-X
ISBN-13: 978-1-58180-508-6
Hardcover with wire-o binding, 128 pages, #32868

In this book for beginning and intermediate artists in all mediums, you'll find great realistic art and specific instruction in mixed media. Christopher Leeper shows you how to paint in watercolor, acrylic and gouache—sometimes all in one painting—and how to add accents and texture with pastel and colored pencil. Take this book into the studio (the lay-flat binding makes it a joy to work with) and build your skills with the 13 demonstrations on subjects ranging from landscapes and suburbscapes to animals and people.

These books and other fine North Light titles are available at your local fine art retailer or bookstore or from online suppliers.